around the bend

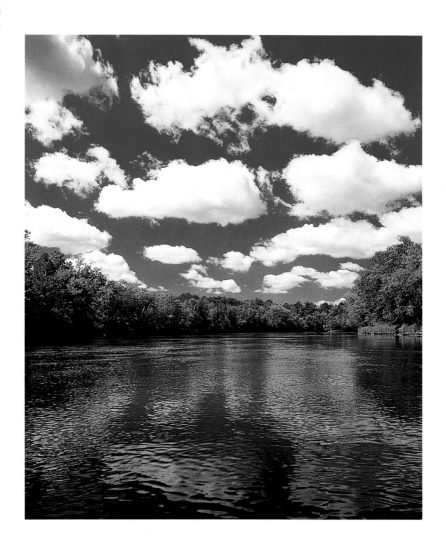

around the bend

A MISSISSIPPI RIVER ADVENTURE

photographs and text by C.C. Lockwood

for Sue

Other Books by C. C. Lockwood

Atchafalaya: America's Largest River Basin Swamp

The Gulf Coast

Discovering Louisiana

The Yucatán Peninsula

C. C. Lockwood's Louisiana Nature Guide

Beneath the Rim: A Photographic Journey Through the Grand Canyon

Copyright ©1998 by C. C. Lockwood

All rights reserved

Manufactured in China

First printing

07 06 05 04 03 02 01 00 99 98 5 4 3 2 1

Designer: Amanda McDonald Scallan

Typeface: ACaslon

Printer and binder: Everbest Printing Co. through Four Colour Imports, Ltd.,
* Louisville, Kentucky*

Library of Congress Cataloging-in-Publication Data

Lockwood, C. C., 1949–
 Around the bend : a Mississippi River adventure / photographs and text
by C. C. Lockwood.
 p. cm.
 ISBN 0-8071-2312-9 (cloth : alk. paper)
 1. Mississippi River—Description and travel. 2. Lockwood, C. C.,
1949– —Journeys—Mississippi River. 3. Mississippi River—Pictorial
works. I. Title.
917.704'33—dc21

contents

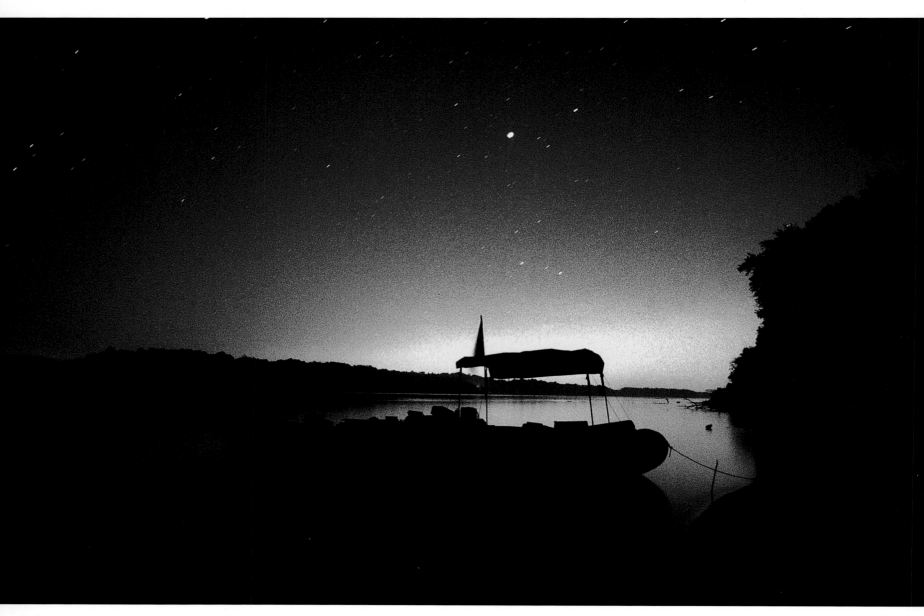

The Grand Canyon river raft that author
C. C. Lockwood used to float the Missis-
sippi, *Huck Finn,* rests peacefully under
the stars near Keithsville, Illinois.

a c k n o w l e d g m e n t s

ONE DOES NOT travel from stem to stern on America's largest river without a lot of help. I received much from many different people and organizations, for many different reasons. Without their contributions of time, knowledge, equipment, and cooperation, I might still be on the Mississippi haplessly rafting.

My photographic expedition of the entire river depended on material support by several companies. Without my raft, the *Huck Finn*, loaned to me by Grand Canyon Expeditions, or my fast red Northwind canoe, loaned to me by Bell Canoe Works, I never would have seen the mighty Mississippi from the inside out. And my ride on the beautiful *American Queen*, as a guest of the Delta Queen Steamship Company, let me view the river with singular ease and perspective. In addition, GT Bicycles and the Bicycle Shop of Baton Rouge loaned me a bike that accompanied me on the raft trip; it proved enormously useful as I explored dozens of river towns and parks. For supplying me with everything from gumbo to T-shirts, Delaware Marine Services, DiGiulio Brothers restaurant, Dream Silk Screens, Fairway View Club, and Simms Fishing Products have my thanks. I am also grateful to Fuji Film USA for providing me with their color-rich Velvia film.

Several organizations and individuals have my thanks for transforming me into "High Tech Huck." I was able to send a story to our Web site each day only because the *Advocate* Online, Cellular One of Baton Rouge, and Nikon Professional Service respectively supplied me with a laptop computer, a cell phone, and a digital camera. Stafford Kendall, my office manager, kept the Web site afloat and typed up the manuscript. Technical assistance of another sort I received from Jimmy Hill, Marty Mathis, and Jim Roland; they went above and beyond the call of duty helping me put the raft together, launch it, and— sixty-three days later—take it apart.

To those who participated in my journey via the Internet: thanks for being there. I especially want to acknowledge the seven schools whose students read my Web page and sent me such interesting questions by e-mail. These include (in Baton Rouge) Broadmoor High School, St. James Episcopal Day School, McKinley Middle Magnet School, St. Aloysius School, Scotlandville Magnet High School, University High School, and (in St. Louis) the Crossroads School.

Many others helped me in various ways to complete my exploration of the Mississippi. You have my

thanks: Jim Addison, Ted Bell, Ouncy Born, Lucette Brehm, Brad Brenner, Rob Brown, John Buie, Clyde Carlson, Bob and Marchand Chaney, Richard Cole, Billy Curmano, Charlie D'Agostino, A. Dave Deloach, Z. Dave Deloach, Mike Denoyer, Dan Derbes, Louie Deveroux, Maury Drummond, Perry Franklin, Dr. Tom Gandy, Steve and Flo Guenard, George Gugett, Leo Honeycutt, Sam Inoue, Warren Johnson, Bruce King, Jack Levine, Charlie Maguire, Doug Manship, Jr., Norman Marmillion, Al McDuff, Charlie Mitchell, Dave Morgan, Butler Murrell, Rob Newsom, Bill Oliver, Jim Olsen, John O'Neil, Clare Pavelka, Bill Pekala, Jennie Peters, Jerome and Mary Peterson, Greg Phares, Sam Prokop, Davis Rhorer, Cliff Roper, Erwin Ruiz, Karen St. Cyr, Captain David Schaeffer, Barbara Schlichtman, Hank Schneider, Neal ("the Bear") Shapiro, Sol Simon, Donovan Smith, Capt. Bobby Solar, Jane Swift, Bobby Wilkerson, Suzi Wilkins, Charlie Wilson, Kristen Wynne, and Patty Young. If I've neglected to mention someone whose kindness enhanced my journey, please forgive the omission here—and thanks to you, too.

I also want to acknowledge the following organizations and government agencies for offering information and granting permissions: Atchafalaya Basin Levee District, Associated Branch Pilots, Iowa 150 Mississippi River Adventure, Louisiana State Parks, Minnesota Department of Natural Resources, Mississippi River Basin Alliance, Mississippi River National Park, New Orleans Harbor Police, United States Army Corps of Engineers, United States Coast Guard, the USS *Kidd* and Nautical Center, and *Waterways* journal. Special thanks are also due to the Port of Greater Baton Rouge and to Exxon for a terrific welcome home party.

Of course, this book would not have come into being without my publisher, Louisiana State University Press. They adroitly helped to assemble here pictures and recollections I had gathered over a two-year period. My special thanks go to Les Phillabaum, Maureen Hewitt, Amanda McDonald Scallan, Claudette Price, and the rest of their staff. I am also grateful to my copy editor, Donna Perreault, for helping the words flow from beginning to end.

Finally, I thank my wife Sue and stepsons Lee and Adam for joining me on various legs of the journey represented in the following pages. They entered into the spirit of this adventure and dealt with me when all I had was the Mississippi on my mind.

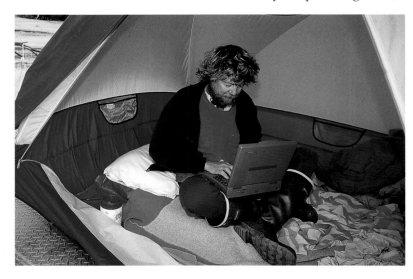

Known as "High Tech Huck" on his Mississippi raft trip, the author journeyed with computer, digital camera, and cell phone.

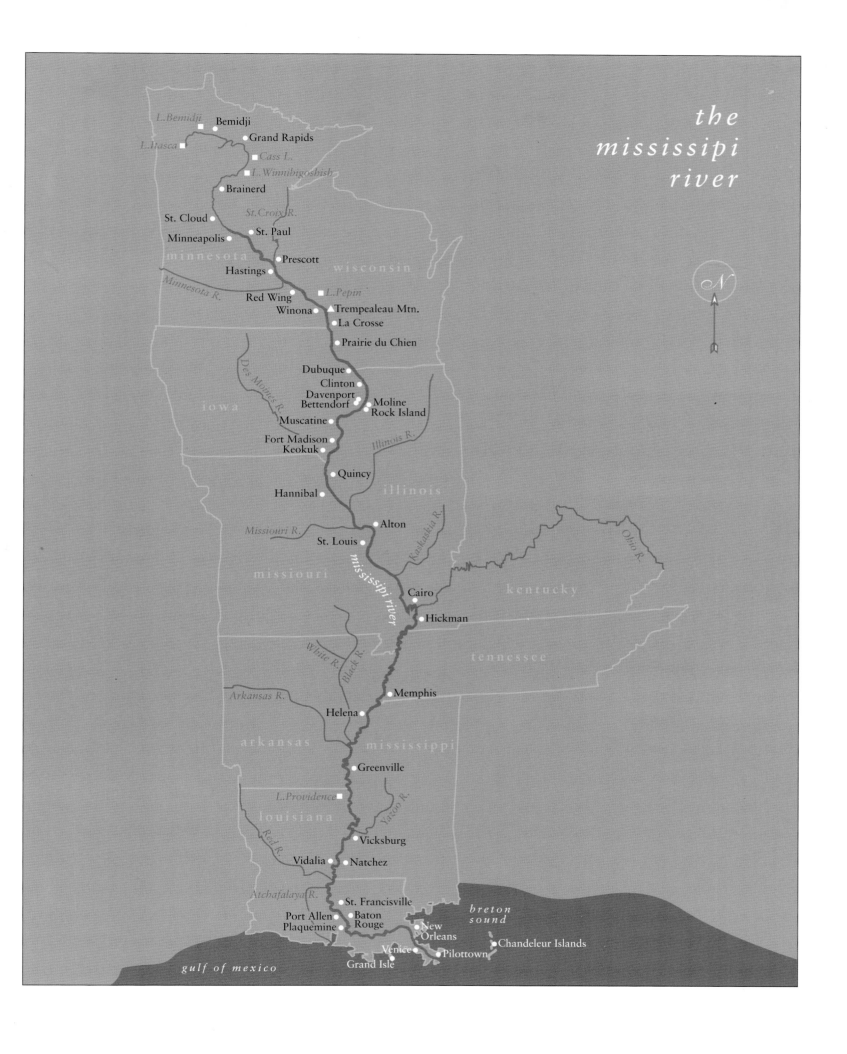

the mississipi river

L. Bemidji
Bemidji
L. Itasca
Grand Rapids
Cass L.
L. Winnibigoshish
Brainerd
St. Croix R.
St. Cloud
St. Paul
Minneapolis
Prescott
minnesota
wisconsin
Hastings
Minnesota R.
Red Wing
L. Pepin
Winona
Trempealeau Mtn.
La Crosse
Prairie du Chien
Dubuque
Clinton
iowa
Davenport
Moline
Des Moines R.
Bettendorf
Rock Island
Muscatine
Illinois R.
Fort Madison
Keokuk
Quincy
Hannibal
illinois
Alton
Missouri R.
Kaskaskia R.
St. Louis
Ohio R.
missouri
mississippi river
Cairo
kentucky
Hickman
White R.
Black R.
tennessee
Arkansas R.
Memphis
Helena
arkansas
mississippi
Greenville
L. Providence
louisiana
Yazoo R.
Vicksburg
Red R.
Vidalia
Natchez
Atchafalaya R.
St. Francisville
breton
sound
Port Allen
Baton Rouge
Plaquemine
New Orleans
Chandeleur Islands
Venice
gulf of mexico
Pilottown
Grand Isle

N

around the bend

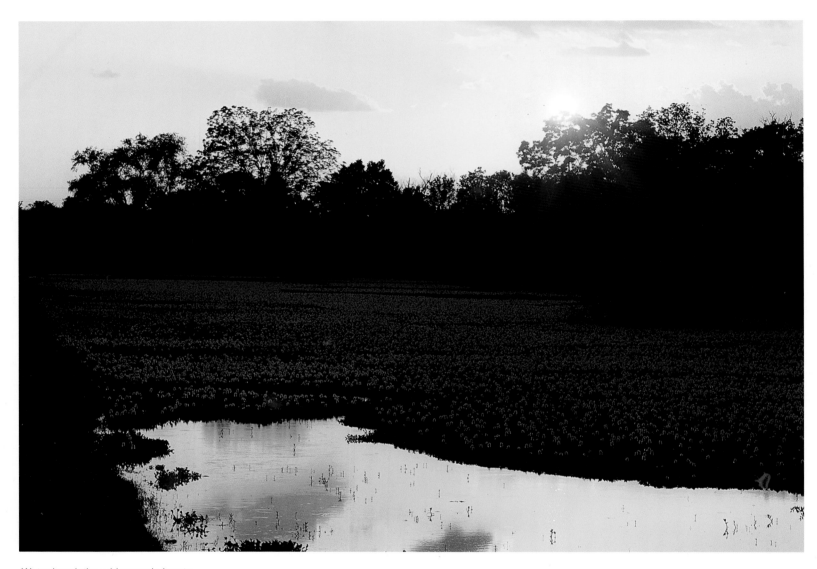

Water hyacinths add a purple hue to
this sunset over the flooded batture of
the Mississippi River.

i n t r o d u c t i o n

\mathcal{M}ANY FOLKS HAVE told me that floating the Mississippi River is their lifetime dream. When they share this confidence, I know that I'm in the presence of kindred souls. To float a river, any river, has always been my ultimate use of a day. So for me to spend eighty days floating on America's mightiest river was a spectacular dream come true.

I got my sea legs growing up in the foothills of the Ozark Mountains taking inner tubes, homemade canoes, and other aquatic craft down the Buffalo and Mulberry Rivers in northwest Arkansas. By the time I reached the age of fifteen, I was regularly exploring the nearby Arkansas River bottoms, which lie just three hundred miles from the river's junction with the Mississippi. My friends and I fished, hunted, and boated these bottoms with Tom Sawyer-like dreams of long days spent barefoot and carefree. Luckily, I have retained into adulthood this tendency of keeping my feet wet.

The Atchafalaya River was my next link to the Mississippi. It's the "wanna-be" Mississippi River; it actually provides a shorter route to the Gulf of Mexico by 185 river miles. Were it not for engineering interventions in this century, the Mississippi would eventually shift its flow toward that route. However, for now the Atchafalaya remains the largest distributary of the Mississippi. It takes part of her flow and releases it into the Gulf of Mexico. The Atchafalaya river basin swamp is a wonderful place of diverse habitats and abundant wildlife. I spent eight years photographing and studying this great swamp, mostly by canoe and tent, but for a year I lived there in a houseboat.

Later, I took this same houseboat to the Mississippi Delta to work on an article for *National Geographic*. Its bayous, bays, and marshes are rich in wildlife, too. It was fascinating to see that alluvial fan at a height of eight thousand feet above sea level from a helicopter one day. In the always hazy coastal air, I saw hundreds of little tributaries branching out above and within the Delta, and followed the three main channels as they leave Head of Passes to merge with the Gulf. I wondered then what the river's other end looked like. From mighty to mini, I imagined.

My aquatic yearning and my previous work led me to begin this project in 1996. I had to float the Mississippi, but how? My first plan was to canoe the entire river; then I found out that Verlan Kruger had already accomplished this feat, and in only twenty-three days. I did not want to challenge that record, for at that pace I would have no time to see anything. When I researched the canoe idea further, I found out that quite a few adventurers paddle down the Mississippi every summer. I needed something

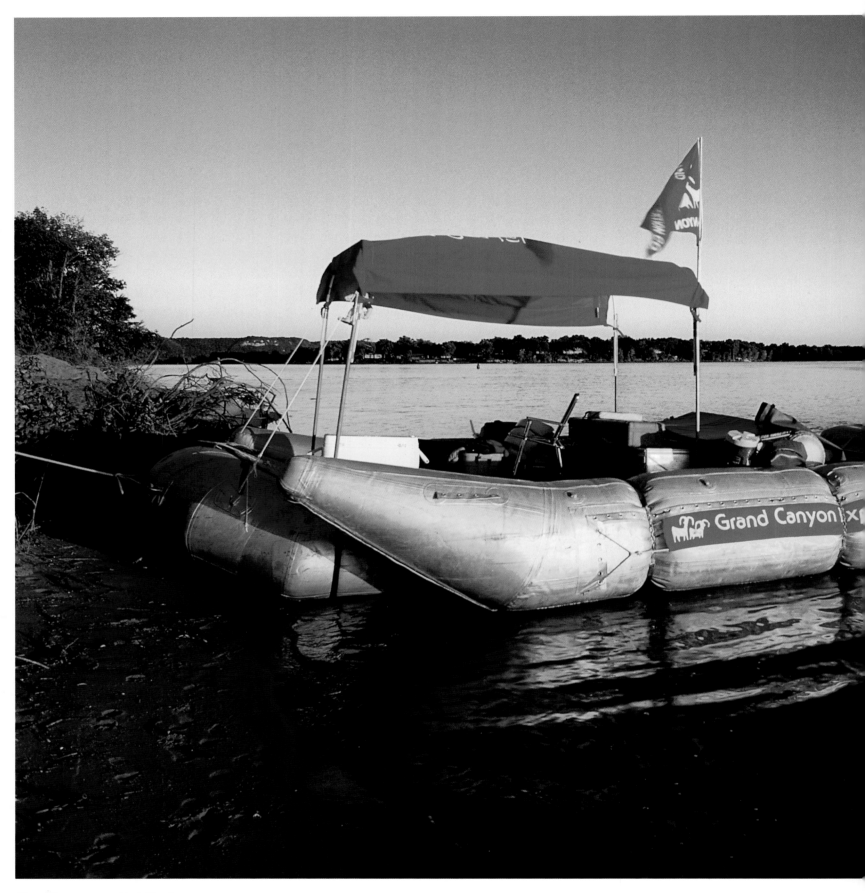

The author prepares *Huck Finn* for
camp at upper Mississippi river mile
758 near Alma, Wisconsin.

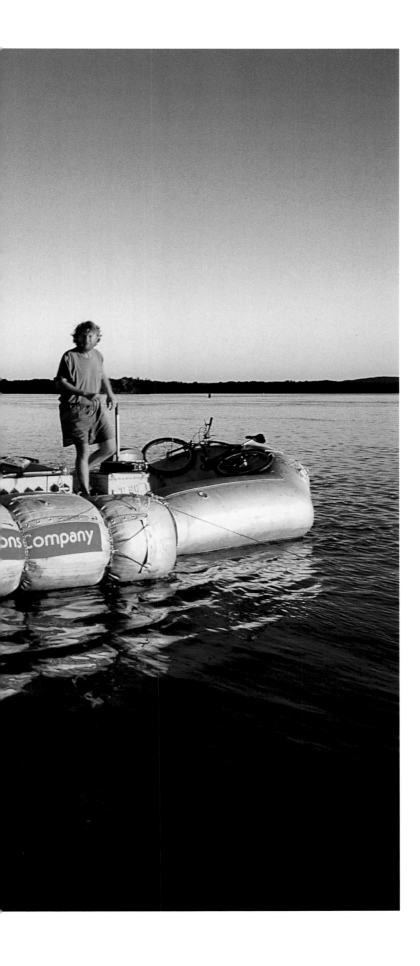

different in which to travel the river. One day while I was at the bottom of the Grand Canyon, I found it.

A thirty-seven-foot, S-rigged Grand Canyon pontoon raft. Such a boat had never before been on the Mississippi River. I believe it would have appealed to Huck Finn. For my purposes it was perfect. It offered plenty of space in which to work. And its shallow draft needs only eighteen inches of water in order to move, so I could start pretty near the river's source. My friends Mike Denoyer and Marty Mathis of Grand Canyon Expeditions agreed to loan me one of their rafts. They thought it would be a hoot to see their rig on the Mississippi. Planning began.

As usual, I wanted to really get to know my subject. So, before the raft trip, I contrived to see the river via plane, helicopter, car, tugboat, paddle-wheeler—any other way I could. The drive was an eye opener and a back breaker. I traveled over six thousand miles on sand, dirt, gravel, and pavement from Venice, Louisiana, to Lake Itasca, Minnesota, on the west side, then back down the east side to Bohemia, Louisiana. Whenever possible I drove on the Great River Road or on any trail near the river that was wide enough to let my truck pass. On this road trip I learned that, at the headwaters, the river was not deep or wide enough to accommodate my raft, and it contained too many obstructions, such as fallen trees and beaver dams. I also scouted the seven dams above Minneapolis built to control floods and generate hydroelectric power. When faced with these dams, I wouldn't be able to portage my raft easily. It would be three thousand pounds fully loaded.

As a result, I modified my plans to raft the entire river. I would first canoe from its source at Lake Itasca to the seventh dam at Coon Rapids, Minnesota, then journey by raft to the Gulf.

Because I wanted to view the Mississippi from every vantage point, I soared above it in helicopters and planes, marveling at its meandering S-curves. I also traveled the river on powerful push boats, giant tankers, and historic paddle-wheelers. From their tall pilot houses I received not only extensive views, but also insights into the lives of their employees. The crew on the *American Queen* works hard to entertain over four hundred passengers at a time, and they succeed, too. In contrast, the pilot and crew of a push boat have two lives: one at home and one on the boat. Some of them spend up to a month at a time on the river pushing stacks of barges from Minneapolis to New Orleans.

I hope that the following pages convey what a changing and challenging river the Mississippi is. By the time the tiny trickle that leaves Lake Itasca reaches the Gulf of Mexico, it has become deep, wide, and powerful. In between these two points I did not get to see every nook and cranny, for that would take a lifetime. But I did see, hear, smell, and feel the life pulsing in and near this important artery of America. Waters and lands that touch the lives of every person in this country.

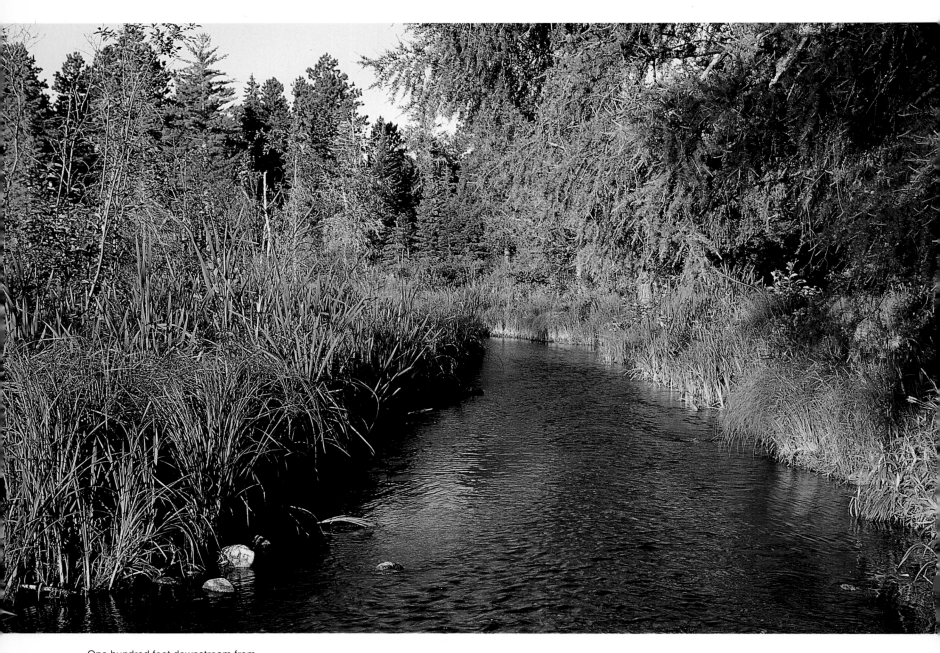

One hundred feet downstream from
Lake Itasca, the source of the Mississippi.

WHEN WE ROUNDED the bend, the great blue heron flushed suddenly. It startled Lee and me as we paddled past the branch of a fallen pine from which the heron had just been fishing. As he flew, the tips of his slate blue wings extended over both banks of the river. The GBH, as bird watchers affectionately call this stately creature, has feathered arms that stretch six feet. Hardly enough, you'd think, to bridge any river, especially the Mississippi.

But so it is just north of Lake Itasca, Minnesota, where this river should be called a stream or a creek or even a trickle. I can jump from bank to bank over the river here; any toddler could wade across it in a few steps. Here at the headwaters glacial scouring and melting formed a basin large enough to start a river that becomes America's largest. Intermittent creeks feed this lake along with rain, snow, and springs. The minute stream that flows north out of the lake gains in volume and momentum with the addition of each tributary: Sissabagamah Creek, Nokasippi River, Illinois River, Missouri River, Yazoo River, and hundreds more.

At its source, the Mississippi is quite different from the massive muddy flow that passes St. Louis, Memphis, and New Orleans. By the time the Old River joins it just above Baton Rouge, its levees can hold between them a flow of 22 million gallons per second. Annual averages indicate that the Mississippi pours up to 420 billion gallons of water into the Gulf of Mexico every day.

Many folks visit Lake Itasca in order to step across the infant river it gives birth to. A jewel of the Minnesota State Park system, the lake also attracts hikers, bikers, campers, and swimmers. I recall with special pleasure the first of three visits I made to this park, on Independence Day, 1996. Hundreds of tourists were milling around the source. Parents were explaining to their children what an important river the tiny stream before them grows into. Most of the kids were laughing, splashing, and wading. One family was singing barbershop quartet–style; others were discussing the pizza they would eat later or the movies they would rent. Ah, vacation time.

Six months later I returned to see Lake Itasca frozen over. The surrounding forest had accumulated four feet of snow, and during those February days I stayed another ten inches fell. The snow covered my cameras every few minutes, but it was light and dry and brushed off easily. The quiet was meditative. Wild creatures were the only company I had: a raven, a whitetail deer, and two river otters that popped up in a hole in the ice. I watched the otters preen their warm fur then slide back under the ice to search

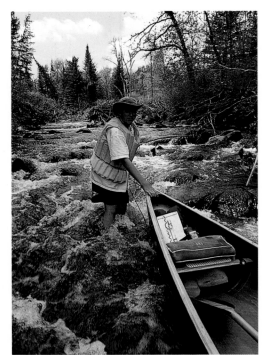

The author paddled the first 480 miles of the Mississippi in a Bell Canoe, which Lee Aucoin here drags through some shallow rapids near the headwaters.

for fish. Despite the freeze, water flowed out of the iced-over lake, burbling over some boulders to make a small rapid. In the calmer stretches a few hundred yards downstream, it does freeze, however; in fact the river freezes up each winter as far south as Missouri. Some snowmobilers I ran into during my February trip said they use the river as a road for long stretches of an eighty-mile trip that starts at Brainerd, Minnesota. Theirs is one form of transportation on the river I hadn't thought to try.

My own journey on the Mississippi began on June 4, when my stepson Lee and I launched our canoe from the boat dock in Lake Itasca. Lee was sharing with me part of the first leg of my journey to the Gulf. We paddled through a cool, light fog hanging close to the lake as the sun began to peek over the pines. In just a few minutes we had crossed the lake and lifted the canoe over the boulders to enter the river. Alternately canoeing and portaging, I would journey 480 river miles winding from the lake to the last dam without a lock just above Minneapolis.

As we paddled during those first seven days, Lee and I marveled at the river's complex course. It flows northward then bends around to the east where it crosses many lakes and wild rice marshes. Before the Twin Cities, the river turns south, then west, and finally south again so that on the map it looks like a big question mark. To the west, north, and east of this question mark, waters drain to the Pacific, the Hudson Bay, and the Great Lakes. The Mississippi itself drains waters from thirty-one states and two Canadian provinces.

Every bend in the river reveals a new spectacle of nature. Around one, a flock of butterflies hovers; around the next, a pair of trumpeter swans and their cygnet float by. At Bear's Den Campsite, a porcupine up a birch tree chews the bark, quite unconcerned about the humans who pause to watch.

In some places, the upper Mississippi resembles the wetlands in south Louisiana, and we found it just as rich in wildlife. On entering a large multichannel marsh with islands of cattails and wild rice, we could only find our way by following the slow current bending the aquatic grasses. On occasion the mud looked to be moving, with hundreds of frogs leaping away from our boat to safety in the grass. Spring was booming with frogs singing and flowers blooming. Turtles appeared especially abundant. Over the first few days, we saw seven turtles of two different species digging holes in the bank in which to drop their leathery eggs. Large soft-shell turtles stacked up like pancakes on every sandbar. Once we snuck up on and touched a snapping turtle two feet long.

We were canoeing on a moving stage where the stars were always changing. Muskrat, otter, beaver, and deer entered and exited by the hundreds. Mother wood ducks decoyed us with their broken wing act, as a dozen ducklings scattered like water in hot grease. Into the marsh grass trees bowed and stretched from the banks, decorated with nests of every description. Swans, pelicans, and diverse songbirds filled the airwaves with distinctive calls. Each day we sighted at least one bald eagle and twice saw its nest.

Camping was great during that first week on the river. The Minnesota Department of Natural Resources has established scenic campsites every fifteen to twenty river miles complete with picnic tables, fire pits, and johns. Because most of the river habitat we paddled through was spongy marsh, we were grateful for these dry places on which to pitch our tents. Only the swarms of predatory mosquitoes disturbed our evenings, often driving us into our tents to eat our meals.

My wife Sue joined us, and at the campsite each night she helped fight off the mosquitoes. By day she followed our progress by truck. Sue, an avid runner, would drive two bridges ahead and park, then run back to the previous bridge and wait on us to canoe the distance. She always waited because Lee and I were always going around a bend. Sometimes we could see the bridge where Sue waited across a small expanse of wild rice and think we were almost there. Two hours later there would be yet another loop before that bridge. Some of the bends were shorter than our seventeen-foot Bell Northwind canoe, and I was glad to have a partner with a good drawstroke to pull the bow around. Around the bend again and again. We really learned the definition of a "meandering river." Before reaching Minneapolis, I could have spelled "Mississippi" ten thousand times with all the S-curves I carved in that winding river.

Sue had just as much adventure driving and running as Lee and I had paddling. Her first brush with excitement occurred on Day 1. Summer had not yet started; kids were still in school that week. Lee and I saw no one at the lake or on the river. Because the highways were empty, Sue thought she could consume a snack, read a map, and search for the bridge by Stumphges Rapids, all at the same time. Then she saw in her mirror the red and blue light flashing behind her. The state trooper told her she had crossed the yellow line three times and wanted to know if she had been drinking. "Why yes, tea," she answered. The first of many people to extend us help, the trooper showed Sue the way to the bridge—down a muddy and deeply rutted road—then gave her a ride back to the paved road for her run.

Sue experienced less sanguine surprise on Day 2. Jogging down a dusty sand road to meet us, she noticed large cat tracks were on top of her tire tread marks. Evidently, a big bobcat or a small cougar had crossed the road in the ten minutes since she'd driven by. Heart palpitating, she beat us easily to the designated bridge.

While Sue and Lee traveled with me, the river widened dramatically at three places: Lake Bemidji, Cass Lake, and Lake Winnibigoshish. We canoed the first two without difficulty: the waters of Lake Bemidji were slightly choppy, and at Cass Lake they were calm. But the winds picked up at Lake Winnie, and the waves were big. So we traversed this large lake—fourteen miles across and maybe ten miles wide—in a small rented fishing boat with a sixteen-horsepower motor. Even so, it was a rough crossing and return, after which we still had to portage the canoe around. Three weeks earlier, we had learned, two boys in a canoe en route to the Gulf had tried to cross Lake Winnie in high winds, but had lost their lives. I know I would have survived the crossing in a canoe, but it wouldn't have been much fun.

At Gosh Dam on the east side of Lake Winnie, fifty or sixty fisherman lined the banks in the turbulent water looking to catch their limit in walleye. This white-meat fish was the best food I ate until I reached my homeland of south Louisiana. At the wooded Corps of Engineers campground nearby where we spent the night, the air was fragrant with pine. The campground host advised us to lock up our food; bears had been visiting recently. We were not so lucky as to see one.

Northern leopard frog.

One hundred sixty-seven bends later and the night before Sue and Lee headed home, we camped at Schoolcraft State Park. It, too, is a scenic wooded campsite right on the Mississippi. As we cooked over the campfire in the twilight, painted turtles crawled to high ground to lay their eggs. The frogs sang loudly and a great blue heron flew by. The next day, Sue and Lee helped me portage around the two dams in Grand Rapids before they drove my truck to Minneapolis, where I would pick it up after I finished my journey by canoe. As I paddled off solo, a tear came to my eye. But I laughed when I reached the next bridge. There a note scribbled on a brown grocery sack was tied to a log hanging over the river: "Stroke, C. C., stroke./ Love Sue and Lee." On the log packs of red hots and peanut M&M's lay next to a fly swatter. Perfect farewell gifts.

DESPITE ITS POTENTIAL DANGERS—and sometimes because of them—the Mississippi has attracted all kinds of travelers and explorers for centuries, at least since nonnative peoples entered North America. Henry Schoolcraft was the first nonnative to view the source of the Mississippi River. He did so on July 13, 1832, some 313 years after a Spanish explorer named Piñeda is said to have sailed by and observed the river's mouth from the Gulf. In 1527, eight years after Piñeda's sighting, Cabeza de Vaca, another Spaniard, speculated that a great river entered the Gulf where a large volume of fresh water had pushed him a mile out to sea.

We have a fairly detailed history of how it happened that Hernando De Soto was sent to eternity in the Mississippi. In May of 1541, De Soto crossed the Mississippi—the first nonnative to do so—in a boat near what is now called Memphis, Tennessee. Only remnants of his group of seven hundred men had survived a trek from Florida in search of gold and other treasures. They only found hardships. The next spring somewhere across from where Natchez, Mississippi, is today, De Soto died of a fever. His troops slipped his body into the Mississippi under the cover of darkness, hoping the Indians would not think their godly leader a mere mortal.

The first southbound expedition of the Mississippi began in the Wisconsin River in 1673. Louis Joliet was commissioned to map out new trade sources for the French. With Father Jacques Marquette, Joliet also sought to convert Native Americans—"savages" in their eyes—to Christianity. Marquette and Joliet traveled in canoes as far south as the mouth of the Arkansas River, quitting in fear of Spanish lands below that point.

The first nonnative explorers to follow the Mississippi to the Gulf of Mexico were led by a fur trader named René Robert Cavelier, Sieur de La Salle. His group used the Illinois River to enter the Mississippi. When La Salle reached the mouth with his twenty-three voyagers, he named the land Louisiana and claimed the Mississippi and all the land it drained for the crown of France. After the Louisiana Purchase in 1804, the importance of La Salle's words became clear. The United States had expanded enormously with the acquisition of all the lands the mighty river drained. Explorers Lewis and Clark then sought northern tributaries to the Missouri River hoping to extend U.S. lands higher into Canada.

Before Schoolcraft documented the source of the Mississippi, a steamboat had made it as far north as Fort Snelling, where Minneapolis is situated today. In 1820 Lewis B. Cass had misidentified the lake since named after him as the river's source. On that expedition Schoolcraft served as the geologist. The actual source was revealed to Schoolcraft in 1832 during his commission to settle a tribal feud between the Chippewa Indians and the U.S. government. A Chippewa chief named Ozawindib (Yellow Head) led him from Cass Lake to Lake Itasca on a three-day expedition.

Lee and I were not the first explorers on the Mississippi. And we wouldn't be the last. Hundreds of adventurers have completed the trip from source to mouth, and many more have tried and failed. No one I know is keeping records, but I would guess that about six groups make it each year from Lake Itasca to the Gulf of Mexico or nearby. In 1997 two men finished Mississippi River swim-a-thons. One of these men was Nick Irons, who was swimming to raise money for and awareness of multiple sclerosis, an illness his father lives with. Nick swam 1,550 miles from Minneapolis to Baton Rouge in 118 days. I had hoped to cross his path on my adventure, but he was swimming in Louisiana while I was rafting in Iowa.

However, I did meet and photograph Billy Curmano, the other swimmer, in the Atchafalaya Basin. I camped with Billy and his support crew on an Atchafalaya sandbar one hot July night and learned about his eccentric performance art career. Once he put on a concert for cows; another time he buried himself for two days to entertain the dead. He called his Mississippi swim a performance art piece and now has an exhibit of his adventure. Between 1987 and 1997 Billy sidestroked the river in a straw hat and sunglasses, doing up to five hundred miles per summer. His swim-a-thon, which started at Lake Itasca, brought him to the Gulf via the Atchafalaya River. He told me that he became one with the river and thus allowed it to take him where it would.

The Atchafalaya is the Mississippi's main distributary and a more efficient route to the Gulf than its parent river. If not for the control structure built by the U.S. Army Corps of Engineers, the Atchafalaya would probably have more than half the Mississippi's flow today. Billy was smart to submit to the river's pull toward the Atchafalaya. I don't think he would have enjoyed the swim between Baton Rouge and New Orleans.

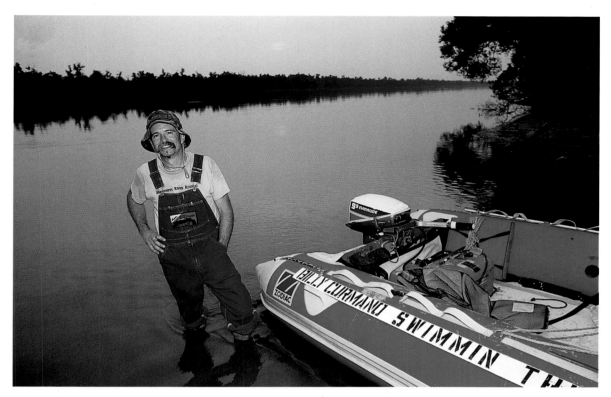

Billy Curmano, Mississippi River swimmer, at camp for the night.

Some who travel the river are aiming to set records for speed. The *Guinness Book of World Records* issued Verlan Kruger and Valerie Fons a certificate for creating a new downstream paddling record in 1984. The two canoed the entire river in 23 days, 10 hours, and 20 minutes. I called Verlan before my own canoe trip to ask him about campsites along the upper Mississippi. He had no such knowledge. He told me that he and Valerie never camped, that they took turns sleeping while the other paddled. Verlan was sixty-one years old when he broke the record with Valerie. Their Mississippi River trip (total 2,348 miles) was nothing compared with the three-and-a-half-year, 28,000-mile journey Verlan made by canoe throughout the United States and Canada, including upstream in the Colorado River through the Grand Canyon. The retired plumbing contractor and father of nine still paddles today and builds canoes that will last. He told me that the one he built for himself has over 38,000 miles on it.

Records don't last forever. In 1989 Mike Schnitzka and a partner broke the Kruger-Fons record by 29 minutes. On the Internet I learned that Mike has been worrying about the plans of Nels Ackerlund to set a new record. Nels wants to kayak solo down the Mississippi in eighteen days. My advice to boaters not interested in records is travel the river slowly. I wish I could have extended my own journey beyond the eighty days it lasted: I still missed a lot of sights.

I believe it's become a sort of cult adventure to go the entire length of the Mississippi. Besides the swimmers, there were at least six other groups on the river with me. While paddling past St. Cloud, Minnesota, I encountered two British Marine Commandos on the river to raise money for SCOPE, an organization for people with cerebral palsy. Sean Johnson and Robert Tweddle were traveling in a World War II vintage collapsible double-seat kayak. We stopped and had a proper cup of tea together above the St. Cloud dam, then helped each other portage around it. Later that evening, we rendezvoused at Boy Scout Point, a DNR campsite. I shared my grits and hot sauce and they shared their noodles and tea while taking in a beautiful sunset and full moonrise. I talked to them when they had finished their expedition and heard how their borrowed tent broke on their last night, near Pilot Town, Louisiana. Sean also told me he slept on a fire ant nest, very briefly.

Of all the river travelers I met, the most interesting was William Patch, or Willie P., the Last of the River Hobos. How I came to meet him is a story in itself. At New Madrid, Missouri, I began to hear about an old man riding the river in a Toyota. A Toyota Celica hatchback. Yes, on the river. I learned then he was two weeks ahead of me and was planning to stop at Memphis, some 150 miles downstream from New Madrid. Even if I moved quickly, I figured I probably would not catch him before he arrived at Memphis. But with a newspaper clipping I had, I could at least track him down when I was finished and interview him by telephone. A man in a Toyota on the Mississippi: could it be true?

Days and miles passed. Shortly after camping just below Caruthersville, Missouri, I was diverted by the sight of a wooden sailboat, a rare sight below Cairo, Illinois. Ordinarily, sailboats avoid the commercial traffic and shortage of marinas on the lower Mississippi, and instead take the Tennessee-Tombigbee (Tenn-Tom) Waterway. The sailors were heading for Mandeville, Louisiana, where they would wait out the hurricane season before moving across the Gulf. We drifted together for a while, figuring that we would have many opportunities to swap tales because we were going at about the same

Willie P., Last of the River Hobos, and his 1968 model Toyota Celica raft.

pace. But following an afternoon spent with television reporters, I became separated from the sailboat. On the night I reached Osceola, Arkansas, I set up camp at sunset on a sandbar across from town and planned to pursue the sailboat the next day.

After tea at dawn, I called up a passing push boat on the radio for information on the sailboat. It was only a few miles downstream, I learned. Fifteen minutes later I had the sailboat in view, seemingly anchored in midstream. Closing in, I noticed the sailors were gazing toward the east bank, and glancing that way myself, I became distracted by an even stranger spectacle: the Toyota, stuck on a sandbar. The sailboat now forgotten, I helped pull Willie off the sandbar and introduced myself to the last of the river hobos.

While we drifted, tied up together, Willie shared his story with me, and his book: a compilation of letters, snapshots, and newspaper articles about himself that he self-published at Kinko's. An experienced river traveler, he has canoed the Illinois, Wisconsin, and Mississippi Rivers in their entirety, not to mention a lot of smaller rivers. He's even done 270 miles on the Amazon. This multitalented man has built and lived on six different but equally bizarre houseboats. In addition, he has made an outboard motor out of a chainsaw and lawnmower parts—and has the pictures to prove it. Proudly he showed me newspaper articles about a trip he made from Illinois to Florida in a Rambler with an engine that ran on corncobs. All his own brainstorms and workmanship.

Now in his late seventies, Willie P. took his 1978 Toyota Celica with 160,000 road miles on it and mounted it on a bunch of thirty-gallon plastic barrels. In place of tires he welded a paddle wheel onto each wheel. The steering wheel was linked to a rudder, and a wooden platform surrounded it all. To drive the car-boat, he simply turned the key and put it in gear. Because water reached six inches above the floorboards, Willie drove wearing rubber boots.

I surveyed this one-of-a-kind vessel. On its passenger seat lay some peppermint candies and cheese puff snacks; on its hood was a pair of tattered shoes that looked ready to fall apart. A plastic owl stood sentry on its bow, and a sign attached to the small raft it towed announced "for sale." Two connected barrels dangled from its side—an improvised dinghy Willie made after he had sold his real dinghy a few hundred miles back (a woman thought it would make a nice flower planter). Willie would pole this makeshift dinghy to shore while leaving his car-boat anchored. Each of the four anchors—big, muddy rocks with tattered and spliced ropes—connected to a corner of the deck. Willie had a real anchor until a tugboat captain, impatient because the Toyota was tied up to a barge, cut his lines while he was on shore getting food.

I asked Willie, why? "People go 90 miles per hour on the highway," he explained, "and then someone gets in an awful wreck and everybody sits and waits while they clean it up. Out here, I got freedom to go on down the river at my own pace." Willie planned on heading to Memphis and staying there until he found a buyer—or a taker—for his unique craft. Later I heard that he spent ten days at the Mud Island Marina in Memphis, where the manager Kathy took him under her wing until someone bought the hatchbacked paddle-wheeler for $150. Then Willie called his wife and went home.

I myself had been tempted to buy Willie P.'s boat and tow it to Baton Rouge. But my own journey was moving me onward, so I waved good-bye to the river hobo and made my way downstream. Go, Willie P., go, I thought as I watched the Toyota chug slowly behind me. I know you have time for one more invention and one more adventure.

IF AT TIMES I was aware of the presence and diversity of people on the Mississippi, at other times the river seemed to me a lonely path to follow. After my wife and stepson returned to the South, I saw no farmers on their fields, no homedwellers on their decks. The Mississippi was expanding as Willow River and other rivers contributed to the flow, while the human presence receded. For a few days I felt the river was mine, a private waterway.

Then, just north of Brainerd, Minnesota, I was reminded of the friendliness of people on the river. I had run out of campsites. The islands I had hoped to camp at were too marshy, so at sunset I went to ask some residents if I could sleep on their pier. After walking up a steep hill to a nice house nestled in the woods, I met Jerome and Mary Peterson. This kind retired couple let me take a shower indoors and set up my tent as I'd asked.

The following evening, at Baxter Campsite, I encountered my first rain on the journey. For eleven days I had enjoyed sunshine and perfect canoeing weather, except for a little wind in the face. Baxter was also the first wooded campsite where the mosquitoes were moderate and I was tickless at bedtime. (All the previous nights, I had removed up to six ticks before turning in.) So free of bugs, I heard the rain beat down on my tent from 11 P.M. until dawn. When I crawled out there was still a light mist. I packed my wet gear and paddled into a fog. A little riffle gave me a good fast start.

I was sweating in my rain gear two hours later when I reached Crow Wing State Park and saw a whitetail doe on the bank. She held her ground remarkably long. I was only fifteen yards from her before she leaped up the steep mud bank. As I rounded the bend and saw the spotted fawn lying under a root-entangled bank, I understood the doe's reluctance to leave. She was worried about her fawn.

The current was carrying me rapidly toward the baby deer, so I had to act quickly if I wanted the picture. Because of the rain, my camera case had not been opened all day. I snapped open the four latches as quietly as possible and pulled out the camera. But when I put on a zoom lens, I saw it fog up. Frantically, I unzipped my rain jacket and wiped the lens filter with my damp T-shirt. What else could happen to thwart this perfect picture? Mayfly attack. From out of nowhere, six thousand or more mayflies descended, intent on committing suicide in my eyes, ears, nose, and on my cameras and canoe. I wiped the lens, slapped at the mayflies, and clicked the shutter.

Thirty seconds and seven shots later, I was past the fawn, the mayflies were gone except for an inch-deep graveyard in my canoe. And a patch of sunlight was peeking through the clouds. At the end of my journey, I found that six of these seven shots were marred by the fog, but one turned out pretty good.

In the river ecosystem, the kamikaze mayflies are an important fish food. The only time I have seen more of them was during my drive up the Mississippi River in late June. I was staying in McGregor, Iowa, at a motel that almost hangs over the river. The owner had turned off the outside lights, which attract the pests, and still the balconies were covered an inch deep with their dead and dying troops. Even though I entered the room as fast as I could, hundreds of them flew in, too; but they died before they reached the bed. I slept soundly.

The rain, let me point out, never caused me any trouble, except to slow down my photography. My gear kept me dry. The wind, however, was often troublesome. Just like in the Grand Canyon, it seems always to blow upstream, in your face, no matter which direction a bend takes you. Sometimes, it was so strong that all the strength and finesse I could muster would avail me nothing. The canoe would still spin. When the wind quit or—rare occasion—blew from behind the canoe, I was in paradise. Beautiful paddling.

Perhaps it was the head-on wind, the all-day paddling, the laborious portaging, and the skimpy meals I cooked on the camp stove. But in the cafés I stopped at I simply gorged myself. I know I shocked some waitresses when, having speedily consumed one meal, I would order a second. If I hit a bridge around lunchtime, I would walk down the road above looking for a café. Once seated and served I would inhale the food, feeling it go straight down to the furnace and become converted into energy as fast as a roaring campfire turns a twig to ash.

I had to portage around a dam each of the two days I paddled between Little Falls and St. Cloud. Blanchard Dam was the tougher of the two. I had a steep climb up of about twenty-five feet and then a steep descent of about seventy-five feet. With cameras, camping gear, food, and canoe, I had seven loads to portage. Round items, like my sleeping bag and waterproof clothes bag, were rolled down the hill. Near St. Cloud, the Sartell Dam caused a long rather than a steep portage. I found a woman willing to portage my gear in her station wagon for a copy of this book. Thus I only had to carry the canoe on my shoulders for the half-mile.

Two days later, I cheered myself into Coon Rapids to finish the first leg of my journey. The beautiful upper Mississippi had challenged me with its curves and amazed me with its wildlife. My trusty Chevy Suburban was waiting for me at Bell Canoe Works, where I regretfully turned in that long

red boat, my friend during the previous seventeen days. Then I drove down the River Road once more, looking ahead to the raft adventure.

I WANTED TO FLOAT down the river as carefree as Huck Finn and Jim. But even they had an agenda: to turn up the Ohio River (which they missed in a fog) and get Jim to a free state. Carefree I was, too, but I had to complete the journey by mid-November. So I picked three solid dates: September 13, to set sail from just below the Coon Rapids Dam in Minnesota; November 6, to pause and party at my home town of Baton Rouge; and November 13, to reach the Gulf of Mexico.

When he knew my starting date, Marty Mathis, co-owner of Grand Canyon Expeditions, brought my raft out in a one-ton truck with a trailer. This raft is like no other ever seen on the Mississippi. Huck's modest raft consisted of bound logs and a sweep oar. Mine was made with three nylon-reinforced neoprene tubes thirty-seven feet long and fourteen feet wide. The center tube, shaped like an oblong donut, is the largest and weighs over five hundred pounds. The two side tubes are modeled after army bridge-building pontoons. They are tough enough to withstand great impacts against Grand Canyon rocks, so I wasn't worried about running into logs.

Inside the center tube sit two aluminum frames. Straps hold the frames and tubes together. A giant ice chest fits in the rear frame along with three gas tanks. Just behind those tanks is the place I stood to drive the raft, which is run by a thirty-horsepower outboard motor. The front frame has three four-by-eight-foot deck boards, under which I stored my supplies, including a spare motor, canned goods for sixty days, boat bumpers, water jugs, chairs, table, generator, battery, grill, Frisbee, buckets, ropes, anchor, shovel, axe, and more. On deck I had a waterproof box that held film, cameras, maps, research materials, and perishable food. Strapped to the tubes were waterproof bags with my clothes, sleeping bag, tent, and rain gear. On deck was also a bicycle, a tripod, waterproof camera cases, and a small ice chest for immediate use. I was rigged for two months. I only needed to stop occasionally for gas, water, and fresh food.

Four of us met at River Park, a boat ramp just below Coon Rapids. Marty Mathis came from Kanab, Utah, with the raft. Jim Roland flew up from Baton Rouge to help us rig. Jimmy Hill and I arrived in my Suburban packed full of cameras, notes, and food. We also carried my floating press room: a waterproof camera case holding a Nikon digital camera, a Cellular One phone, a laptop computer, and all the accessories needed to send a story into the Baton Rouge *Advocate* Online.

The deal we struck a few months before was that, with the use of this equipment, I would send a short article of my adventures each day with a picture to the newspaper's Internet location. It was ironic that a guy like me—who could barely type a letter on a computer, who had never before touched a cell phone, and who is totally committed to Fuji Velvia slide film—would become High Tech Huck. In contrast to Mark Twain, who wrote *Life on the Mississippi* many years after his experiences as a river boat pilot, I transmitted writings about my experiences almost as I composed them. I simply hooked up my laptop computer to my Cellular One phone, called America OnLine's 800-number, and sent the words flying to my office in Baton Rouge. There Stafford checked my spelling and sent the text electronically again to the *Advocate's* Web site.

The four of us blew up the tubes on a warm gray morning. The threat of rain teased us as we worked to rig, load, and organize the boat. The *Huck* had been freshly painted silver and topped with a bright red sun shade made especially for this voyage. The sun shade announced, "Gulf of Mexico or Bust." After six hours we entered the river, which was clear, shallow, and about 150 feet wide. My three friends were joining me for the first few days of rafting.

I was excited as we began to float. The water depth dropped to less than two feet deep a few times, but as we only needed eighteen inches, we never quite dragged bottom. After a couple of miles we reached the navigation channel maintained by the Army Corps of Engineers. The channel in the upper Mississippi is dredged to 9 feet deep and 300 feet wide, and below New Orleans to 45 feet deep and 750 feet wide. Depth would not be a problem again if we stayed in the right place.

Soon the Minneapolis skyline was in view, and we traveled underneath bridge after bridge. It was getting dark when we stopped at the eleventh span just above St. Anthony Falls, where the lock and dam system begins. The Twin Cities once led the world in flour production. Their flour mills, supplied by

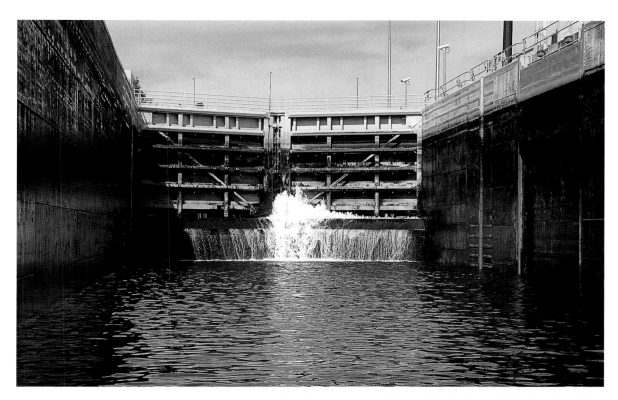

Upper Saint Anthony Falls Lock.

Midwest grain, were powered by a waterfall audible six miles away in downtown St. Paul. After dinner, we wondered where we would camp in this historic district. The shore was steep; and even if it hadn't been, I really did not want to set up tents there. Ultimately, we got protection from the rain by tying up under the Third Avenue Bridge. It was a jovial night, much like a children's slumber party, as four buddies swapped stories then spread out their sleeping bags on the raft's deck.

Dawn greeted us with a heavy fog. We could barely see the other side of the river. It slowly lifted as we ate breakfast and prepared to be on our way. Upper St. Anthony Falls Lock and Dam greeted us immediately. We approached this lock and pulled a signal cord to notify the lockmaster we wanted to pass through. He announced on a loudspeaker that we had a fifteen-minute wait while he brought the water to the upstream level.

The Army Corps of Engineers has built twenty-eight locks and dams on the upper Mississippi River. Each one is located by a waterfall or rapids that formerly impeded river transportation. The system allows recreational and commercial boaters to travel over 1,800 miles from Minneapolis to the Gulf of Mexico. Once we motored into St. Anthony's, the lockmaster closed a gate behind us and threw us a couple of ropes to hold on to. Then we started sinking, a lot faster than I expected. We dropped 50 feet in a matter of minutes between those massive lock walls. The *Huck Finn* was back in a canyon—a man-made one this time. We passed through two more locks before lunch that dropped us 25 and 38 feet, respectively. The drop in sea level from the Twin Cities to St. Louis is about 405 feet over 700 miles. By comparison, the Grand Canyon run on the Colorado River drops over 1,800 feet in 280 miles.

In St. Paul, we stopped at the Yacht Club and saw some of the sail and power yachts that would be following me downstream on their winter migration. Hundreds of boats go south to spend their winters in the Caribbean or Florida. They meander with the river as I was doing, slowly, to enjoy the autumn and to avoid getting to the Gulf before hurricane season is over. Most of their insurance does not cover damage on the Gulf Coast before November 1. All these folks were friendly, and most who passed circled back to take a picture or video of my unique craft.

We camped just south of the Twin Cities making 35 miles in two days of my 1,880-mile journey. In order to keep on schedule, I would have to travel 50 miles some days. On Day 3 my friends headed home and I began to raft the river solo. As the suburbs receded, the views all around became more scenic. But throughout my journey I enjoyed the alternation between city and country, and sought to capture images from both environments.

Discovering a nighttime rest stop during the raft trip was as interesting as on the canoe trip. One night early on I camped on an island of sand. It must have been fifty feet tall and steep enough to ski down. If I had a pair of boards with me, I would have tried it, for the thrill of the ride and to outrun the mosquitoes—not as numerous as those who pursued Lee and me, but enough to annoy. My tent, my shelter for the next fifty-nine days, kept them at bay. I slept well in spite of all the barges and trains. It would be noisy from here on down. Tracks flank both sides of the river most of the way to St. Louis.

After my night on the sand island, I woke early to cruise on to Red Wing, Minnesota, a riverside

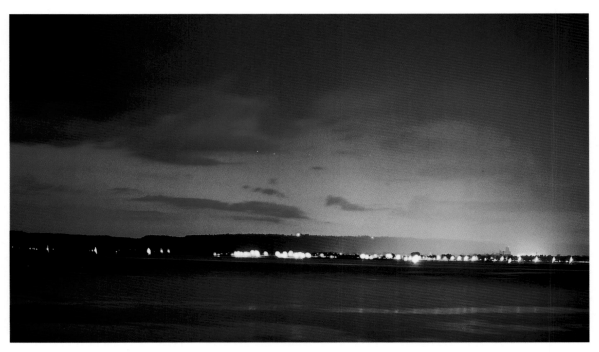

A rainstorm drenches much of Lake City, Minnesota, yet spares the land at left.

town I wanted to explore again. On my earlier driving trip, I had stopped in Red Wing and climbed Barn Hill to get a view of the river and the city. At the town's museum, I found out that Henry David Thoreau had climbed the hill in 1861, as had many early explorers of the Mississippi. Homesick French settlers traveling with Father Hennepin gave the hill its name, thinking it resembled their barns back home.

This trip, Claire Pavelka and Bob Musil of the Red Wing Visitors and Convention Bureau gave me a tour and tons of information. It was a good time to be collecting facts because a big thunderstorm was dousing my boat and filling my custom-made awning with buckets of water. I was interested to learn about Alexander P. Anderson, the native of Goodhue County (where Red Wing is located) who invented puffed rice. Claire also gave me history on the Red Wing Shoe Company, incorporated there in 1905. During the Depression, the company developed and sold shoes costing ninety-nine cents a pair, so that people might afford them. Later, I watched Scott Keith and Mark Connelly throw pots that would become salt-fired stoneware modeled after products made by the RedWing Pottery Company between 1860 and 1890. The old red brick factory had just been restored and turned into a shopping mall.

The last spot on my Red Wing tour was the houseboat village, which I was eager to see. The harbor is full of houseboats situated on studs so they can rise and fall with the river. Claire said some people call it Gin Pole Village, because during the Prohibition era boat owners there would store their booze inside the poles. I motored the *Huck Finn* into this village and took a few photos of the houseboats with traces of sunset showing through the waning storm clouds.

At dawn the next day I enjoyed a cup of tea and watched from my wonderful campsite the flow of muddy waters coated with the glow of a ten-carat gold sunrise. Between sips, I photographed in three directions. Here's what I saw. Downstream and east: a pastel sunrise. Across the river: a steep bluff with a smattering of early fall colors. Upstream: the harvest moon in descent after serving as my night light. This was my first good photography day since my raft journey began.

I was hoping to follow the fall colors all the way to Louisiana. One good frost, I knew, would get the leaves changing hues. When the full palette of fall was on them, the bluffs I was passing would be a patchwork of reds, browns, yellows, and oranges, for they are filled with mostly hardwoods of many different species. In early September, the only trees changing were a few cottonwoods and willows on the sandbars and a few sumacs on the hillside.

Within a week of beginning the raft trip I felt fully in the swing of things. By then the *Huck* was mostly clean and organized, thanks to calm winds facilitating my work on it. I was trying to avoid the misery of dealing with a computer and cameras on a dirty boat when the wind did pick up. I feared my equipment would not last long in those conditions.

As I moved down the river, I continued to see wildlife, but less frequently. Even near the Twin Cities I spotted two eagles. Most abundant seemed the GBH and beaver. Twice one night a beaver woke me with a loud SLAP. I guess it was startled to see my raft—a strange object—tied to its habitat. In protest or applause, it slapped the water with its tail and dove away.

After a peaceful and productive morning on Day 5, I started out for Lake Pepin. A tail wind was blowing briskly when I entered the lake, a natural one unlike the lakes created behind each lock and dam

on the river. Some call it the widest place in the Mississippi. It is two miles wide in places and twenty-one miles long. Lake City, on the Minnesota side of Lake Pepin, is the birthplace of water skiing. In 1922 some brave lad there strapped a couple of boards to his feet and took off. I am glad he did, for I have enjoyed skiing since I was young. My stop the day before in Lake City had been fraught with technical difficulties. After two and a half hours of computer blues, ol' High Tech Huck—me, not the raft—was ready to strap on his own boards and light out of there.

My experience at Lake Pepin conformed to the rule: calm sunrises and sunsets with still air and glasslike water, between which an afternoon period when winds picked up and blew hard in my face. This pattern made midday a difficult time to do anything; the peaceful front and end of each day were the times I most liked to photograph, raft, write, and M.O.M. (meditate on the Mississippi). Of course, I couldn't cram my whole day into those three lovely hours.

Around mile 758, before I reached Lock 4 above Winona, Minnesota, I decided to stop and set up camp early. It was only 6:30, but the wind had died, the water was calm, and the potential for a good sunset existed. In honor of my wife's arrival in Winona the next day, I took my first bath on the raft using its solar shower. This contraption soaks up the sun's rays to heat the water with its plastic bag, clear on one side and black on the other. The falling angle of the sun would make this gizmo hard to heat up as winter approached.

That night I was sleeping peacefully until a push boat's spotlight woke me up. This was a frequent occurrence. Curiosity, it seemed, moved the tug captains to shine that seventy million candlepower beam my way. Between midnight and six o'clock other push boats had gone by. The wind was brisk and the skies were blanketed with clouds. I was on the river by 6:17, not wanting other boats to precede me. The wind was against me now, and I was sure the locks would be crowded. Sometimes the wait at the locks can last for hours because the push boats have priority over "pleasure craft."

As it happened, I passed rapidly through Lock 4, for the push boats had all made it through before I got there. By 10:00 I was only two locks and twelve miles from Winona. I estimated I had plenty of time before my 3:30 rendezvous with Sue. Then my bowl of cherries tipped over: my first tank ran out of gas, and when I hooked up the second tank, the engine quit after thirty seconds. I reviewed my knowl-

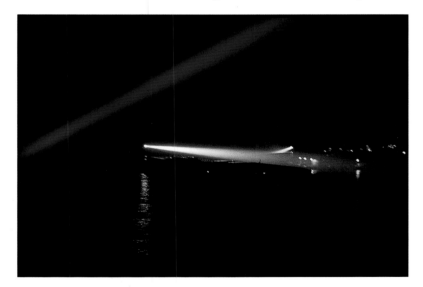

Push boat searchlight, Fort Madison, Iowa.

edge of outboard motor repair; I worked and I cranked the pull cord until my hand was blistered. No joy. At 12:30, I felt my time was running out.

So I switched to my spare motor, an awkward job on an S-rigged raft. But I was moving again. Unfortunately, so was the wind. My sun awning was being blown to its limits. Regrettably, I decided to wait before I took it down. While the *Huck* was entering Lock 5A, the wind took it down for me, but relatively gently, for it held onto one pole instead of flying into the river. I reached Winona one hour before Sue arrived and found a mechanic to fix the motor. It was water in the fuel, a simple problem. Happily reunited, Sue and I set up camp on the island across from the city so as to be in position the next day to visit the houseboat community there.

We ended up visiting the community sooner than that. The wind was bending our tent on the boat into weird shapes as we heated our gumbo on the camp stove. Disconcerted, we listened to the weather forecast on my marine radio and what we learned scared Sue: severe thunderstorms with hard rain, hail, and gusts to 80 miles per hour. With winds already at a steady 25, we moved the tent off the boat and into the woods, on a flat spot away from big trees. But around ten o'clock, at Sue's urging, we broke camp and motored over to the houseboat community. There, for the third time that evening, we pitched our tent and managed to get some much needed sleep.

Sue and I had tied up to Sol Simon's two-story, two-room house floating on fifty barrels. His is the only house in the community with a banister all the way around, for his son Moses was born there. A member of the Mississippi River Revival Board, Sol had moved to Winona from the Twin Cities and

chosen the artsy Latsch Island houseboat community for its economy. This able carpenter is the ultimate recycler. He bought an old houseboat for five hundred dollars and transformed it into a nice place using mainly construction site discards. Most recently, Sol fixed up a very old farmhouse with his wife, son, and a three-legged dog. Some discarded windows bound for his new house lay in the back of his truck as he showed us around.

There are almost one hundred houseboats on Latsch Island and nearby Wolf Spider Island. These islands both lie just across the Mississippi from Winona. About twenty-five boats have permanent residents, and the others are vacation homes and actual boathouses. None is expensive. Most evolved from some other structure and had barrels added to make them float. One of them used to be a pig house. Another was fitted with a recycled Ford Pinto motor and a paddle wheel to greet President Jimmy Carter when he came through on the *Delta Queen*. I was told some Secret Service agents boarded this latter one because they thought it looked like a floating bomb.

Next door to Sol's was Leslie's boat. This youthful grandmother acquired her funky boat for free. Its walls are covered in bright fabrics and display her drawings and beadwork. Leslie works as an artist, selling her pen-and-inks of the boats and of astrological signs at Renaissance festivals. We were curious about how she managed in the winter. She explained that she places plastic sheets over her large windows and uses lots of wood in the stove. When the Mississippi freezes over, people who stay in the village with her can walk, drive, or ski right up to her door and join her for coffee talks.

Later Sue and I borrowed Sol's canoe and paddled a couple of miles into the backwater. We went to a rookery where great blue herons nest in the spring. No herons, but the trees were chock full of cormorants. We heard the frogs singing, saw beaver-gnawed tree trunks, and stretched our muscles after being on the raft. At this place, as at so many places I visited on my Mississippi adventure, I wished for more time than I had to photograph and explore.

The swimmer Billy Curmano, who lives near Latsch Island, came to see us off. We hadn't gone too far before we came to a mountain in the middle of the river—the only such geological feature in the whole Mississippi. Legend has it that the mound of earth broke off of the cliffs near Winona and floated down the river. Intrigued by Trempealeau Mountain, as it is called, we looked for a good place to park the *Huck Finn* and found it—next to a double railroad track that runs on a manmade levee right down the middle of the Mississippi.

A sketchy but nice trail that Sue and I hiked leads up Trempealeau Mountain. It was a steep but beautiful climb. Mist flower, daisy fleabane, goldenrod, and five other blooms I am not familiar with adorned the way. Blue jays, ruby-crowned kinglets, and black-capped chickadees fluttered above in the

Gossip over coffee on a Latsch Island houseboat.

red leaves of sumac. We passed by Indian mounds en route to the top, where we beheld a spectacular view from six hundred feet above the river.

Hungry after the hike, we took the raft down to the town of Trempealeau and ate a great lunch at the hotel there. We learned that this hotel holds an outdoor concert every couple of weeks, and we had just missed the Ozark Mountain Boys by five days. At the town's marina I charged my computer. Ordinarily my laptop received its power from the raft's motor via a series of hookups: extension cord to ACDC converter, converter to twelve-volt battery, battery to outboard motor. On this day, however, as the raft had been parked, I relied on the help of the dockmaster. To one and all she energetically gave assistance. When a boat came to the marina for fuel, she would jump on a bike and go speeding down a steep and narrow two-hundred yard ramp onto the dock where the pumps were located to gas them up. Life is rich.

We ended up waiting in Trempealeau long after we planned to leave it because a push boat with fifteen barges at Lock 6 had to be broken down and sent through in parts. When we finally got off at five o'clock it was warm and sunny. At mile 705—that is, 705 miles above Cairo, Illinois—we set up camp with fine clear skies overhead. Though cool the night was dry, yet Sue and I awoke to a soaking wet *Huck* and a dense fog. Not good for boating. After a quick breakfast we began to inch our way south to

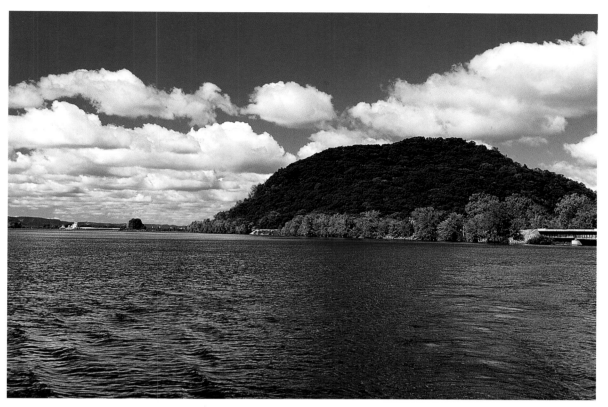

Trempealeau Mountain rises in the middle of the Mississippi.

La Crosse, Wisconsin, where I intended to meet up with a *Waterways* journalist.

The tugs and big boats usually stop in fog this heavy and perhaps we should have, too. But going slowly in that rubber boat was pretty safe. We illuminated the navigation lights and readied the fog-horn and spotlight as we edged along the right side of the channel. I also turned the motor off every few minutes to listen. We could only see about twenty-five feet around us, but luckily we were in an area with many buoys. A few hunters and fishermen passed us in small boats. They were creeping through the water, too.

The one thing I needed but did not have at hand was my marine radio. Lock 7 was coming up and I needed to call the lockmaster, who would not be able to see me in the fog. I thought I had left the radio in Winona where we had listened to the dire weather forecast. Later, when the fog cleared, I discovered that the radio had only been misplaced. In order to get into the lock, I used my horn. When the lock-master let us out the south end, we could discern a big tug and a dozen bass boats floating in the fog, waiting to enter the lock. It was a ghostly sight. I sure was glad tugs and barges cease to move in foggy weather.

The sun started to shine just as we reached La Crosse, an attractive river town enhanced by many nice parks. At the Bikini Marina Yacht Club, we located without difficulty the *Dawn Treader III*, the boat Jerry Troyanek uses to cruise America's navigable rivers. Jerry writes about river marinas and pub-lishes his findings in *Quimby's Cruising Guide*. He claims that it took three years for him to travel all the rivers covered in this helpful guidebook. Jerry lives alone on his boat, and while I was on my journey he was checking out the marinas on the upper Mississippi and St. Croix Rivers.

A couple days after seeing Jerry, I dropped Sue off at Dubuque Airport, sad to see my #1 deckhand go. Afterward, I visited Boatels Marina, where I was absorbed into another modern river-life story. Car-roll Oelke and his wife Joan were watching the marina for the owners, who were off at a boat show. The Oelkes, a retired couple living on a houseboat, only expected this late in the season to have to check in a rental houseboat or two. As it happened, they were called to assist in an emergency. A messenger from the Miss Marquette Riverboat Casino, about two miles north of the marina, came to report that a lady had had a heart attack in the casino and her husband was supposed to be out fishing on a houseboat. Fortunately, it took the Oelkes and a few volunteers less than an hour to locate the husband, who promptly attended his wife at the hospital.

I had some fine photo opportunities camping just across the river from McGregor, Iowa. It was at the Holiday Shores Motel in this quaint river town that I had experienced the mayfly attack the previous summer. Writing in my tent, I could barely see the town, only 150 yards away, so dense was the fog. Nevertheless, my Nikons were clicking that morning. The lakes behind this island looked good in my lenses, as did the town, which appeared and disappeared in the fog. At sunrise, the wind blew a bit of the fog away, letting a patch of copper-colored light hit the waters.

McGregor was one town of many where my GT bicycle, ordinarily strapped to the raft's stern, really came in handy. Thus transported I took in the Alexander Hotel, built in 1899, and the River Queen Bar across the street, whose sign announces it to be "A Drinking Establishment for River People." I pumped

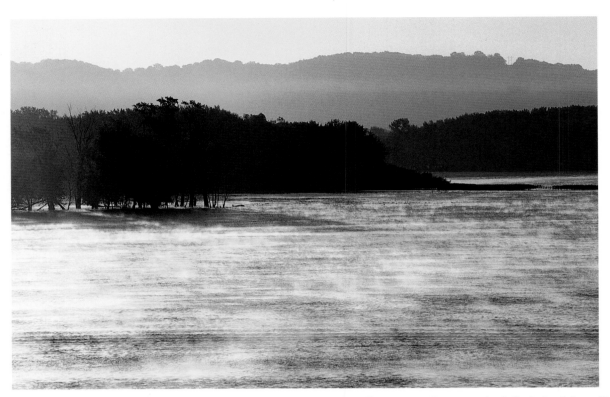
Foggy morning on the Mississippi River.

up a steep hill using my lowest gear and lots of calories, which caused me to shed a few layers of Patagonia fuzzies. On McGregor Heights Road, I found a group of mostly summer homes on or near the river bluff. They commanded a fine view of the river and of Prairie du Chien, Wisconsin. Each day, I noticed, a few more trees exhibited fall's colors. As I descended the hill, sunset was coming on, but in the semidarkness I saw two turkey gobblers cross my path. Upon noticing me, they ran.

Just below McGregor is Pike's Peak State Park on the Iowa side, Wyalusing State Park on the Wisconsin side. At this juncture the Wisconsin River contributes to the Mississippi flow. During my driving trip, I had marveled at the panoramic views offered from the heights of both parks. Wyalusing, in particular, has an extensive trail system for hikers.

Leaving McGregor in the late afternoon of Day 11, taking a last long shot of the town, I noticed a boat following me. I stopped and they caught up. A group of employees from the 3M Plant in Prairie du Chien had left work early to enjoy what they believed would be the last good warm day on the river. They just had to ask what the heck I was driving. After satisfying their curiosity, I asked about their work at 3M and learned that they make 400,000 sponges every day. When I had bid farewell to the sponge makers, I got a few miles closer to Guttenberg before camping on the boat for the night.

The rule had been that clear nights were followed by foggy mornings. The next morning was the exception that proved the rule. A clear morning burst forth and warmed quickly, drying the dew rapidly. I rafted the ten miles to Lock 10 and passed through easily, free of any competition with tugs in the pool below. In Guttenberg I stopped at the 615 Marina and was greeted there by Lloyd Bahls, who told me a little about the local fishing. He said the action picks up when the water drops to 54 degrees: then the walleye start biting right below the dam. Lloyd declared that when these fish are running good, you can almost walk from boat to boat all the way across the river.

Apparently, the fishing remains good until the water temperature drops to 38 degrees; then it picks up again when the river freezes. Tina, head waitress at the Riverside Restaurant, told me the Mississippi freezes almost up to their location, but it stays open in the fast water just below the dam. This oasis of moving water makes an ideal fishing spot for the eagles, who come when the freeze begins. Tina pointed to a cottonwood tree just five feet from the window before me that serves as an annual perch for our national bird. The restaurant leaves binoculars out for their lunch customers. I hope to return to Guttenberg some January to use them.

At the town's library I examined its facsimile copy of the Gutenberg Bible, the first book printed in the Western world. This copy is a rare treasure. Johann Gutenberg printed about 200 copies of the Bible between 1450 and 1456. According to the librarian, 46 copies of this original printing are known to exist. In 1913 printers in Leipzig, Germany, made 310 facsimile sets of the original two books using modern printing methods. Guttenberg, Iowa, ended up getting one of these facsimile sets after World War II.

Also in Guttenberg I met Gary Ackerman, a fisheries biologist and the husband of the librarian I spoke with. Gary explained to me why, during the last few summers, a dead zone has been created in the

Gulf of Mexico off of Louisiana's coast. Huge quantities of pig droppings dumped in the river end up in the Gulf and release ammonia ions. The ammonia is very toxic to fish and also causes phytoplankton blooms, which in turn deplete the water's oxygen. The fish that are not killed by the ammonia die from lack of oxygen later.

Gary also explained to me why sedimentation has become a problem for the whole Mississippi River flood plain. A pool (or lake) forms behind each lock and dam. The pool slows the current down and the sediments drop out. Since the locks were built in the 1930s, about one-half inch of sediment per year (five feet total since the system was created) has filled in the backwaters. This sedimentation of backwater marshes has contributed to worsening floods in recent years. Of course, the river channel is kept open by dredging. Gary tells me this dredging adversely affects the fisheries, especially the perch and bluegills. It's ironic Louisiana marshes are starved for sediment while Iowa, Minnesota, and Wisconsin have too much of it. If only the upper and lower Mississippi could trade their problems, thus creating solutions for both. Something nature did on its own before man's meddling.

People living and playing along the Mississippi—not just scientists like Gary—observe changes in the river. During my next stop, a short one, in Cassville, Wisconsin, I met a couple just returned from water skiing. (It was a nice day, I reflected, but a little cold for skiing.) The fellow's interest was piqued when he learned that I was a photographer; he had just returned from a nature photography workshop in Chicago. He pointed out the clarity of the water near Cassville and attributed it to the siphoning work of the zebra mussel. This prolific mussel is an exotic species that was introduced to the Great Lakes by ocean-going vessels, and from there made its way down the Mississippi. It probably does help clear the water, but it also causes a bunch of problems throughout the Mississippi River Valley by clogging up water intake valves.

My own progress was 'clogged' when I attempted to pass through the lock in Dubuque. Via radio, the lockmaster said it would be closed until 7 P.M. while its massive lower door was being temporarily replaced for repairs. Perhaps I had entered the Zen-like state of river travelers, because I wasn't worried about the delay. Anyway, I wasn't expected anywhere for seven weeks. And I did want to explore the city of Dubuque, historically renowned as the first settlement in Iowa, founded by Julian Dubuque.

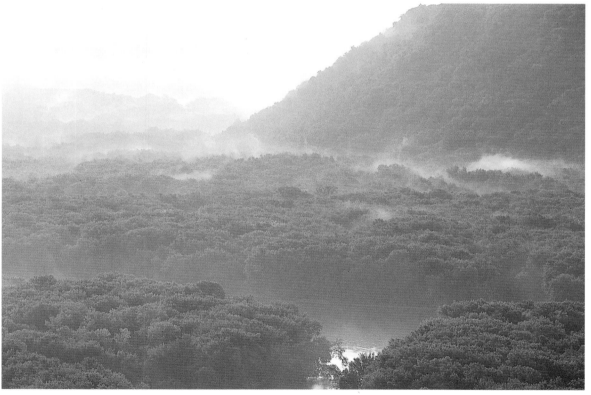

The Wisconsin River meets the Mississippi south of Prairie du Chien, Wisconsin.

Kevin Kapp, a local multiformat photographer, found me above the lock and offered to guide me to the viewpoint at Eagle Point Park. Before we left we watched as one of the 100-ton gates on the lower end of the lock was removed. Leonard Ernst, assistant lockmaster, lent me a hard hat so I could photograph the immense operation from the sunny side. It was undertaken with relative speed and efficiency. From a distance the work crew of about fifty appeared to scurry around like a colony of ants, dwarfed by their huge equipment. They had at their disposal three barges, two tugs, a smaller work boat, and two cranes, one of which could lift 350 tons.

Watching this engineering feat, I was reminded of others: the railroad track constructed down the middle of the river, the numerous bridges in Minneapolis, the powerful grain-pushing boats. Humans

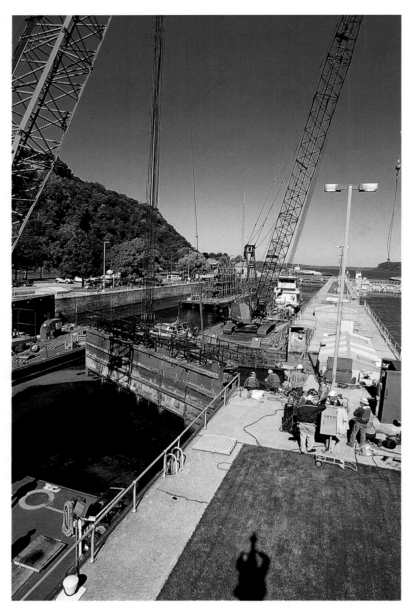

Replacing a door on Lock 11, Dubuque, Iowa.

seem able to do anything, I reflected. We just need to practice doing the right thing and taking care of the earth as we progress into the next century.

After Kevin and I observed the repairs for a while—he with a rare panorama camera made in 1908 that takes 360-degree photos—we drove up to Eagle Point Park. This town park overlooks Lock 11, the pool, and the city, and is well worth the dollar entrance fee. Halfway up the hill a wonderful flower garden and a giant statue of a bald eagle greet visitors. In the 1930s the park used a $200,000 grant to build some attractive pavilions and reception halls that are available for rent. They are made with native materials and designed in the Frank Lloyd Wright prairie style. At the park's summit the view and the walking path are perfect. We followed this excursion with lunch at the Tollbridge restaurant, built on the footing of the old toll bridge that was blown up in 1982.

Back at the lock, the push boats were stacking up but the repairs were nearly done. I went into the lockmaster's office to thank Leonard and to see if I could precede the push boats through the lock as I had arrived first. There I met Nicholas Bainbridge, the lockmaster, who declared, "You'll never make it in a raft. If the winds don't blow you over in Pool 13, the towboat traffic will run over you below the Quad Cities. And if you make it through these they shoot at you with guns near Cairo." (Note: No one shot at me.) Safely through the lock, I met Kevin in his johnboat and followed him to the other side of Dubuque. There were plenty of fishermen and pleasure boaters on this stretch of the river, even that late in the season. Before we parted, Kevin and I explored Catfish Creek. This creek enters an old lead mine area and some Indian caves just below the bluff, and a towerlike structure marks the grave of lead miner Julian Dubuque. The creek reminded me of the entrance into Grand River Flats in Louisiana's Atchafalaya swamp.

South of Bellevue, Iowa, and Lock 12, I saw some folks on a beach eating lunch next to their kayaks. I glassed them with my binoculars and could see they didn't have enough gear for a whole river trip. I turned back to visit them and rediscovered what a small world it is. Three men and a woman from Chicago were on a weekend paddle/camping trip. The daughter of the married couple went to Louisiana State University and had applied for a summer job at the Backpacker shop in Baton Rouge where my gallery is located. Two of the fellows had kayaked the Grand Canyon and were astonished to see a baloney boat (that's river slang for my pontoon raft) on the Mississippi.

En route to Savanna, Illinois, I stopped to photograph a conglomeration of houseboats on a beach and recognized a bluff at Mississippi Palisades State Park. I had stood on the that bluff the previous summer and captured a fabulous sunset on film. Studying the bluff now, I saw a man hanging from a rope. I motored over close to the cliff and looked through my binoculars: it was a rock climber, and he had a broom dangling from his kit of ropes, pitons, and caribbeaners. I stopped to watch and learn what use he made of the broom. At length I had the answer: to sweep a crack in the rocks. If he wasn't cleaning a route for a free climb, perhaps he was a geologist examining the cliff's composition.

It was my turn to be gawked at when I tied off to the public dock of Sabula, Iowa, where half the town was waiting. Sabula became an island city after the lock and dams were put in and raised the water level. After visiting with an Illinois family in their summer home, I walked around town and searched out the white pelicans, who were reported to be feeding on the big lake. Disappointed by the birds' absence, I carried on to Clinton, Iowa, by crossing Pool 13, one of the biggest pools in the system, in very rough seas.

Casinos line the Mississippi from Marquette to New Orleans. When I pulled into the Anchorage Marina in Clinton, I had misgivings about sleeping so near to the *Mississippi Belle* gambling boat, adjacent to it. However, that marina turned out to be quieter than some of my wilderness campsites situated near train tracks. I pulled in next to a small cabin cruiser that I had first passed in Marquette, Iowa. On board I met Frank and Linda Smith from Flagstaff, Arizona, who were realizing a dream so many of us share: to travel the length of the Mississippi River. The Smiths were headed to New Orleans via the Tenn-Tom Waterway, which winds first through Mobile, Alabama.

In a light sprinkle I bicycled the next morning around downtown Clinton, where I saw a wonderful red courthouse with a copper green roof around the clock tower. Then I shoved off once more, taking Beaver Sloughs rather than the river's main channel, heavy with Clinton industry. Not for the first time did I notice what I hoped was treated water pouring out of spouts into the Mississippi. And again I wished I could have seen the river before factories. The river takes in many of our wastes, and every town and industry along it contributes. I floated toward Le Claire, Iowa, thinking how important it is that we all do our best to minimize and monitor those wastes.

At Le Claire I learned the local history from Dudley Stevenson, a volunteer guide in the museum. Dudley showed me a polished and varnished slice of a massive American elm tree that was felled in 1984 after it died of Dutch elm disease. For a hundred years this tree was a landmark, signaling river boat captains to stop in Le Claire and get a pilot to help them through the rapids there. Buffalo Bill Cody was born in Le Claire, and so was Professor James J. Ryan, inventor of the flight recorder, seat belts, and other auto safety features. Very near the Buffalo Bill Memorial is the *Lone Star,* a paddlewheel wooden tug that was retired in 1968. Of greater interest to Baton Rougeans like myself was another boat on Le Claire's river front, the *City of Baton Rouge.* Currently serving as a dock for other party paddle-wheelers, the *City* was once the car and passenger ferry between Baton Rouge and Port Allen, Louisiana.

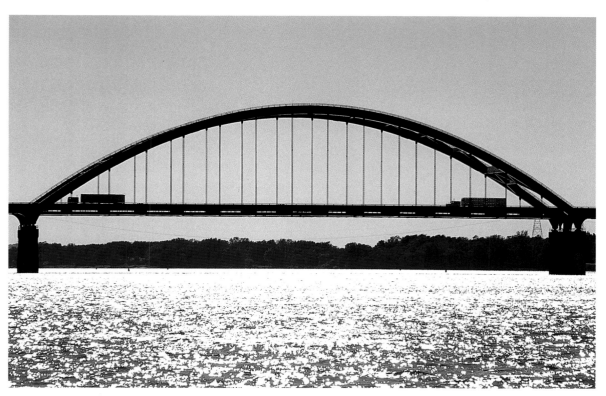

I-280 bridge between Illinois and Iowa.

One of the great boons of my river journey was that I was acquainted with so many fine people along the way. My stay in the Quad Cities was enhanced by my welcome into Bob and Marchand Chaney's riverside home. I had met this retired couple from Illinois the previous Mardi Gras in Akumal, Mexico, where I was vacationing with my family. When they heard my plans to travel and photograph the Mississippi, they insisted that I stop to visit them.

Once I tied up the *Huck Finn,* we took a tour of the Illinois side of the Quad Cities, which is actually a cluster of fifteen communities dominated by Bettendorf, Davenport, Moline, and Rock City. The combined population is just under half a million. Bob had rightfully praised Moline's river front. No levee obstructs one's view of the river from the grassy picnic areas stretching for eight or so miles. Plans are underway to extend its bike and jogging path forty more miles to Savanna, Illinois.

The Quad Cities area is home to the world's major farm implement manufacturers. John Deere has located its international headquarters here, an architectural marvel. Downtown East Moline the new commons area has a centerpiece museum: the John Deere Pavilion. Inside this beautiful structure are computerized exhibits; outside Deere farm equipment is displayed. The agricultural equipment industry

John Deere Museum, East Moline, Illinois.

has done a lot for this area.

We had to cross a bridge to reach the Rock Island Arsenal, a massive army complex constructed out of local limestone just after the Civil War. Signs we saw mentioning the U.S. Navy, Marines, Coast Guard, and Army Corps of Engineers indicated that those government services, too, have a piece of this rock. On the lands adjacent to the arsenal the first golf course west of the Mississippi was created. (I wondered: if you are an island in the Mississippi, should you be considered west or east?) A U.S. Army general touring Scotland in the late 1800s saw a course there and was inspired to have one made on Rock Island. It's now a beautiful private course (on an otherwise military island) with a real old-fashioned clubhouse. Most awesome was the major general's mansion residence. It is reputed to be the second most impressive government residence, next to the White House.

Sunset was colorful as we returned to the Chaneys', stopping en route at Illiniwek State Park. A community group had just donated forty boulders there to make a beautiful rock garden. Nearly every rock had a native plant or animal etched into its flat side as a sort of modern-day petroglyph.

On Day 16 of my raft trip I was still enjoying the Chaneys' hospitality when a low-pressure Canadian front suddenly blew in. I ran down to the *Huck Finn* just in time to take the sunroof off before nature did it for me a second time. Soon Bob, his neighbors Mike and Tony, and I were hard at work tying extra lines to the raft and mounting bumpers all around it. The winds were steady at 32 miles per hour and gusting to 47. The waves were white capping, so much in fact that battening down and nursing *Huck* through the storm was my only option. I couldn't move on that day though I wanted to. My experiences that day lent support to the local dictum: if you don't like the weather in Iowa and Minnesota, wait a day—tomorrow it's going to change. Indeed, I hadn't seen the same weather twice since I launched the *Huck*. The next day was somewhat more mellow, and after making some minor repairs to the raft, I drove toward Campbell Island.

Leaving the slough behind the island, I met two young men in a dive boat who motored over to examine my raft. Bernard Sietman and Dan Kelner are freshwater mussel biologists employed by an environmental consulting firm. Their job that day was to supervise divers transplanting mussels from under the island bridge to a safe location. The bridge was due to be rebuilt.

The biologist showed me some of their samples of *Megalonaias nervosa,* commonly known as the washboard mussel. Thinking I might stump them, I asked if they knew about *Margaritifera hembeli,* a rare Louisiana mussel I had photographed for my *Discovering Louisiana.* Bernard fired back instantly, "That's the Louisiana pearl shell—an endangered species." We talked of my next destination, Muscatine, Iowa, at one time the pearl-shell button capitol of the world. Now mussel habitat is vanishing as locks and dams have changed the ecology of the river.

Somewhat reluctantly, I bucked back into the wind and went thirty-three miles to a lovely beach a few miles above Muscatine. The wind was dying as I beached the *Huck*. I heated some chicken noodle soup in the starlight of a perfect night and went to bed early. As I watched the sun rise the next day, I remembered Mark Twain's observation in *Life on the Mississippi* that the sunsets around Muscatine were

Before the locks and dams were constructed, numerous species of freshwater mussels were prolific in the river; now many are rare.

Bank stabilization in Southwest Pass.

the prettiest he ever saw. The sunrises, I can avow, are also beautiful there.

While waiting for admittance to Muscatine's Mussel Shell Museum (open only by appointment), I walked around and photographed the city, focusing in particular on the county courthouse. This granite structure looks proud, with flags and cannons standing guard out front and a clock tower rising above. Its clean, elegant lines appealed to me, and I wondered if our modern glass structures would interest future generations as much as this century-old building did me.

I believe the *Huck Finn* was often featured in the newspapers of towns we passed by, and Muscatine's newspaper was no exception. As I approached the wall of an auxiliary lock at Lock 17, at the bidding of its lockmaster, I noticed the paper's photographer waiting up above to get a picture of my raft. It would accompany the story already taken about my journey. I climbed up on the lock, met shift boss John Young, and while we talked, I took some photographs. My subject was the *Cynthia Lane,* a push boat out of the port of New Orleans. It had to do a break down: the remedy for when the barge lineup is too long to go through the lock in one load. The push boat pushes the first three-by-three (nine) barges into the lock, then backs out and lets a winch pull them through. Afterward, the tug and the rest of its barges go through and reconnect with the first load. It's scary watching this process from right above the lock: three barges fill a width of 105 feet; the lock is only 110 feet wide.

John showed me a series of snapshots of an accident at Lock 20 that happened in 1969. One of those giant lines (ropes) that you see along any dock broke while really taut and snapped back to kill a deckhand. It hit him so hard it knocked him out of his shoes. John shows this series to all young deckhands to let them know how dangerous not paying attention can be. He claims the towboat captains call his one of the best kept locks in the system. It's certainly an attractive one, with a tended flower bed shaped like the number *17* and purple martin houses made in the shapes of river boats.

Famished but too tired to cook, I was headed for the Lighthouse restaurant in Keithsburg, Illinois, the town just below the retired railroad bridge. (A section of the bridge had been dynamited so that boats could pass by.) However, in the reflective glow of sunset I see a boat heading directly for me, and it

takes only a moment to register that it's Bill Oliver's sleek *Silver Otter.* This small boat has an ancient 1957 Evinrude motor, and its bow rides high, for Bill has loaded the stern with guitar and camping gear. Bill had been on a singing tour through Minneapolis, Pittsburgh, and Cincinnati; then he set about finding me to enjoy a little river life between cities. He has two bands, both geared toward kids. The Otter Space Band is actually Bill playing solo, and his friend Glen Waldeck plays with him in the Environmental Troubadours. Bill and I share a passion for river adventure. Years before Bill had traveled the Missis-

sippi River from Hannibal to Houston in a homemade raft. After meeting up with Bill, my dining plans changed. We ate together before a campfire and entertained ourselves with river songs.

Bill was still strumming his guitar the next morning as he trolled behind me. We parted when we reached the Army Corps of Engineers' dredge; I pressed on and he turned back. I had seen the corps' boat, the *Thompson,* a few hundred miles upstream. It must have passed me during the night. Its crew was digging the shipping channel to nine feet and making more sandbars. Much controversy surrounds the question of how to dispose of this dredge material. Some is piled in massive sand hills, some is put out specifically to enhance wildlife habitat, and some is put back in the current to dig up again downstream.

In Burlington, Iowa, I ate a fine prime rib sandwich at Big Muddy's, one of dozens of restaurants thriving on the Mississippi's shores. After eating, I moved the raft down to the city dock, where the local fire department was practicing with their hoses. They appeared to be trying to fill up the Mississippi, but in actuality they were training a new recruit. With their help I found a Federal Express deposit box. Included on the film I was sending to Baton Rouge was a picture of Burlington's new cable-stayed girder bridge. I toured the town, zigzagged down Snake Alley—"the most crooked street in the world," according to *Ripley's Believe It or Not*—and then returned to the *Huck* to catch up on some miles.

Another beautiful sunset was brewing, and it felt mighty peaceful cruising in my raft during this very mellow time of day. So content was I, I passed up some nice sandbars, thinking there would always be another one. I was wrong. Darkness fell, and it got harder and harder to pick out a campsite. I went slowly up to shore a couple of times with my Q-beam shining only to be turned back by rocks, logs, and shallow water at the shore. Somewhat tired and worried, I got out my map.

I was in Pool 19 above Keokuk, Iowa, which has very few islands. Since it was totally dark by then, I decided to play it safe and persevere until I reached the next marina, at Fort Madison, Iowa. As soon as I went under the double-decker railroad/highway bridge, I recognized Fort Madison from both my *American Queen* trip and my driving trip. Its marina was nice but not for sleeping. A siren on the bridge sounded every time the bridge opened for a push boat, and trains blew their whistles as they crossed the town's streets. As the streets were very close to one another, trains were pretty much hooting throughout the night. A real noise-a-thon. Was the sunset cruise worth the sleepless night? Emphatically, yes.

The next morning at breakfast, I met a couple of electricians who were working on the bridge. They were avid duck hunters and knew a lot about Pool 19. When I told them that I had seen hundreds of hunting blinds in recent days, they guessed, correctly, that I had probably seen the most the day before in Pool 19. This shallow pool is the only one in the system that is in private ownership. It has few islands, but more duck blinds than any other pool, some of which are pretty large and elaborate. They have a place to park and hide the boat, a hunting area (naturally), and sometimes heaters, stoves, and even a card table. The electricians said their wives always think they are cold and suffering out there duck hunting. I guess not.

The dam that creates Pool 19, Keokuk Dam, has the longest drop of any lock except the first one, at St. Anthony's Falls in Minneapolis. The power company that has a generating plant at Keokuk Dam owns most of the land. One of the men informed me that before the dam, a ford existed where the rapid used to be, at Nauvoo, Illinois, just a few miles south. An hour later, I beached the *Huck* at what looked like a boat ramp in Nauvoo, but was really the road from which the Mormons set off to Utah.

Nauvoo was a community founded by the Mormon prophet Joseph Smith and his followers. They had moved here because they were persecuted elsewhere. But the persecution continued in Nauvoo and Smith was killed. Brigham Young took charge and in February of 1846 started the exodus to what is now Salt Lake City, Utah. He led his people down the road (the one I'd tied up at) and across the frozen Mississippi. They wintered in Iowa, and the following year 143 men, 2 women, and 3 children entered Utah. During the next twenty years 70,000 Mormons passed through Nauvoo on their way West. All the western towns they established are modeled after this Illinois town.

Mormons, mostly volunteers, had completed a massive temple just before they left Nauvoo. They finished their work even after they knew they would be leaving. The temple was erected on a hill above the river and stood 165 feet tall. It must have been quite a landmark for passing boats. The structure was burnt by arsonists in 1848, and a tornado knocked most of the limestone walls down two years later. A model of the temple is displayed near the site of its original foundation.

About forty years ago some Mormons returned and started buying back and restoring the old town, which is quite large. It contains much authentic stuff that remained on site because the Mormons left so quickly. For example, the blacksmith's shop has the original anvil and bellows. I rode my bike from the old village up to the temple site, where a garden surrounds the building's foundation. I especially enjoyed seeing the statue garden at the visitors center. Beautifully arranged around paths, trees, and flowers are thirteen bronzes depicting women. Each lifelike figure portrays a different value or emotion: love, fulfillment, motherhood, joy, family, courtship, and more. Sculptor Dennis Smith created all but one.

The statue garden of the Mormon Visitors Center, Nauvoo, Illinois.

Rafting toward Keokuk, Iowa, I considered again how the Mississippi flows through and touches so many states. After Keokuk I would pass the border of Missouri, my fifth Mississippi River state. Many days before I read a sign on the river bank indicating that I was in Minnesota, Wisconsin, and Iowa all at the same time. By my count, the *Huck* floated in more than two states eight times, the last being where Arkansas, Louisiana, and Mississippi all touch in the middle of the river.

During my more leisurely moments on the river, I calculated how its miles are apportioned among the states. Minnesota has the longest interior stretch of the river—535 miles—and it touches the greatest total of river miles—773. Louisiana is the only other state with exclusive use of the Mississippi, for 325 miles beginning just below Fort Adams, Mississippi. In total river miles, Louisiana ranks third, with 527, just behind Illinois, with 581. Mississippi is fourth (410), then Arkansas (321), Iowa (313), Wisconsin (231), Tennessee (187), and finally Kentucky (51). Some students of the river will say there are a number of sections where both banks of the river lie in that state. I'm inclined not to count those places where a meandering loop of the river was cut off and the state boundary moved to contain it. They usually amount to just a few miles.

Another subject of almost constant reporting in my Web page articles was the weather. Like our human ancestors, before the advent of electricity, I was in it all day, every day. And like them, I just dealt with it. My garments were a little more high tech than theirs, but only in lightness, for oil skins, wool, and other animal hides have amply protected humans for centuries. If it was rainy, cold, and windy, I just donned my fuzzies and Gore-Tex rain gear with hood zipped and tied but for a small circle around my nose and eyes. I canoed and rafted through many fine days when I thought more of my comfort and joy than I thought of my hardships during wet ones. My only weather wishes were on rainy days when I would pray for a temporary respite at tent-erecting time. Once my little house on the river was up, it could rain as hard as it pleased for I was warm as a bear in its winter coat.

The wind was in my face when I stopped for gas at the Keokuk Yacht Club. The club was under reconstruction, but the bar was full and the manager helped me get gas, water, and ice. I rested while a double load went through Lock 19 just downriver. When it was my turn to go through, the lockmaster put the *Huck* in with a ski boat. As we sank thirty-eight feet, the two boys in the boat yelled questions about *Huck* across the lock bay. Remembering my difficulties with beaches near Fort Madison, I asked about sandbars below. They assured me there were many nice ones near their hometown of Warsaw, Illinois.

Once out of the lock, I looked for the Coast Guard tug and barge *Scioto*. It's a buoy-tending vessel that I arranged to photograph while the workers repair buoys. She was easy to spot just below Longeneckers, formerly a push boat and now a popular restaurant. Waving at the folks enthusiastically beckoning me from the restaurant, I continued on to the *Scioto* where I hailed the officer in charge, Todd Mullineaux. We planned to meet in a couple days.

About that time, a fellow dining at Longeneckers named Duby motored up in a big johnboat. He owned land across the river and kindly invited me to camp there. I looked at the setting sun, heard rumblings in my stomach, and decided to take Duby up on his offer. He showed me the deep water behind a small island that led to his camp. He had a trailer there before but it was lost in the Flood of '93. It was a good beach and far enough from Keokuk and the railroad tracks to give me a peaceful night's sleep.

Duby offered to run me over to the restaurant in his skiff, so I went with him and met owners Rhonda and Brent Longenecker. After I ate a fine stack of ribs in the top deck bar and heard a few local stories, Duby was nowhere to be found. So it was Brent who took me back to my raft, by car—a much

longer trip than by boat. Just when we pulled in to the old camp, a contrite Duby showed up in his boat. We chatted for a while and I learned he was another river person who desired to travel the length of the Mississippi.

I got a little sprinkle at 2 A.M. and started to put up the tent. But then I thought, "what the heck," and instead wrapped myself up in my Gore-Tex sheet like a taco. In the morning, I left camp pretty early aiming to go fifty-six miles to Hannibal, Missouri. I would have to pass through two locks, and I wanted to get a brief look at Quincy, one of the larger cities on the Illinois side of the river. Lock 20 had a marker showing the flood levels of '73 and '92. Both measurements were well above the platform where the lockmaster office sits.

Quincy has a nice river front park and three bridges just above Lock 21. The town looks fine from the river. The previous summer, I stayed there in a hotel overlooking the river. I also saw some cavelike warehouses dug out from the limestone rock and wondered if they existed in Mark Twain's time. Below the lock, I parked *Huck* on Goose Island and hopped off to swim and bathe. I needed the rest because standing and driving the raft for many hours at a time was physically demanding. Before heading to Hannibal, I took a self-portrait, me and the raft in the afternoon sun.

I arrived at Hannibal at 6 P.M. and found George Walley, president of the town's convention and visitors bureau, waiting on the Hannibal Boat Club dock with cameras in hand. He was snapping away as I pulled in. Via e-mail, I had let George know when I was arriving. I'd also asked him to arrange for me to meet and photograph "Tom and Becky," the 1997 incarnations of Twain's famous characters.

I walked around downtown Hannibal in the twilight and was reminded of Samuel Clemens on most every street. Samuel Clemens, mostly known by his pen name Mark Twain, is the author of *The Adventures of Tom Sawyer, Adventures of Huckleberry Finn,* and so many other great literary works. His *Life on the Mississippi* is in my view the best book ever written on the river. In Hannibal there is his home, a museum, his father's law office, Becky Thatcher's home, a statue of Tom and Huck, a sign marking the jail site where Muff Potter was imprisoned, Cardiff Hill, and many more sites connected to Clemens' life and Twain's works. Just out of town is Tom Sawyer's cave.

My favorite visit to Hannibal coincided with the Fourth of July, when the town celebrates Tom Sawyer Days. Every year at this time the Tom and Becky contest is held to choose a boy and girl to act and dress as the two originally did in Twain's books. The winners are selected on the basis of their costumes, poise, knowledge of Tom and Becky, and more. It's quite an honor. Main Street was crowded as the judges let the retiring Tom and Becky walk around the contestants atop a flatbed truck and tap their successors on the shoulder. Television and print journalists surrounded the new winners. The runners-up get to serve as alternates, for Tom and Becky are in demand at a lot of events around Hannibal and beyond. They make over three hundred appearances a year, sometimes out of the country.

Another competition, even more exciting, is the fence-painting contest. It recalls Twain's story of Tom white-washing the fence in *Tom Sawyer.* The kids competing were judged on costume, speed, and paint coverage of the fence. Their costumes invariably consisted of ragged pants and shirts, and their accessories included corncob pipes, straw hats, and every item that Tom Sawyer was said to have touched. The junk just kept coming out of those kids' pockets while the judges watched: a dead rat (some kids had a real one), a fishing pole, marbles, a bandaged toe, an orange peel, a frog . . . on and on and on. At the word "go," the Tom wanna-bes made a fifty-yard dash to a section of fence where a brush and a bucket of whitewash waited. There were six lanes, so each heat had up to six boys. Each kid gave the fence between two and ten paint-splashing strokes and dashed back. Not a one finished his whole piece of fence. Evidently, they were all going for the speed points.

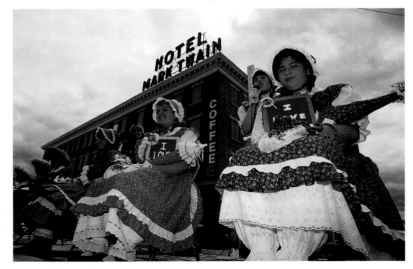

Finalists in the Tom and Becky contest, Hannibal, Missouri.

For two days continuous games were played in the hilarious mud volleyball tournament. I wasn't sure what mud volleyball had to do with Tom Sawyer, but guessed that it was connected with his aversion for cleaning up. The three courts were sandbagged pools of mud and water. Any quick leap for a

U.S. Coast Guard buoy tender *Scioto* at work.

ball would cause a player to fall face first in the slop, as at least one foot would stick in the mud.

On the *Huck* and at the Mark Twain museum, I photographed the 1997 Tom and Becky alternates—otherwise known as James Behrens and Sara Lipp. They told me that afterward they were due to visit a Presbyterian Sunday-school class. A busy weekend, as usual. I shoved off after lunch and chased the *American Queen* toward Clarksville, Missouri, which claims the highest point overlooking the Mississippi River.

I had a couple hours' wait at Lock 24 above Clarksville. While I wrote on my laptop to make use of the time, the skies went from golden twilight with a crescent moon to pitch black. I was glad to see the *Scioto* floating peacefully below when I finally emerged from the lock. The next day I would photograph the Coast Guard at work. Before our rendezvous they had to move downstream and install some reflectors and lights. I would catch them on the rebound.

With my morning free, at sunrise I crossed the river into Clarksville and tied up the *Huck*. The town had a quaint river front, like many others along the Mississippi, and a visitors center with live animals, including two very weird foreign cockroaches. Lookout Mountain Park above Clarksville is closed now. It once had a two-chair ski lift that brought tourists to the top. I hiked up there now and saw the dilapidated tower that claims a spectacular eight-hundred-square-mile view. This old park brought back memories of vacations with my family: the model cowboy town, the incredible leaning house, the snack bar, tower, pony rides, and those plywood characters with holes in which to stick your face for photos. Someone ought to remodel and reopen this place. Every kid needs to defy gravity by walking in a leaning house.

I found and tied aside the *Scioto* downstream at mile 249. On board I met the officer in charge, Scott Pickering. He told me that there are thirteen different cutters or groups in the Coast Guard that handle the navigation aids on American rivers. The *Scioto's* territory stretches between Lock 13 and Lock 25. After the ice breaks up in the spring, up to 50 percent of the buoys in this area alone are damaged, lost, or moved. The *Scioto's* primary duty is to repair these; its secondary duty is to search and rescue.

While I spoke with Officer Pickering, the Church Creek Light and Daymark at mile 249 (above Cairo, Illinois) was being replaced. The old one had been temporary and located on shore. Three men were up on the replacement pole and others assisted from a crane. To create the finished product from a naked pole took about one hour. I took some shots of the job and checked out the tug itself. The *Scioto* was immaculately clean and seemed a pleasant place to work. Officer Pickering explained their schedule: they work north of their home base at Keokuk, Iowa, for one week, then move south for one week, then take a week off. I asked if he knew how many buoys there are on the Mississippi, and he did not have a guess. If I got bored sometime, I could count the daymarkers myself: they are all marked on the map. As for the buoys, there must be thousands.

Red Right Returning. Many years ago I took Coast Guard Auxiliary and U.S. Power Squadron navigation courses and learned this phrase. Remember it and you can find the channel and your way on most inland waterways. What it means is that the red buoys and red daymarkers will be on your right when you are returning to land from the sea. Thus, going upstream you'll find red buoys are on your right (starboard side) and green buoys on your left (port side). Going downstream, as I was doing, it's just the opposite. As long as a boat moves between the red and the green it will stay in deep water and on course.

Staying on course is not as easy as you'd think on the Mississippi. It's possible even to get lost. There are a lot of islands, sloughs, and joining rivers that can easily get boaters turned around. Many of the is-

Golden Eagle paddlewheel ferry.

lands are blocked on one side by rock jetties that the Army Corps of Engineers puts in to maintain the main channel of the river more easily. So to make sure you go the safest and shortest distance, you must pay attention to your position between the buoys.

The daymarkers let boaters know where they are on the river relative to Cairo, Illinois. Lake Itasca, Minnesota, is 1347 river miles above Cairo. Then at Cairo the numbering system starts over: this town is 953 river miles above Head of Passes, Louisiana, where the fingers of the Mississippi Delta begin. You can always find your orientation on the river if you find a daymarker. For example, going downstream just above St. Genevieve, Missouri, you see a marker on your right reading "126.1." That means that you are 126.1 river miles north of Cairo.

Camped below Lock 25, I heard coyotes yip, raccoons chatter, and beaver tails slap. My fourth mammal of the night was signaled by a pungent odor, which woke me to a great pink sunrise and the *Mississippi Queen* chugging upstream. With the smell of that skunk drifting away behind me, I motored down to mile 228 where the *Golden Eagle* ferry takes cars between Missouri and Illinois. The *Golden Eagle* is the only paddlewheel ferry on the Mississippi River. It was built in 1936, and Captain Scot Baalman thinks it's been on the river since then. I parked the *Huck* and rode across the river with Scot, whose family had recently bought the business. He complained that the rudders were not in the right place, making it difficult to land, but I noticed he did a great job of it. The ferry can hold eighteen cars but once squeezed on twenty-two Volkswagens. Most of its patrons are local but tourists use it on weekends. Back on my raft, I followed the *Golden Eagle* across the river a couple of times to get a good shot.

At Grafton, Illinois, the Illinois River enters the Mississippi. I moved on to this pretty river town that sustains a commercial fishing industry. As I neared it I was interested in a massive house that stands out like a lighthouse beacon high upon a bluff. It was Tara Point, a bed & breakfast owned by Larry and Marge Wright. In my drive and research, I read about, visited, and looked at many bed & breakfast accommodations along the river. Tara Point had the most spectacular view. From the Wrights' deck I could see for miles up and down the Mississippi, and up the Illinois River. The entire hillside in front of Tara Point is covered in redbud trees, which according to Larry are gorgeous in the spring.

From the Wrights' deck I could also see Our Lady of the River Shrine at Portage des Sioux, Missouri. I was headed there next. I asked Larry if the Sioux Indians used to portage over to the Missouri River from there and he confirmed my suspicions. Amazing what you can get from a name. I mused on the chance early explorers had to name towns, rivers, canyons, and mountains.

I had also seen the shrine's statue the previous summer from the beautiful campus of Principalia College. I had stopped at this Christian Scientist institution during my drive along the river. The college's chapel sits on the bluff as do the residence and classroom buildings. The view from there almost equals in splendor the one at Tara Point.

I took a little break on an island across from the college and rearranged my cargo. My supplies were thinning down a little, so I combined some things in storage to make my craft more efficient for work. Then I pulled into the Palisades Yacht Club, which is next to the shrine. Despite poor light from clouds, I took a few pictures then moved on to the village of Portage des Sioux. That night on the raft, I covered myself up to my eyebrows with my Gore-Tex sheet and slept. The first mirror I saw the next day showed a perfect line of red dots across my forehead, which the sheet failed to cover. Evidently I underestimated the mosquitoes' desire for a meal.

In a stiff breeze I rafted next toward Alton, Illinois, where a reporter working for the local paper was going to meet me. It was a gray morning and very splashy from the wind, so I did not take too many pictures. But I did photograph a group of old tugs assembled in what seemed to be a boat graveyard. There was a rusty, ancient dredge that looked very small compared with ones working today.

In Alton's marina, free-lance reporter Sue Hurley heard my river story and took pictures of *Huck*.

After she finished, I bought a sandwich and munching toured the new marina. The Alton Marina was recently built behind the old lock wall. The new Lock 26, two miles downriver, is called the Melvin Price Lock and Dam. It is twelve hundred feet long, so the push boats do not have to break down to go through in two loads. It also accommodates small crafts like mine in a six-hundred-foot chamber. As I was whisked through the small chamber, I thought, "Only one more lock to go."

The wind kept picking up as I headed toward the confluence with the Missouri River. This important tributary starts in Montana, and when combined with the lower Mississippi it makes the fourth longest river in the world. The flow and the current really increased as I crossed where the two rivers join. *Huck* was happy to be back in whirlpools and eddies like the ones he's used to in the Grand Canyon. I looked forward to turning off the motor and drifting a while after passing through my twenty-eighth and final lock this trip. First I had to head down the Chain of Rocks Canal. At river mile 187 in this canal I celebrated reaching the midpoint of my Mississippi adventure.

My next inspiration to photograph was the 630-foot-tall St. Louis Arch. The city's river front prior to this landmark is pretty industrial. The Eads Bridge, the first bridge built on the Mississippi, in 1874, signals to the river traveler that the arch is imminent. I had visited the Arch before, one Fourth of July along with thousands of other people come to witness an air show. Members of the U.S. Army skydiving team amazed us by parachuting in patterns around the Arch. Now below it in the *Huck Finn,* I again experienced awe at the immensity of this shining silver structure. The view of the river and city from within it is spectacular, but you have to be prepared to squeeze yourself into a tiny cable car with others to see it. From the waterfront I took a digital photo of the only floating McDonald's on the Mississippi River, with the Arch looming in the background. Double arches . . . get it?

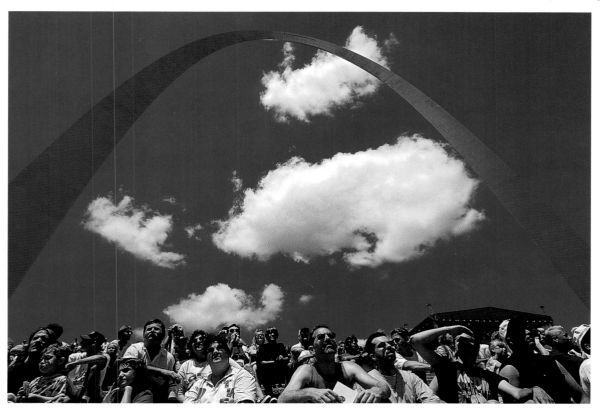

St. Louis Gateway Arch on the Fourth of July.

A photography and geography class from the Crossroads School in St. Louis came to see me off at the Arch. The students also followed me on the *Advocate's* Web page. I told them about my adventure and they took a lot of pictures of *Huck.* I learned something from them, too. One Captain Sellers, who taught Samuel Clemens about river piloting, wrote under the pseudonym Mark Twain before Clemens did. The Mark Twain we all know took that pen name after Sellers died.

The current was strong as I resumed my voyage. After one hour I calculated my speed and was surprised to find that I had made 10.75 miles per hour—2.5 miles more than I had made each hour riding above the locks. I happily realized that with the increase in speed, I would have more time for shooting pictures.

Hoppies Marina in Kimmswick, Missouri, is one of the two last marinas on the river in that state. Marinas and gas pumps would not be so plentiful during the rest of my trip. Immediately after I tied up, Edward Lekosky was at the dock, a self-proclaimed Mississippi River historian with a specialty in boating. He was rattling off facts and figures as fast as my ears could take them in. He suggested I stop at Fort Chartres, Illinois, on my way downstream and follow a trail he had made across an island to the fort. (I never did find that trail.) In this marina I also met Alan and Marge, a retired couple from En-

gland. They left the British Isles two years ago in their thirty-four-foot sailboat called the *New Chance.* They were embarked on quite the adventure: crossing the Atlantic, sailing the Great Lakes, and now heading down the Mississippi.

In the small town of Kimmswick I found Theodore Kimm's grave. This man founded the town in 1859 when both railroad and boat traffic made it a thriving community, only forty miles south of St. Louis. The advent of the automobile diminished the commercial importance of Kimmswick and many of its historic buildings then deteriorated. In the 1970s a restoration project revitalized the town. A banner informed me that I would miss its Apple Butter Festival, by only eight days.

After a near-freezing night, I moved on toward Crystal City, Missouri, at a leisurely pace. Four old-timers greeted me at the Plattin Rock Boat Club. When I asked what they were looking for from the deck overlooking the river, they replied, "Boats like yours." I asked these boat lovers for directions to town and biked in to find quaint neighborhoods with cobblestone streets lined with American elm trees preparing to turn yellow. Downtown Crystal City was all brick. Across the main highway was its sister city, Festus: a much bigger town with all the fast-food places.

During my bike tour spiders had taken over the *Huck.* Once on the river, I learned why. Hundreds of spider webs were drifting in the wind. I could see them silhouetted against the cliffs. I drifted a lot and made it to river mile 135 for camp. That night I built a fire because like the previous night it was getting mighty cold. The moon gave me enough light to type by, but my fingers soon chilled and stiffened. So I just enjoyed my fire and the moonlight on the river.

My wife Sue met up with me in St. Genevieve, Missouri. I pulled into its Gabouri Marina just behind a Canadian American cruise ship that was taking its passengers from Chicago to New Orleans. After Sue arrived from the St. Louis airport, she ran and I biked into town to photograph the oldest brick building on the west side of the Mississippi. It was built in 1785, fifty years after St. Genevieve, the oldest permanent community in Missouri, was settled by the French. Newspaperman Mark Evans told us that there were more French colonial homes there than anywhere else in the United States.

A few hours before sunset we found a photogenic camp for the night. Not only did it have abundant firewood, but it gave us a view of a spectacular sunset. We enjoyed a fine reunion supper with a rising moon that looked just like a pumpkin. When we set up the tent on *Huck,* we noticed the water was rising into our kitchen site on the beach. So I moved the raft up a few feet and tied it down with three lines. Though it was still moving downstream a little more than I liked, it seemed OK.

At 3 A.M. we were startled awake by a big splash on our sleeping bag. In the movie version of this scene, the Beach Boys' tunes would be the background music, for the *Huck* was surfing and a four-foot wave came over its side and into our tent. I was beginning to associate excitement of this sort with a visit from Sue. Shocked by the cold and the water, I dressed hurriedly, took in all three ropes and tossed them to Sue, then hopped back into the boat to motor upstream about two hundred yards and away from Surf City. Luckily the sun came up warm, melted the frost, and dried our sleeping bags.

That day was cool and beautiful, and it was great to journey again with my favorite deckhand. We motored down to Kaskaskia State Park to meet Keith Jackson of the Carbondale, Illinois, PBS station. Then we pressed on to Tower Rock riding neck and neck with a push boat from Memphis called the *Bart C. Tully.* It was pushing a big load of rocks. Since St. Louis, rocks lined the river's banks; the Army Corps of Engineers uses them for bank stabilization and channel training. In addition, rocks cover most of the beaches. Too many rocks: I would prefer seeing the river more natural.

We arrived at Tower Rock just before sunset. It juts out of the Mississippi River just like Mount Trempealeau, but it's not a mountain. Flat layers of limestone give this tower an elegant look. It wears a small forest at the top like a crown. The current and eddies made photographing it from the boat a challenge, as they tossed the *Huck* around like a toothpick in a gutter during a rainstorm. Afterward, we beached the raft in a great spot between the two currents and carefully climbed to the top to check the view. It was steep and the rock crumbly. There were many holes in the top where artifact hunters must have been at work. The view was good, especially in the late evening light. I looked downstream at Tower Island, on whose gravelly western shore we camped for the night.

At daybreak the sun glowing through the fog was beautiful. In its light we built a breakfast fire and had extra cups of tea, congratulating ourselves on our uneventful and restful night. The fall colors, too, showed themselves well in the foggy light. Among the pictures I took that morning was a three shot.

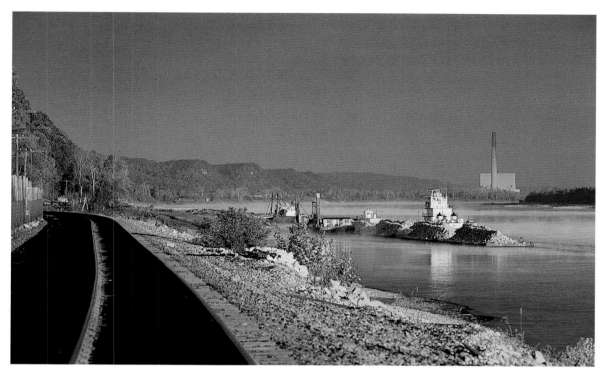

A variety of river commerce at upper Mississippi river mile 135.

That's what I call a photograph with more than one subject: in this case, a push boat, the railroad tracks, and a power plant joined in one frame. From this point onward, industry is the rule on the Mississippi.

We drifted the few miles to our day's destination: the 3,400-acre Trail of Tears State Park, in Missouri. There we parked behind a seawall that's supposed to be a harbor. (I think the flood of 1993 did some damage to it.) Ready to stretch our legs, we first hiked the beautifully forested Shepards Point Trail, which leads to a good viewpoint above the river. The bluff, higher even than Tower Rock, is made of the same limestone. We could understand why the squirrels here are fat: acorns and hickory nuts littered the trail.

Next we walked to the memorial of Cherokee Princess Otauki, the daughter of Chief Jesse Bushyhead. Otauki was one of several hundred Indians to die while waiting for the ice to disperse on the river during the winter of 1838–1839. They were on a forced march to Oklahoma, having been removed by the federal government from North Carolina and other eastern states. In the museum we learned that thirteen thousand Indians were exiled from their homelands, and one in four died on this march of eight hundred miles.

The next morning's dew turned the dry, cracked earth we had parked on into buckshot mud. It stuck to our boots like super glue. By the time we loaded the kitchen gear, the raft was filthy and unsuitable for a photographer to work off of. So we gave *Huck* a bath. We wanted to leave early but couldn't for the fog, thus we only reached Cape Girardeau at about 11 A.M.

The town was named after a French soldier, Jean B. Girardot, who started a trading post here in 1733 then moved on. Louis Lorimier came to the area in 1793 and established the city with a Spanish fort. Lewis and Clark came through here, as did famous frontiersman Davy Crockett. With the arrival of the steamboat, the Cape became the busiest port between St. Louis and Memphis.

The old part of Cape Girardeau is protected by a levee wall with two big doors that are open when the river is low. We admired the mural on the wall depicting the five-state area, and walked around the old part of town. Most noticeable in the historic part is the Common Pleas Courthouse, high on a hill about four blocks from the river. Confederate soldiers were kept in its dungeon during the Civil War.

There is a new part of Cape Girardeau, built near highway I-55, with malls and other modern structures. Towns are developing differently today than in the past. Now interstate access for semi-trailer trucks and cars compels growth and influences residential and commercial planning. The originally established areas of Cape and other river towns thrived in the steamboat days, then grew dilapidated with the onset of automobile traffic. Many historic districts are now being remodeled as shopping and tourist areas with decorations of memories past. I learned that during the 1800s the river front—with its gamblers and hustlers and paddle-wheeler docks—was typically where the poor of a town lived. The prime real estate in that era was on safe, dry highlands. Today a reversal in valuation is apparent, as river front or view home sites sell at a premium.

We returned to Cape's river front to see that *Huck,* as usual, was drawing a crowd. Sue was flying back to Baton Rouge as I motored hard toward the confluence of the two big rivers at Cairo, Illinois. At river mile 25 I set up the tent to catch up on my writing. As I wrote, a beaver right off the port side was gnawing on a branch. At dawn I was surprised to find no dew and warm weather. And no trains. In this

region, the Mississippi meanders again as it did near Lake Itasca. Now in my raft, I would be going around the bend again and again. To avoid the curves, the railroads moved the tracks inland.

The last twenty-five miles on the upper Mississippi consist of two sweeping bends. As I rounded them, I first saw the I-57 bridge, then the Missouri-Illinois bridge, and then Fort Defiance State Park. The park is situated right on the point between the Ohio and Mississippi Rivers. As you might suppose at this juncture, the river is big there. I took a few pictures, but from my low angle on the Huck, the river's breadth wasn't revealed.

AT THE OHIO-MISSISSIPPI confluence I moved from the upper Mississippi River to the lower Mississippi River, the latter a river of greater breadth and more full of man's work. I also entered a more familiar river, one that I have experienced with some regularity since childhood. My memory was deeply stirred as I rafted below Cairo. I would enter a new town and my previous trips there would flow back to me. When at length I passed under the highway I-40 bridge and saw the Memphis skyline, I recollected my visit there during the previous summer's car trip.

On that visit, my friend Donovan Smith led me to the top of the Cotton Exchange building at sunset. The view from there was great, and the cloudy skies had become purplish as the sun dropped. I photographed the interstate bridge and Mud Island from that height. Down below that night a blues festival was rocking the streets. We walked around and listened to some very good guitar pickers. Beale Street is a blues-driven attraction that is just a few blocks off the river. On my rafting trip, I stopped there again: the music and barbecue kept me hopping. Its atmosphere is reminiscent of New Orleans' French Quarter.

Mud Island, with its Mississippi River Model and museum, is a wonderful addition to the Memphis waterfront. A monorail brings visitors out to the island. The ingenious river model replicates in miniature the entire Mississippi River system, tributaries and all, with water flowing through it. At the end is a large swimming pool: the Gulf of Mexico. You can walk down the entire river in about ten minutes, and in the summer you can swim in the "Gulf."

Four friends joined me at Mud Island Marina just before I left the City of Blues. During our days together we were singing the blues, too, at least about the weather. We had high winds, rain, and cold for their entire trip. I think the only times we were comfortable took place around a campfire. There were compensations, however. Wayne made his great chicken-and-sausage gumbo, and Bobby grilled some juicy steaks—both great improvements to my usual river fare.

When my friends got off at the Helena, Arkansas, boat ramp, I noticed the last of Tunica Casinos across from me. These casinos string out from Tunica, Mississippi, like a mini-Las Vegas. One showed up well from the river, for it had a twenty-story hotel under construction. I also noticed in Helena the little park with a viewing platform that I had visited in the spring at high water. On that earlier journey I could barely get to the boardwalk. Once there I saw picnic tables floating by. Now the deck towered about four stories above the river. The Mississippi is certainly a different river from season to season.

I myself was feeling the change of seasons strongly around this time. The day I left Helena, luckily the wind was behind me except on westward bends. The tips of my fingers were cracking from the wet and the cold, and from opening the snaps on my camera case. But the discomfort this caused was the least of my difficulties. The *Huck* began to show engine problems: it seemed to need new spark plugs. After I cleaned them, the raft would go fast for a half-hour, then return to quarter-speed. In addition, my prop started spinning without moving the craft. I discovered it was totally stripped, so I replaced it. All day long I worked on the engine, while big push boats slid by.

At my next camp, I was reminded that great pictures sometimes had a price. At sunset the skies cleared and the cold came. A flock of white pelicans and the beautiful cold-front sunset cheered me after my exertions on the boat. I had moved downstream and at twilight found safe anchorage behind a sandbar. Next day I was photographing a spectacular sunrise when my tent blew into the river. It was soaked, but I got the picture, and in the sunshine on the way to Greenville it dried.

Still beset by engine trouble, I arrived at the mouth of the Arkansas River. Tall sandbars marked the spot where it enters the Mississippi. I have fond memories of growing up on the banks of this river in Fort Smith, Arkansas. Some three hundred miles upriver from where I was now passing, we

hunted, fished, camped, and had sandbar parties during my childhood. A great region to grow up in.

My concerns now were much more mundane: still engine problems. On the bank a mile below the mouth, I saw a bunch of trailers and a man on a four-wheeler. When I pulled up to the bouldered bank, E.G. Hill descended the fifty feet to the raft. He is a retired farmer and a caretaker for the Ozark Hunting Club. He ended up giving me a hand in switching to my other engine. E. G. says he's always happy to help another person. I think he could have done the job by himself, he was that strong.

The Memphis skyline at night, viewed from Mud Island.

While we worked, E. G. asked me if I had seen any bear, and I knew by the way he was asking that he wanted to tell me his bear story. Late one afternoon two months before, he saw at his camp what he first thought was a big deer. He decided to sneak up and get a closer look. Because the wind was blowing his way, he thought he could get close. But he couldn't see the animal when he neared his garden, so he began picking some tomatoes. Then he noticed an elderberry bush moving. There is the deer, he thought, and edged over closer to the bush. When the bear sow popped up from eating, E. G. was only twenty feet away. He froze. The bear commenced to eat again, and E. G. tiptoed backward until a tree stood between them, then he hustled back to his camp, unscathed.

Because the engine troubles had put me behind schedule, I drove right through another beautiful sunset to arrive at the Greenville Harbor around 8:30 P.M. I was hoping Doe's wasn't closed. Patrons at Doe's restaurant walk in through the first kitchen, where the steaks are cooked. Then they pass through

the second kitchen, where the French fries are made and the dishes washed. Through the next door they enter the dining room. When I reached this last room, the waitress seated me alone at the largest table. All the others were taken, but most of the people were finishing up their meals. I had learned the previous summer from the veteran waitress of forty years that Doe's had no menus. And I had learned also that the steaks and fries soaked in drippings were out of this world. In her southern drawl, she rattled off the small selection. I again ordered a small t-bone (a two-pounder), medium rare, with fries and a Bud, and prepared to eat a meal that would make a cardiologist have heart failure.

The place is old. I think the house was built early in this century, and for a while it was a black honky-tonk that served hot tamales. (I once sampled these tamales, and they are great, too.)

Doe's Eat Place, Greenville, Mississippi.

Eventually, Doe's turned to cooking steaks, too, and thereby achieved its local fame, despite its rather shabby atmosphere. If I'm within a hundred miles of this place, I will drive out of my way to stop and get a red-meat fix there.

The next morning, I floated past the three casinos in Greenville and out into the six miles of Greenville Harbor. It's a push boat mecca. There are push boats resting, push boats up on dry docks getting repaired, push boats working. Back in the Mississippi, I found the waters were calm. A good day on

this widening river. The general rule regarding the miles below Greenville is that an endless sandbar stretches on one side and a dirt bank with rocks on it on the other side. They alternate sides at each bend.

That day I saw cormorants flying everywhere, indicating that catfish ponds were nearby. Small groups of ducks also passed overhead. And just when I crossed into Louisiana a flock of two thousand scaup (wild ducks) took off. It was getting dark, so I pulled behind the first island in my Louisiana and tied up to a floating tree that is stuck on the river bottom. As I ate my ham sandwich supper, I heard a barred owl give its seven-hoot call—I knew I was home.

That evening the blackbirds entertained me. I identified redwings, cowbirds, and (I think) Brewers blackbirds. The brown females of the first two species stood out in the waning sunlight as they flew in undulating circles above the cove. Most of them then landed on the trees, and I was thinking they were going to roost. The quaking treetops full of birds reminded me of aspen trees in a breeze. As more and more arrived from two different directions, they flushed from the trees and dove down to the water. In my binoculars I saw their heads dipping into the water, obviously for a pre-bedtime drink. Then the birds surprised me by gathering on the sandbar. They hung out there until dark before heading off to a roost I could not see.

The blackbirds woke thirty minutes after I did. I heard their cacophony of cackles first, then saw their ten thousand silhouettes in the pink skies of morning. They passed overhead, their wing beats shushing, without dropping a thing on me or the *Huck*. Two hours later I was passing Lake Providence, a cypress-lined oxbow lake that was once part of the Mississippi. Many similar lakes that were meanders cut off from the big river exist in Louisiana, Arkansas, and Mississippi. The night before I had wanted to stay at Lake Providence; that morning, unfortunately, I had no time to stop.

During my most recent visit to this lake, I stayed with Steve and Flo Guenard in their antebellum home called Arlington Plantation. My bedroom had a bullet hole in it from some past confrontation. I also flew with Steve in his Super Cub. Super Cubs have been around a long time; bush pilots use them more than any other sort of plane, I would guess. I sat in front so I could shoot pictures out the open door while Steve piloted from the back. We flew up to Greenville, back down to Vicksburg, across to Poverty Point, and back to Lake Providence. The river was high with water in the willows and no sandbars showing. At Transylvania I saw the water tower with a bat painted on it. One local storekeeper in that one-horse town has capitalized on its name: it's Halloween every day in his store.

That flight was as instructive as it was beautiful and fun. On the levee we saw a man sand-bagging a boil. When a boil occurs, the water pressure from the high water has sent a springlike flow through the

Mississippi Delta catfish ponds.

porous clay soil under the levee and out the other side. The simplest method of stopping the flow, which could increase and undermine the levee, is to sand-bag around the boil and make a little pond above it. The water pressure then keeps the water from increasing its flow.

South of Greenville Steve and I saw the checkerboard pattern of the catfish farms. While most of the ponds were a monotonous green from the air, one combined colors in an interesting way. There they were feeding fish from a trailer pulled by a tractor. A stream of yellow feed was shooting out into the pond as the tractor moved around it. Happily for my picture's composition, a school of black catfish followed the feed, adding black to the yellow and green.

Having bypassed Lake Providence, I neared Vicksburg. About six miles upstream from the town I came around a bend and could see its bluffs. The Yazoo River channel, made by the Army Corps of Engineers, then took the *Huck* and me toward downtown Vicksburg. Before 1876 a big loop of the Mississippi passed through downtown, where the siege of Vicksburg had taken place. Then in that year, probably during high water, Old Man River decided to take a shortcut and leave the city riverless. The Corps went to work, and by 1903 Vicksburg had a river front again. Now it boasts many industries, four casinos, and Mississippi River Adventures. Dave and Peggy Shaeffer run this last operation: a fun historical tour by jet boat.

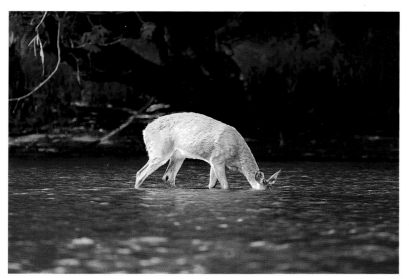

Whitetail doe feeding in the Mississippi River.

Luck was with me when I ran into George Meyers, who owns Annabelle Historical Home and Bed & Breakfast. He offered me a very comfortable bed and a real breakfast of silver-dollar biscuits, eggs, sausage, and fruit. (Not just a few croissants in a basket placed in your room.) Annabelle was built in 1876 by John Alexander Klein as a home for his son Madison Conrad, who got married and moved to Virginia without having lived in it. Klein lived in Cedar Grove, then the biggest house in Vicksburg and now a nice bed & breakfast, too. With dollars from the casino industry, Vicksburg has restored quite a few nice homes in its historic district. It has also created a beautiful park commemorating the Civil War battle fought here: I found its rolling hills, manicured landscape, and monuments to be meditative.

Just after the Civil War, land was available for homesteading in Winn Parish of central Louisiana. Richard Johnson told me how his relatives migrated from the Clarksdale, Mississippi, area to this land, of which he still owns a small piece. The year was 1872 when his grandad Shelton Regions—accompanied by his father, two brothers, stepmother, baby, cart, oxen, and belongings—reached the steam ferry at Vicksburg. Times were tough and cash was hard to come by, so when the ferryman told them the passage prices, the family had to decide whom they could afford to board and cross the Mississippi that way. In the end, they paid five cents for each of the two adults and six cents for the oxen and cart. The baby went for free. An additional fifteen cents could not be wasted on the three teenage boys, however. They were sent upstream one mile, where they cut some baldcypress knees to use as floats. Then they swam the river, the current bringing them downstream to meet their parents at the ferry landing on the Louisiana side.

I left Vicksburg, well rested and very late in the afternoon, with weekend company. My favorite deckhand Sue was back and this time with my stepsons Lee and Adam. The Jim Roland family with the male half of their quadruplets joined us, too. They had their ski boat to add to the armada. It was twilight by the time we were three miles out of town, so we set up camp then, regrettably across from a large power plant. The food, the company, and the campfire were great—the view and the plant-associated noise were terrible.

At river mile 405 the next day we met Jim Roland's cousin Richard. He took us on a quick tour of Winter Quarters, once a plantation and now an eight-thousand-acre hunting club. This area of the world is rich in whitetail deer. The habitat, called "batture," is described as the land between the river and the levee. In a wildlife management class at Louisiana State University, I learned that this area can support more deer than any other habitat can. Driving this portion of the levee the previous summer I saw some 150 deer in one day going through Tensas and Madison Parishes. At night even more are visible. Touring the Quarters in our Blazer with Richard, we saw lots of tracks but no deer.

This area has always been of interest to me. The first canoe trip I made as a professional photographer was along the Tensas River. It was 1972 and I was looking for the ivory-billed woodpecker near the area where it was last officially sighted, in the 1930s. Sadly, I did not find one. This woodpecker is gone from the United States, but a few members of the species may possibly exist in Cuba. Louisiana black bear are trying to make a comeback here. Visitors to the Tensas National Wildlife Refuge run a small chance of seeing one.

The day we toured Winter Quarters, the area was dry. Purple weeds created a continuous line of contrast against the green wheat and clover planted to attract the deer. But Winter Quarters has flooded each of the past eight years. Before the 1990s, Richard said, the area only flooded periodically. He attributes the floods to the work of the Army Corps of Engineers along the river. My research has taught me that big oak trees can hold one thousand gallons of water. When these trees are cut and replaced by new parking lots or highways, this storage is lost and runoff into the Mississippi River is accelerated. So as the years pass and development increases, less water can do more damage, and God help us when we really have a flood like the 1927 disaster again.

After a fabulous night of camping, on a four-mile sandy island, I bid my sandy crew farewell at Natchez Under the Hill. My next camping destination was the new part of St. Catherine National

Wildlife Refuge, just south of Natchez. On previous visits to the refuge I had encountered ducks, deer, turkeys, eagles, and alligators. This time, however, no safe place for the raft presented itself, so I drifted on down a few miles and camped behind an island on the Louisiana side.

I awoke to another glorious morning and took off into a strong west wind. One sudden gust lifted my big blue sleeping pad with my twelve-pound tripod on it and flung the tripod into the water. The wind blew a stinging spray in my face for the seven-mile western bend I was traveling. Thus far the river had claimed one pocketknife, one coffee cup, and my tripod. Not bad for a two-month expedition.

At river mile 315 you come to the Old River Control Structure, designed by the Army Corps of Engineers to regulate the flow of water between the Mississippi and the Atchafalaya Rivers. The Red River also meets these two here. The Atchafalaya is the first and the major distributary of the Mississippi—again, the wanna-be Mississippi. It is only 130 miles to the Gulf of Mexico from this point via the Atchafalaya in contrast to 315 miles via the Mississippi.

Water always seeks its shortest unobstructed route to the sea; the Old River Control Structure serves as the obstruction that prevents nature's course from happening. Many people believe that if this structure broke, the river would abandon New Orleans. Not so. In the first place, it would take many years for the change of course to take place. During that time, engineers could maintain a dredged channel past Baton Rouge and New Orleans. In addition, the structure could be rebuilt whenever the water did become low. At present, the Corps actually has two control structures—the second because they almost lost the original one during the high-water years of 1973 and 1974. They ensure that, for the time being, the Mississippi will stay in its channel.

Across from the entrance to the Atchafalaya is Fort Adams, Mississippi, a town lost in time. Z. Dave Deloach has a camp on Lake Mary and knows the area quite well. He took me to Bill and Murtis Martin's store. A real general store. In addition to fishing, Mr. Martin buys and sells fish, pecans, and crawfish; he also sells gas and rents hunting camps and about anything else people request. Fort Adams was under water in the spring of 1997. This is another place that will flood frequently in the future.

Near the river where I parked the *Huck* were six camps with a great view of the river. Dan Allen, a retired railroad man from McComb, Mississippi, came down to see my boat. From their camp, situated where Clark Creek enters the river, he and his wife Bobbie catch catfish and watch the tugs go by. It's a nice day's hike to see the eleven different waterfalls on this creek, a couple over forty feet high. As we walked up the steep bank to his camp for coffee, Dan pointed to a cocklebur plant and told me, "You know, even the latest, smallest plant that gets hit by a frost will still put out at least one bur." I know how determined and prolific those plants are, for I have been covered in burs from head to toe.

My excitement mounts as I press onward next day toward Baton Rouge. En route I pass the Old River Locks, which let boats take a shortcut to Morgan City and Houston via the Atchafalaya River. On my left in Angola I see the Louisiana State Penitentiary, where a prison rodeo is held each Sunday in October. The devil-may-care prison cowboys put on quite a show: they are fearless of the bulls. Above Angola roll the Tunica Hills I know best. Steep hills, quite like the Appalachian Mountains, are covered with oak, beech, and magnolia trees. The Louisiana Nature Conservancy has a trail where you can explore this habitat.

Part of the trail follows Como Creek, which snakes its way through steep ravines on its way past Como Plantation and into the Mississippi River. At the mouth of the creek I camped, not on the raft, but fifty feet up a steep bank where I had a beautiful view. Kenwood Kennon, past owner and current caretaker of the plantation, has supplied the campsite with a firepit and rotating grill, and he came by to give me a tour and barbecue some chicken. His gift for hospitality is broadly evident to guests of his Shade Tree Bed & Breakfast, which has three unique suites. If there was an Academy Awards for bed & breakfasts, his would certainly win an Oscar for most fabulous accoutrements. When Kenwood left, I noticed that both upstream and downstream, the river was free of factories and residences—the last time on my southward journey that the panorama would show no signs of civilization.

Cat Island and the swampland at the foot of Tunica Hills have come to be known as the land of the giant baldcypress trees. Here a few years back I photographed the national champion baldcypress, whose circumference is more than fifty-three feet. It would take about nine NBA centers to stretch their arms around this tree and enclose it. And it's not the only big baldcypress here. Most have two trunks or some

The author's homecoming parade into Baton Rouge.

other deformity that kept them from being cut with all the other virgin cypress back in the early part of this century.

After fifty-five days in the *Huck,* I pass in rapid succession Port Hudson State Park, Southern University, and the industrial plants of North Baton Rouge. At Earl K. Long Bridge a tugboat leads me to the Baton Rouge river front, where we stop at the USS *Kidd* for a party on the levee. Four hundred school kids who have been following my journey on the Internet cheer me in. I not only got a party but a night in my hometown. In the thirty years since I first came to Baton Rouge, the river front has become quite attractive—both sides of it, seen from boat or plane. I have photographed the river much here over the years, catching it at sunset, at moonrise, and even with floating ice.

What Baton Rouge lacks is a marina for small boats, but I guess it's a little too dangerous for much pleasure boating above here and below even more so. An experienced boater with a safe craft who travels the Mississippi below Baton Rouge must exercise great care as the commercial traffic picks up. Industry and boating concerns literally line both banks of the river. Ocean-going tankers, powerful harbor tugs, and oil service crew boats add to the busy push boat traffic.

Sometimes the willow-covered batture or a sandbar hides some of the industry. I was distracted from it this way myself while going around the bend a few miles above the Sunshine Bridge. I saw horses. Not just a couple, but fifty horses and riders on a big sandbar jutting out into the river. The group was right by the river's edge, saddled up and gazing at the water, when we came into view. These men, women, young adults, and children come from Darrow, Louisiana, at least once a month to ride. Their presence created a unique Mississippi River sight.

Riders from Darrow, Louisiana, horse around on a sandbar.

The Bear, a Grand Canyon river guide, had joined me in Baton Rouge to help for a few days. We motored up to the sandbar and the riders seemed just as startled by us as we were by them. Soon after introductions, I hopped up on a horse named Yo-yo to ride down the beach, seeking assurance beforehand that Yo-yo wouldn't buck me. (Since childhood I have been bucked off a horse three times.) Half the horsemen followed and I survived the ride, as did the digital and regular Nikon-cameras around my neck.

The Bear and I headed toward Hymel's Seafood Restaurant afterward. I have been going to this place for raw oysters and boiled crabs since my college days. (I couldn't get the Bear to try an oyster.) We passed under the Sunshine Bridge to get to Hymel's. This bridge was funded during the governorship of Jimmy Davis, the so-called "singing governor" who penned "You Are My Sunshine." When the bridge was first built, locals say it connected sugarcane field to sugarcane field. Nowadays there is paved road on both sides and lots of traffic.

Yet plantation houses still punctuate the Mississippi's shores all the way to New Orleans: Tezcuco,

Laura Plantation, Vacherie, Louisiana.

Houmas House, Oak Alley, San Francisco, Laura, and others. I admired the stately white mansion of Nottoway across the river from the sandbar where I camped, the last island until the Delta. The original owners moved into Nottoway in 1859 after about ten years' work. It probably took them another year to shut its 200 windows and 165 doors: the mansion boasts having more apertures than any other house in Louisiana. Its grounds are beautiful, shaded by thirty-foot banana trees and century-old live oaks.

To my mind, the most photogenic of the plantations is Oak Alley; and the most interesting is Laura, in Vacherie. Laura differs from the others in that it was a Creole plantation. At Laura there are no stately white columns in Greek Revival architecture. Its parts are painted in various bright colors: living quarters would be one color, the kitchen and the barn in others, and so on. Laura was also a working plantation. If you did not work, you could not live there. Most intriguing of all, three generations of women ran the place. It lost its Creole status when the third woman president, Laura, married a man who was not Creole and moved to St. Louis. Today Norman Marmillion is painstakingly restoring and researching the history of this site.

The river is big as it winds toward New Orleans. I really felt dwarfed by its breadth, by the ships, and by the industry. As camping spots were few, I made friends with tug service company employees to tie up with them along the banks. The big photographic disappointment on this stretch came at Bonne Carre Spillway. I was surprised to see sediment piled high in front of it. Perhaps it had dropped out of the current as the river fell the previous summer.

In the spring, when the New Orleans river gauge reached seventeen feet, the Army Corps of Engineers opened the spillway. A carnival-like atmosphere prevailed, for it had not been opened in many years. To get there I had to park about two miles down the levee. Television trucks, protesters, and gawkers lined the fence as they opened the gates. These consist of timbers—about ten to a gate—that were drawn out one at a time. Tons of water poured out in Grand Canyon rapids style. It would have been a wild ride in a raft.

I was as cold as I have been the whole trip motoring into a gray and rainy New Orleans. Louisiana humidity, along with wind, made it seem a lot colder than up north though the temperature was comparable. After maneuvering carefully about tankers and navy boats, I stopped first at a group of houses reminiscent of the houseboat community at Winona, Minnesota. Then it was downtown.

We parked near the Jackson Street Ferry and took a cab to the River Walk. I wanted to see the wharf area that a big cargo ship hit in December of 1996. Though no one was killed, the accident showed how dangerous life on the river is in the Crescent City. Ten months later repairs were still in progress. We walked then to the Aquarium of the Americas, which I had visited many times before. The shark tank is a must-see, as is the exhibit of rare white alligators with blue eyes.

Everyone who enjoys New Orleans' French Quarter has his own food agenda. Mine was to consume raw oysters at Felix's Oyster Bar, then escort the Bear (along for one last day) to Bayona restaurant for a fine meal. Since entering Louisiana, I was slowly catching up on my spicy food quota. Sated, we walked Bourbon and Royal Streets like millions of tourists before us.

This horse was now heading for the stables. Alone again on the river, I prepared to raft briskly the seventy river miles toward Pilottown and Southwest Pass, the wind notwithstanding. I went through the lock at Empire at dusk with four oyster boats. Originally, the oyster community south of New Orleans was almost totally comprised of people from the Dalmatian coast of the former Yugoslavia; now various cultures are represented among their captains and crews. I saw Croatians, Mexicans, and various Orientals. An ominous weather report had moved these hearty fishermen off the coast. I parked at the marina and put up my tent on deck, a decision I was thankful for at 2:30 A.M. when a rainstorm started. The rain fell until sunset the next day.

The marina opened at 5 A.M., so I got up just before in case any fishermen needed my spot in front of the gas pump. None did, so without moving I had tea and microwaved sausage biscuits with the oys-

termen. At 8 A.M. I could postpone my departure no longer, and the *Huck* and I ventured into the rain and through the lock against a strong southeast wind. I was soaking wet an hour later when I passed Fort Jackson. Twice I have visited the town during its annual Orange Festival. Louisiana navel oranges taste delicious but are getting rarer, as refinery land brings a higher dollar than orange groves.

In another hour I passed Venice: only Mississippi and marsh from there on down. I wanted to stop and check out the boat ramp as an alternate take-out place, in case the seas were too rough to cross to Grand Isle. However, the wind and rain were increasing, so I opted not to pause here in order to get to Pilottown more quickly.

When I crossed the river to pass Delta National Wildlife Refuge, I battled three-foot waves. The blowing rain needled my face, yet if I turned my head, the raindrops on my hood created a sound like an amplified popcorn popper. The raft was taking the waves like a North Sea salvage ship, and I was singing and laughing at the hardship Old Man River was giving me. The refuge tower stood out like an old friend above the overgrown lawn. The refuge once housed two couples who managed the place, but now the houses, office, and dockhouse are gone; the area is managed from afar. It was here in 1979 that I lived on a houseboat and prepared a story on the Delta for *National Geographic.* This refuge is home for deer, ducks, geese, and pelicans.

At Cubits Gap, where four passes go to the Gulf, the seas became even rougher. Fortunately, Pilottown was in sight. I pulled into the harbor and met Mike Miller, a pilot who had just got off an upstream ship and had seen the raft. He helped me tie up and took me in the pilot station. Here twenty pilots live for two weeks, then switch with twenty others and take two weeks off. The pilots explained that the Bar Pilot Association, which brings ships from the sea buoy at Southwest Pass to Pilottown (twenty-two miles upriver), has been in business since the 1870s. Before then, freelance pilots fought for ships and sometimes traded their services for some cargo on board, such as a hog.

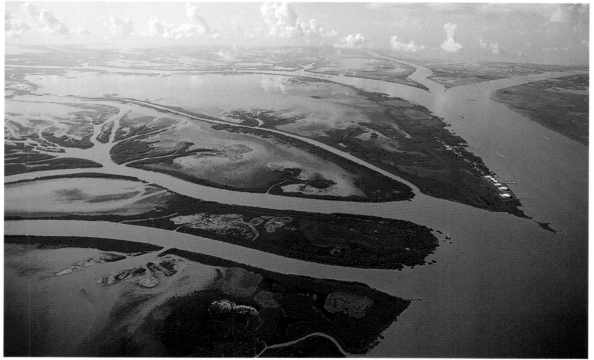

River pilots are needed by ocean-going, deep-draft ships because these local pilots know the shifting sandbars. Even today, with billions of dollars spent on dredging, diking, and channeling, the river changes and changes. After they are guided to Pilottown, ships then continue to New Orleans with the Crescent River Pilot Association and to Baton Rouge with the New Orleans / Baton Rouge Pilot Association. I rode with Bar Pilot Jack Levine while researching the *National Geographic* story and remember the strange sensa-

Head of Passes, Louisiana.

tion experienced by those who travel in the pilot house of a cargo ship. From six stories above the massive hull, you can only slightly feel the motion of twelve knots of speed and hear very dimly the hum of powerful engines way below.

To board a ship, a pilot first gets on top of his pilot boat and pulls beside the moving ship; then he climbs a rope ladder up twenty feet or more. In the old days a big boat dropped a rowboat in. An apprentice pilot would row the pilot to the ship, which had almost stopped, and then the pilot would have to climb a longer rope ladder to get on board. During World War II this practice gave the Japanese submarines at the mouth of the river an easy target to sink some ships. Two were sunk in May of 1942 and thirty-three men died.

Pilottown used to have a school and a population of over three hundred. It still has a Post Office and

about eight full-time residents, not counting the pilots. Early the next morning I visited Edna Smith, the Postmistress, and got the local scoop. She commented that many journalists got the town's story wrong. One time a photographer shot a picture of a boat and claimed it was the mailboat, which it was not. I sent a hand-stamped postcard to my family, and afterward realized that I was dallying, delaying the end. Though I felt ready to finish my journey, I also felt some apprehension. I knew I would miss the river, the sun, and the stars. Perhaps especially the stars, in whose company I dined and rested most nights.

So it was ten o'clock on November 13 before I shoved off into a fog on this the last day of my Mississippi adventure. I crossed the river so that I would be sure to take Southwest Pass—not pull a Huck-and-Jim and miss my destination in the fog. During the noon hour, the rain gave me one more round of face pelting. But fourteen miles later, when the pilot station at Southwest Pass came into view, the skies began to clear. The sun's rays on the choppy water danced like a million shiny dimes. And four brown pelicans led me toward the lighthouse.

At 1:15 I touched the Gulf of Mexico with a war whoop to put Geronimo to shame and leapt for joy on *Huck's* slippery deck. I had gone 1,840 miles on that raft plus 480 by canoe during a total of seventy-nine days. A lone white pelican circled as if to salute. Perhaps he had been following me for many miles. The five-foot swells felt good, and the smell of the salt air filtered by miles of open sea invigorated me. What a day! Bar Pilot Bob Hensley came by and was kind enough to photograph the Gulf, the lighthouse, the raft, and me with my digital camera. Then to commemorate the moment, I took a self-portrait.

Bobbing in the swells, I directed my gaze northwest across the water to my intended destination of Grand Isle, Louisiana. I had picked this fishing village because I did not want to fight the current for thirty miles moving upstream to Venice. But sea fog covered the waves. Thinking it imprudent to go alone into a fog across open water, I headed back to Venice.

As it happened, the tide was with me and the current almost nil. Occasional thunderheads moved among the low-lying clouds and fog. But shafts of sunlight poked out to give the river a steel blue-gray cast. I focused on the rocks, jetties, pilings, and docks lining the river and protruding into the marshland.

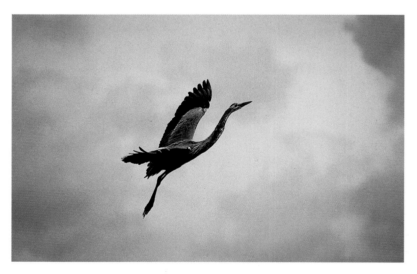

Great blue heron.

Again, humans' influence on the Mississippi struck me forcibly. Only the river's first few hundred miles could be called wilderness. And intelligent planning is needed now more than ever so that the mighty river is not degraded by our wastes and wanton growth. Yet I found peace during my months on the river, and much beauty. I had fun.

A great blue heron flew by. Here at the river's mouth he seemed a small creature. His wing caught a glint from the sun dropping out of a purple cloud and disappearing into the marsh grass. I looked to the east where the heron had come from and saw the rising moon, which the next day would be full. It occurred to me that the constants during my entire trip had been open air, the big sky overhead, and, yes, the great blue heron. Every day of my Mississippi River adventure, one of these birds appeared to me like an enigmatic escort. Perhaps the same one.

the photographs

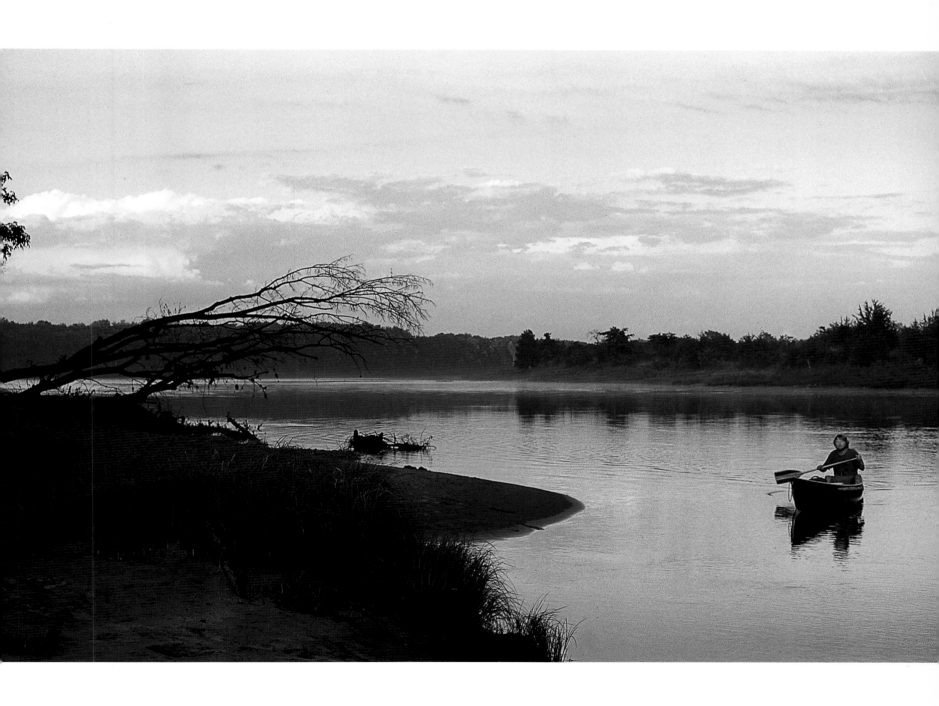

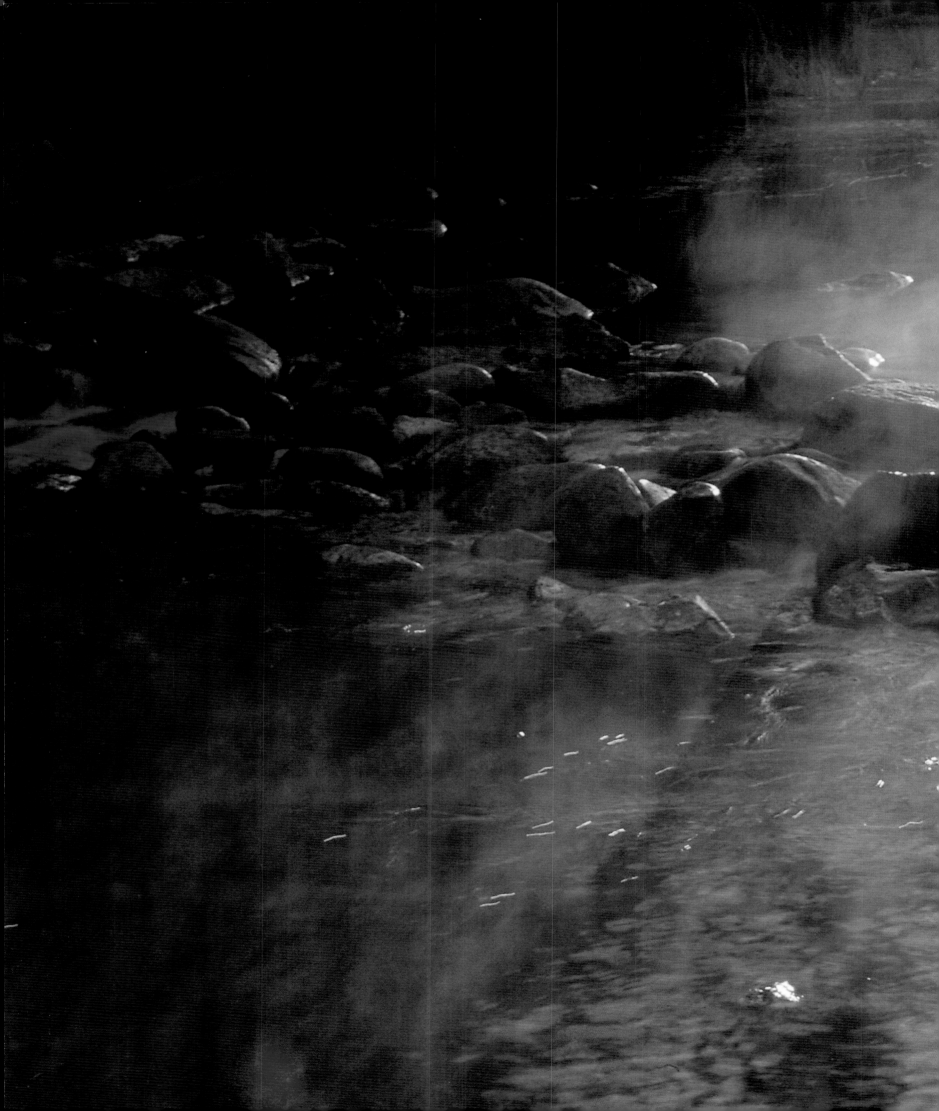

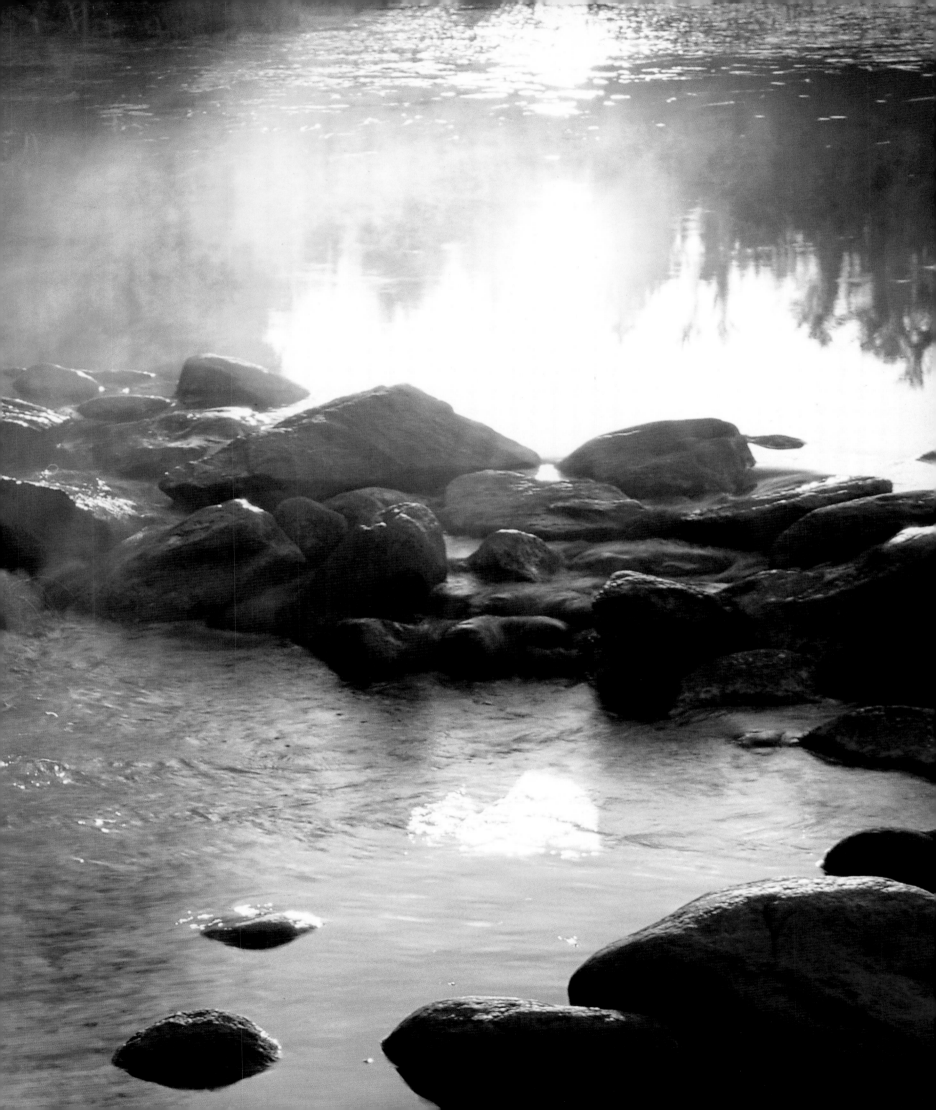

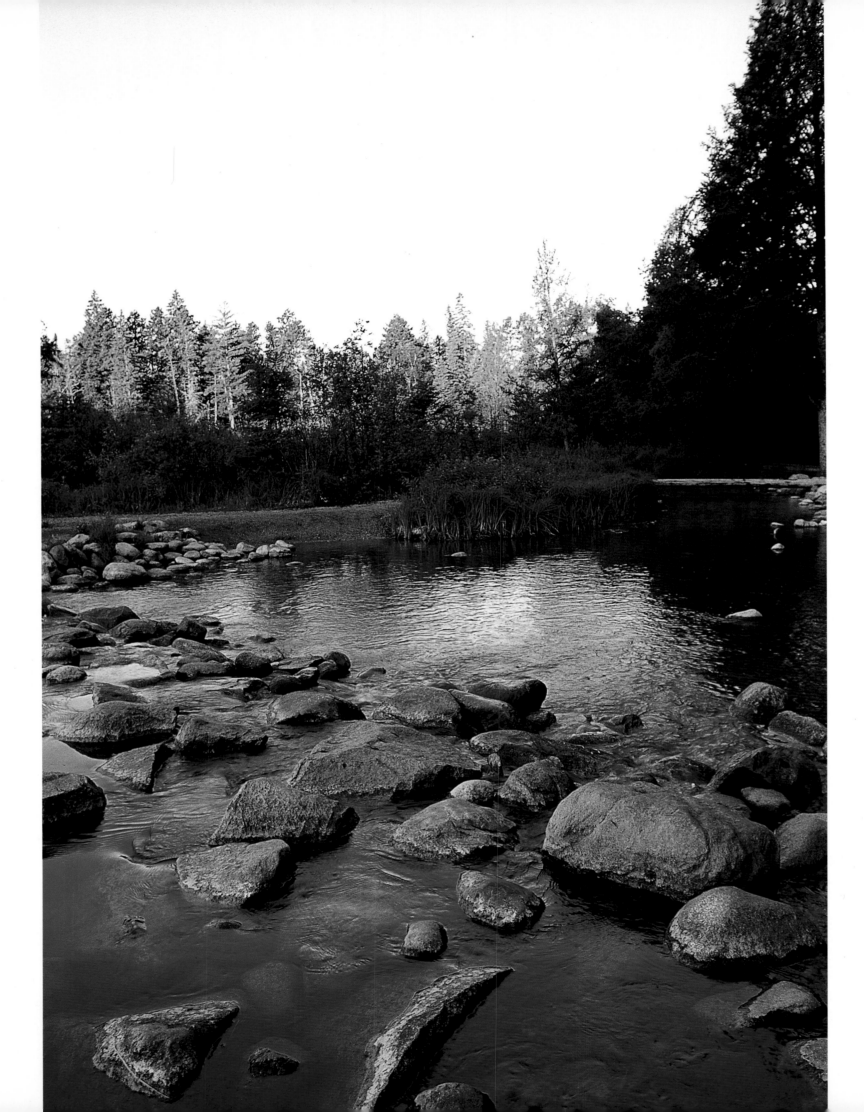

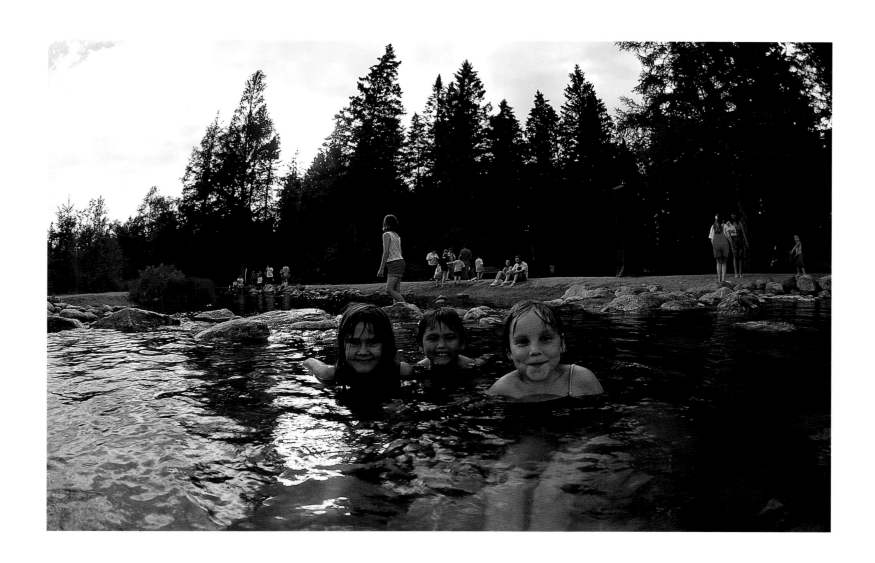

Lake Itasca contributes its waters to the tiny stream that becomes the mighty Mississippi. Peaceful at sunrise, the lake *(previous double page)* and the stream beginnings *(left)* become filled by midday with tourists drawn to frolic near this famous site *(above)*.

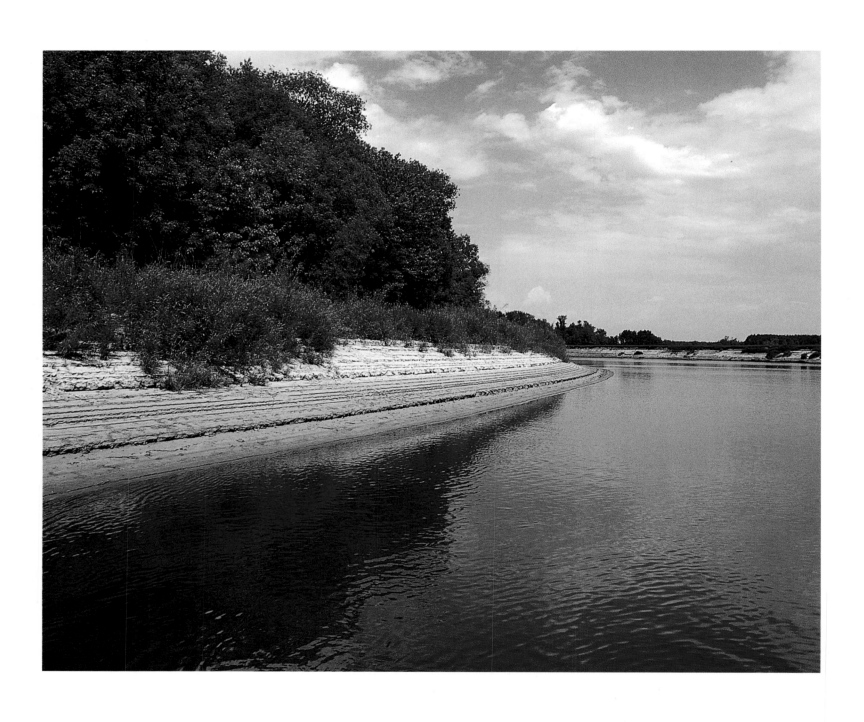

Above Minneapolis, the upper Mississippi is a narrow and tranquil river in most places *(above)*. Layers of sand and willow trees mark its various flood levels *(far left)*. A hungry mosquito, common enemy of river travelers, waits outside the author's tent at sunrise *(left)*. Campers are welcome at many of the parks that abut the river in Minnesota, such as Sterns County Park *(overleaf)*.

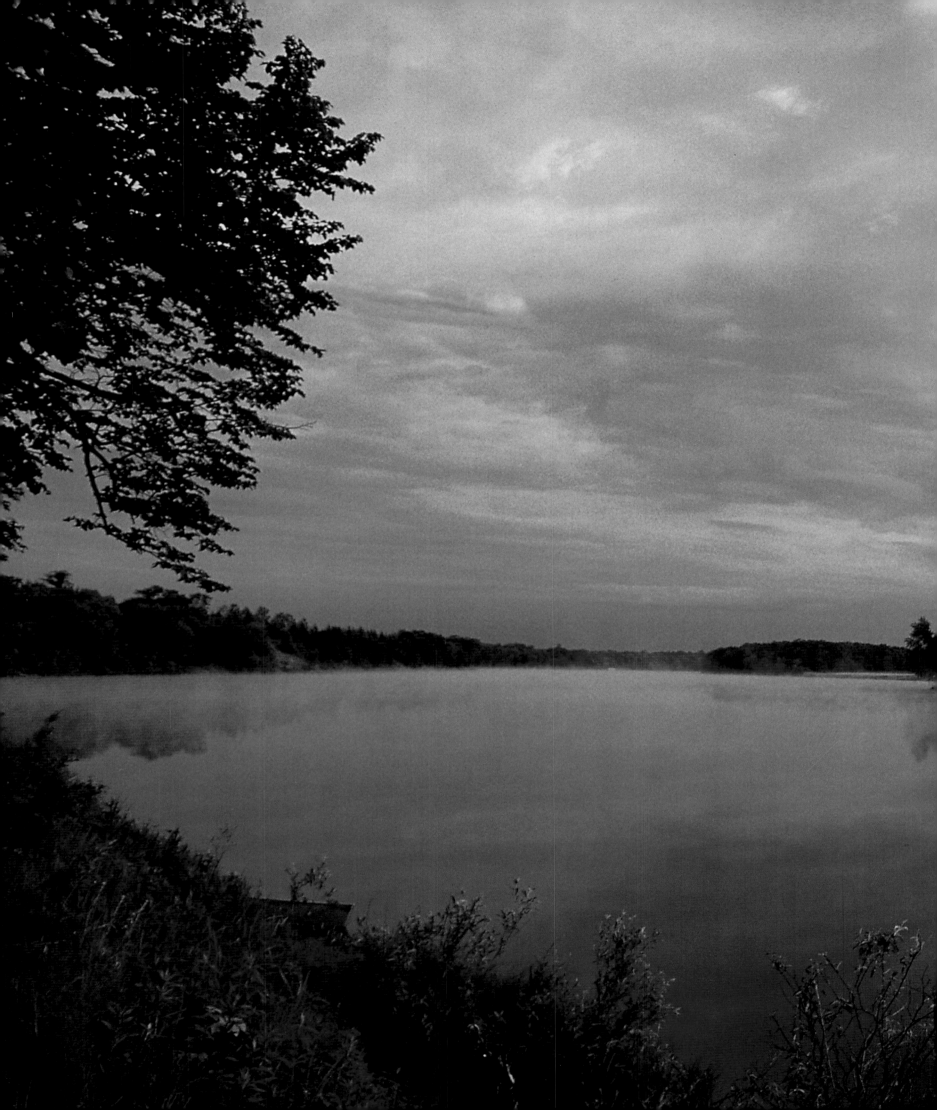

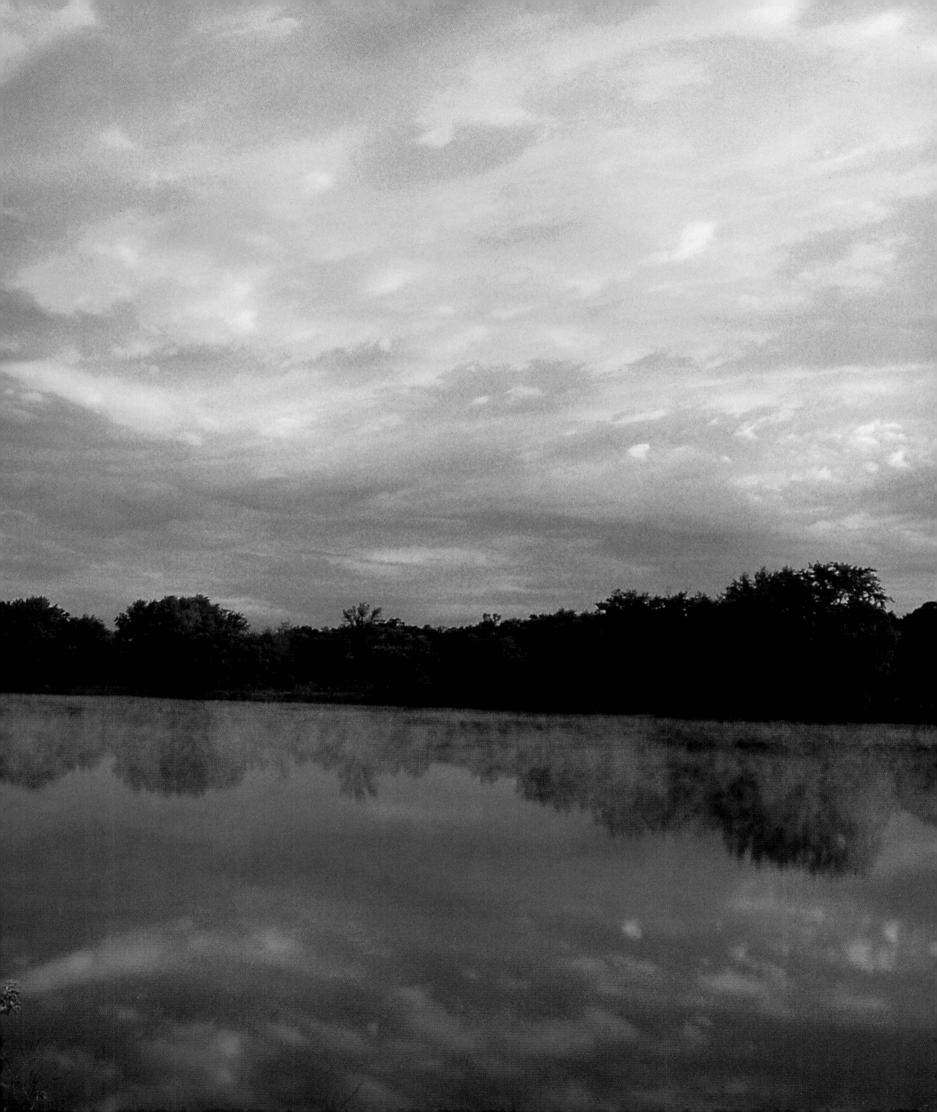

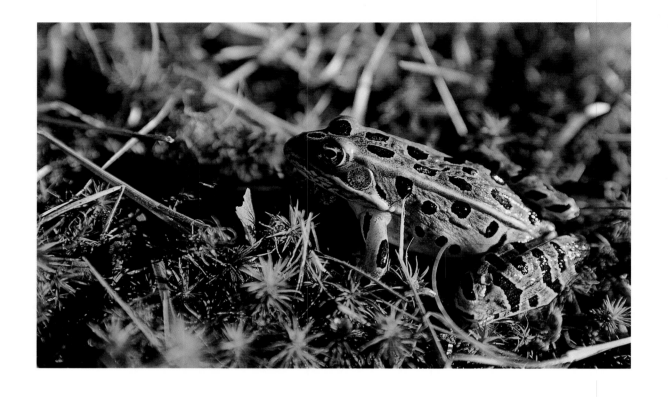

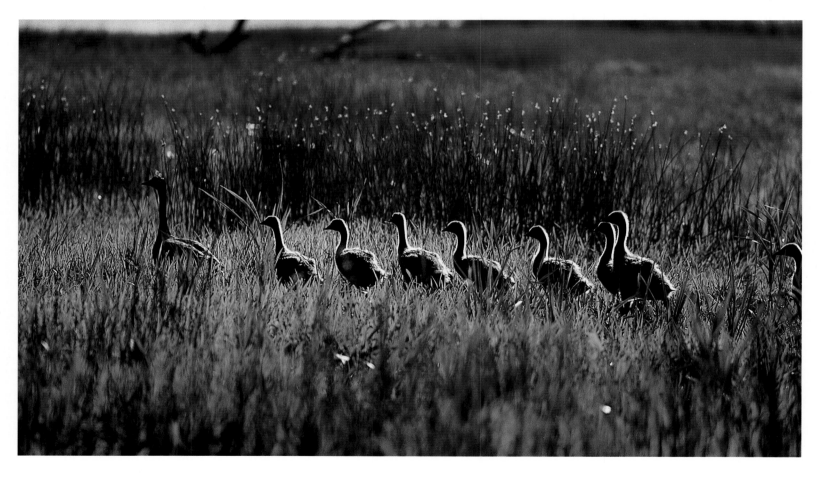

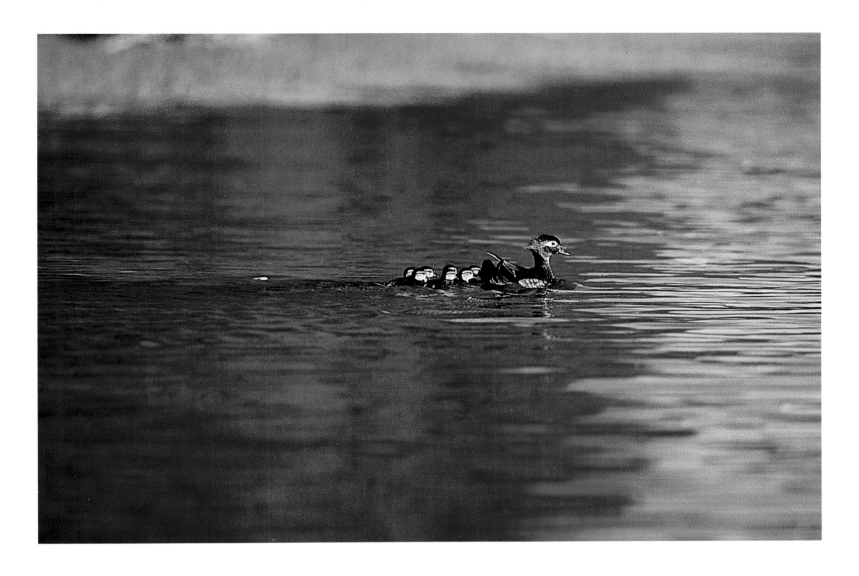

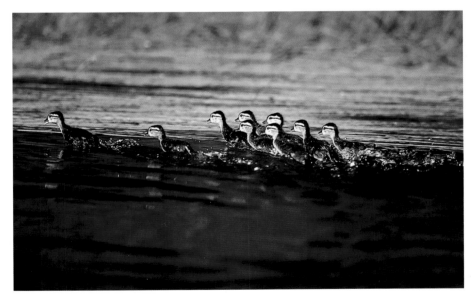

Wildlife is abundant along the first three hundred miles of the upper Mississippi River. A leopard frog is camouflaged in the foliage *(top left)*, a Canada goose leads her goslings in search of insects in the marsh grass *(far left)*, and a wood duck guards her new hatchlings then sends them skedaddling across the river at the approach of the author's canoe *(left and above)*.

A rainbow graces the afternoon of a
rainy day *(above)*. An alert whitetail doe
scrutinizes the author *(right)*, who pad-
dles by to discover her fawn under the
bank *(following page)*.

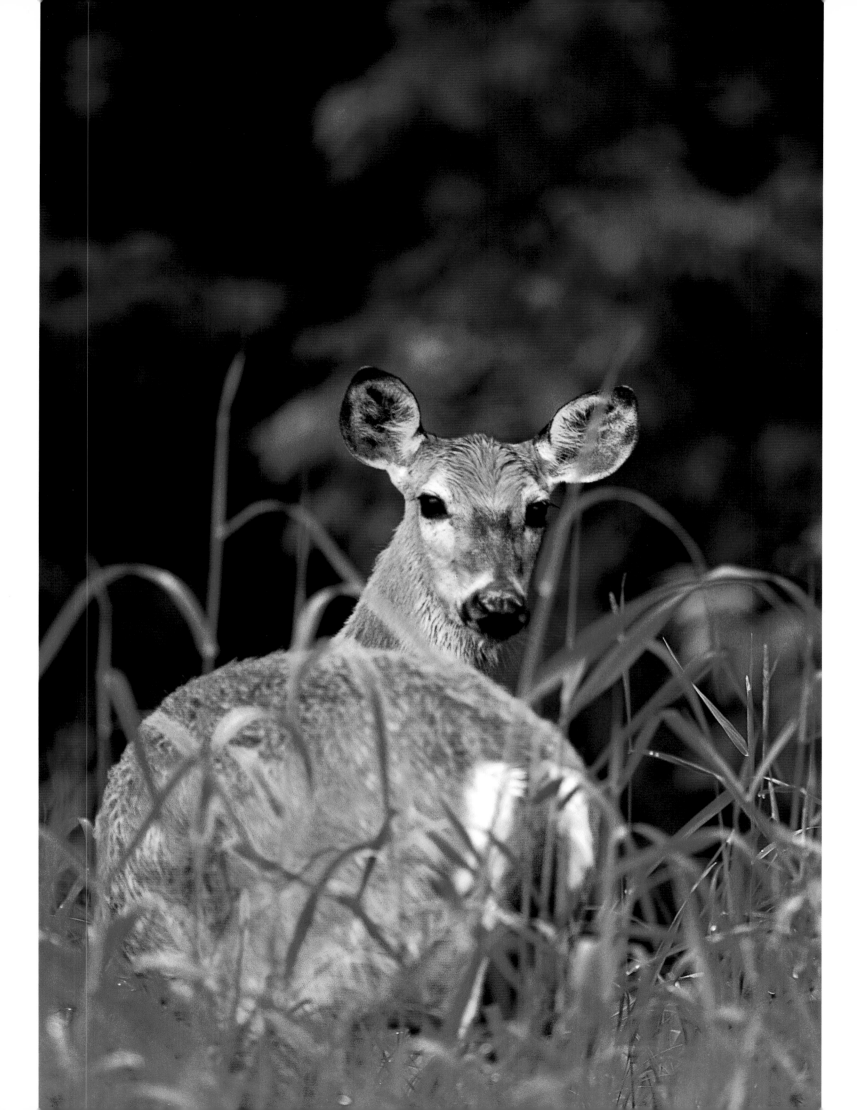

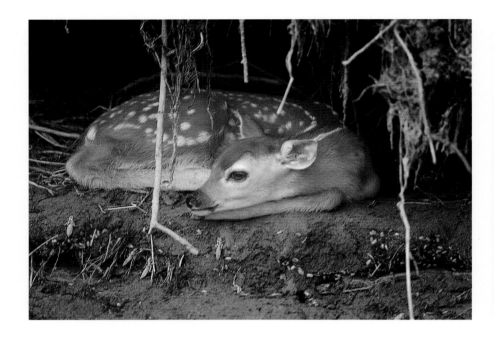

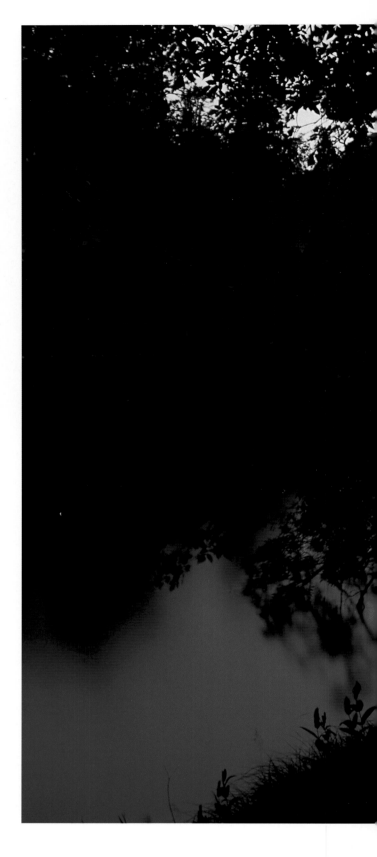

A long exposure blurs a small rapids
near the Baxter campsite *(right)*, one of
the most scenic canoe stops on the
upper Mississippi River.

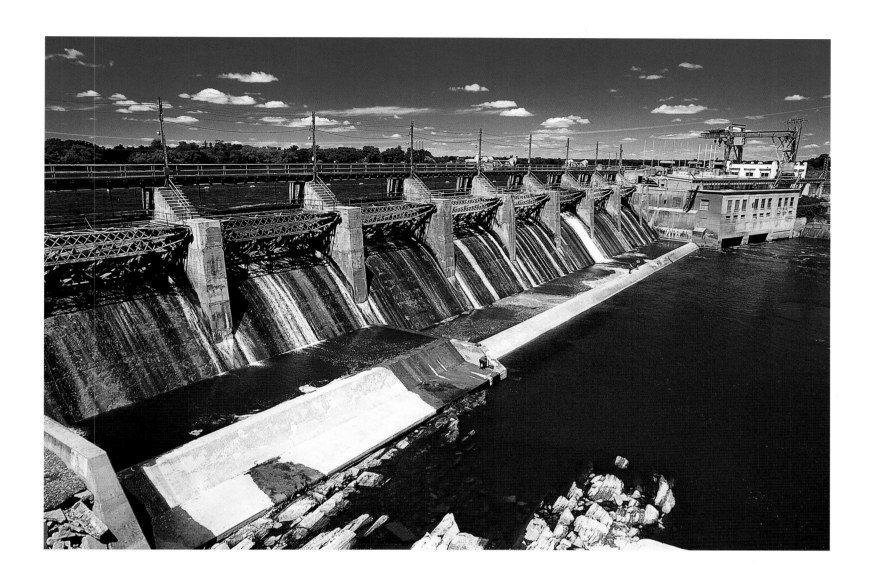

From behind the frozen Minnehaha Falls *(far left)* and in front of the Little Falls Dam *(left)*, the frigidity of Minnesota winters is made dramatically clear. Between Lake Itasca and Minneapolis, seven dams punctuate the upper Mississippi, and canoeists like the author must portage around them in making this trip.

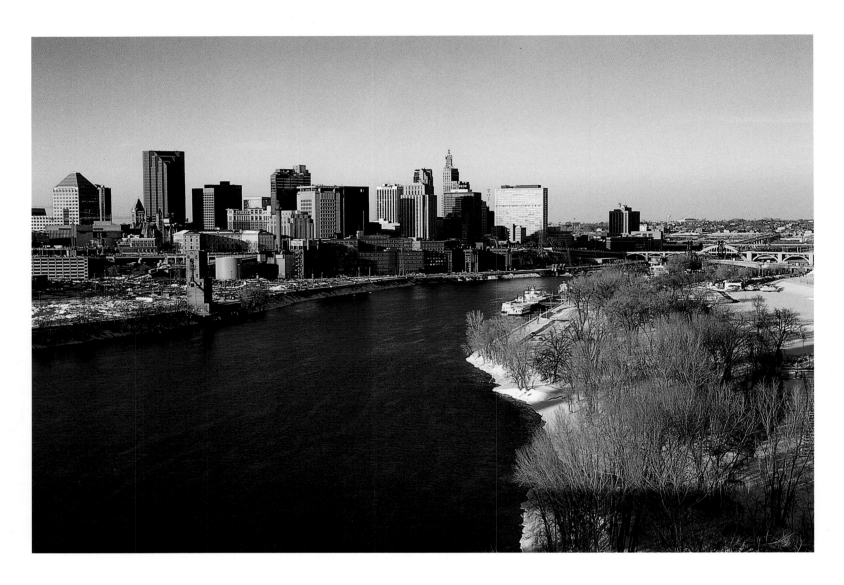

A harbor tug *(right)* moves barges full of almost any product you can imagine to and from riverside industries in St. Paul *(above)* and Minneapolis *(far right)*.

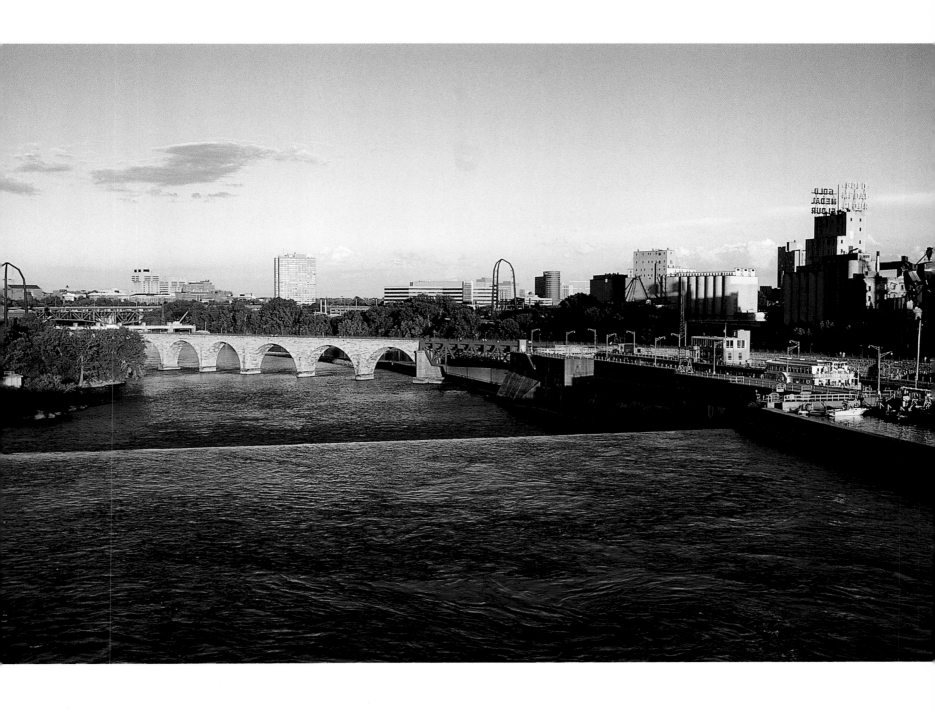

61

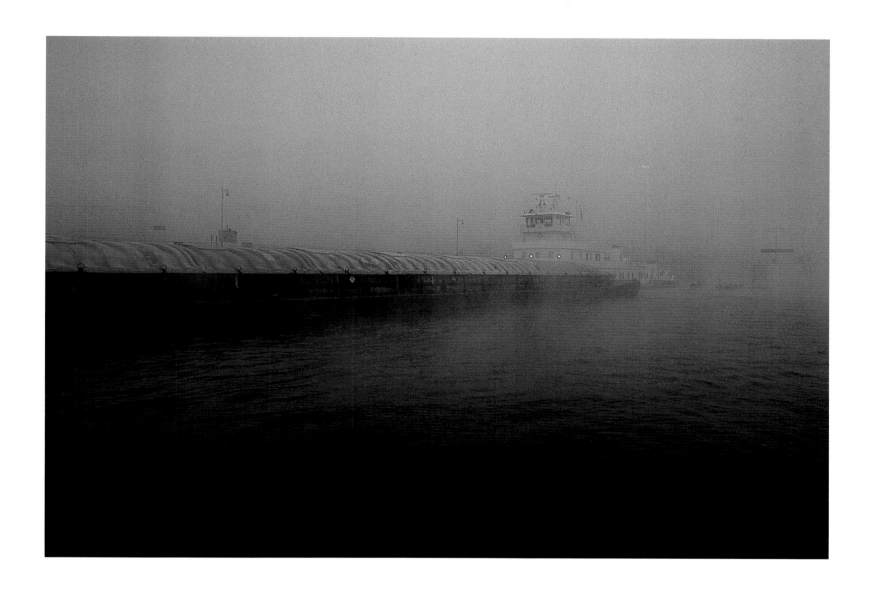

The Mississippi widens above each of the twenty-eight locks and dams into lakes like this one a few miles above Lock 7 *(left)*; there the author passed a push boat and barges that appeared like ghosts out the opaque screen of moisture *(above)*.

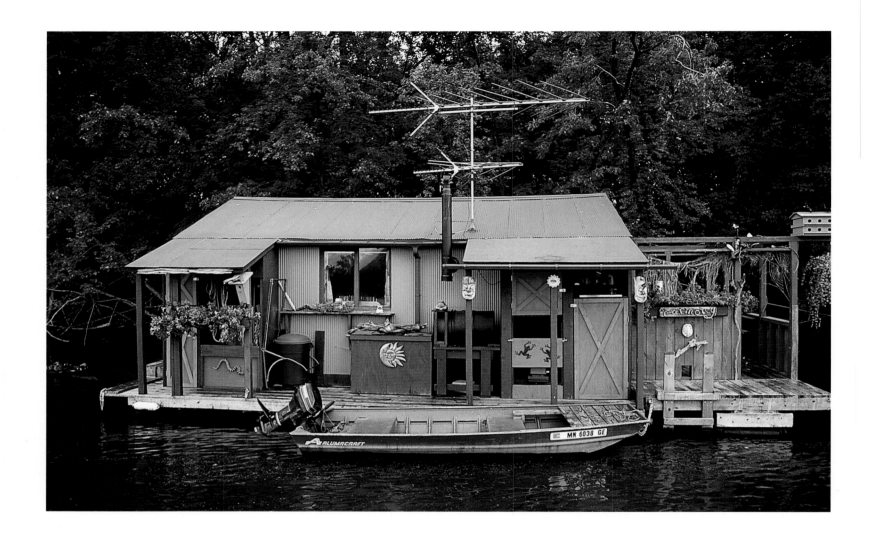

More than a hundred unique and home-
made houseboats like this one *(above)*
anchor to Latsch Island near Winona,
Minnesota. The river appears placid at
day's end on upper Mississippi river mile
1125 *(right)*. A passing thundershower
partially obscures sunset over Lake
Pepin *(overleaf)*, a lake formed naturally
in contrast to those that the river's lock
and dam system created.

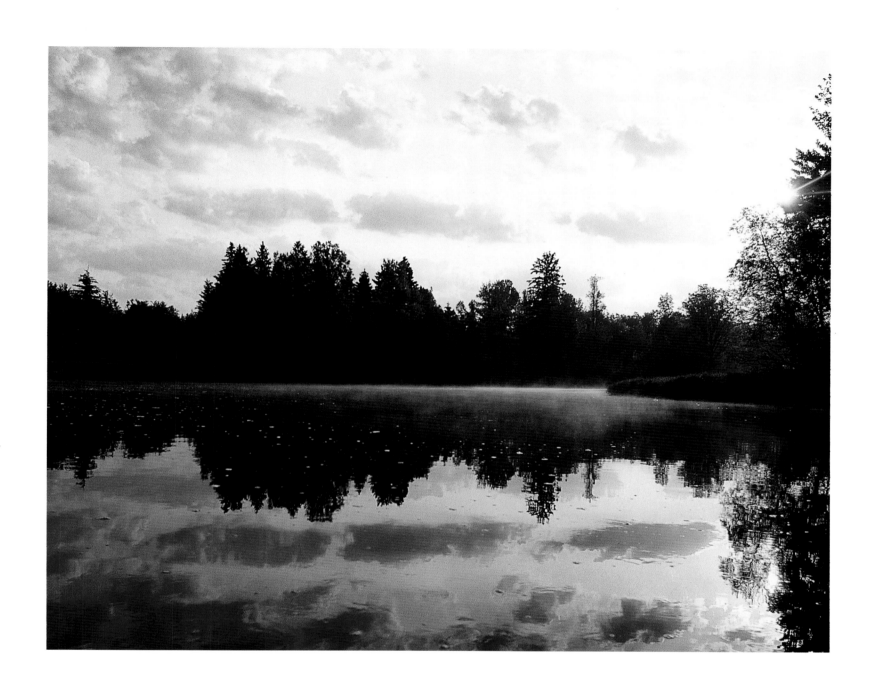

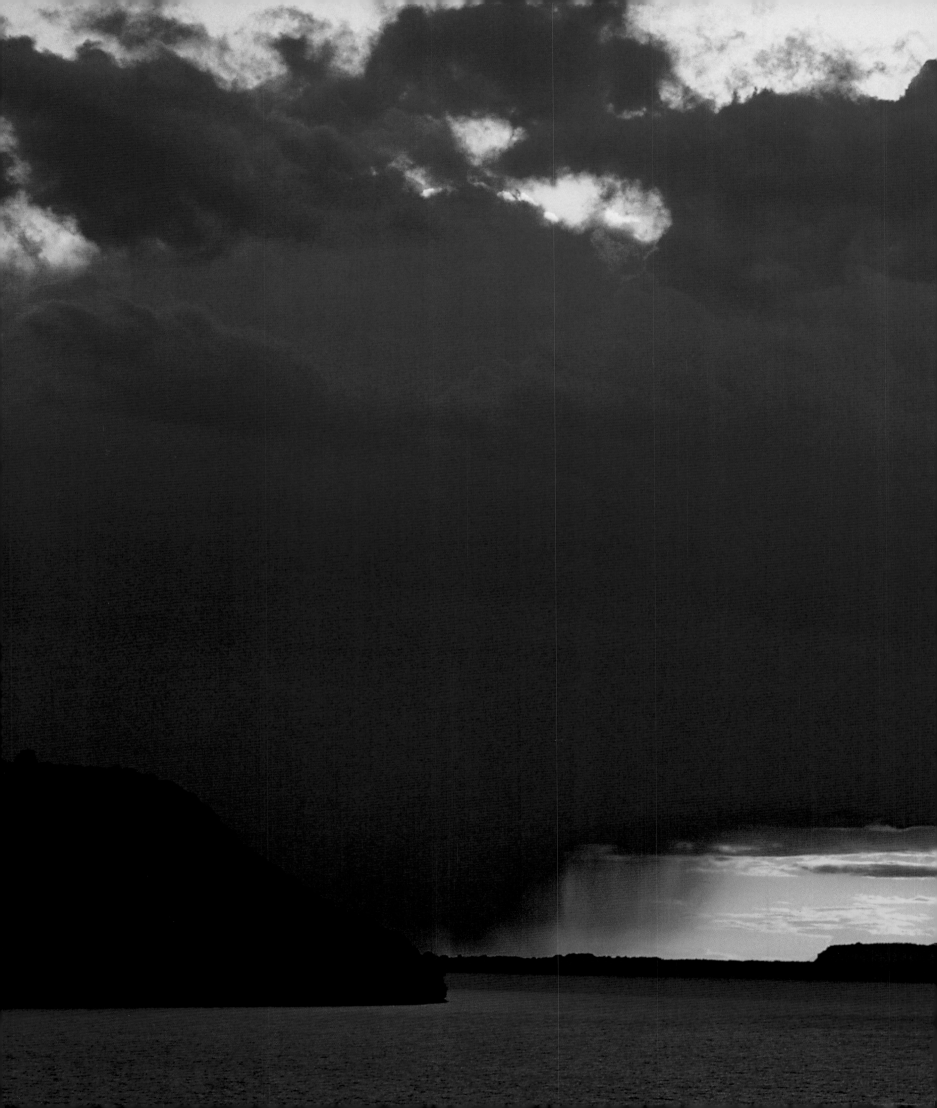

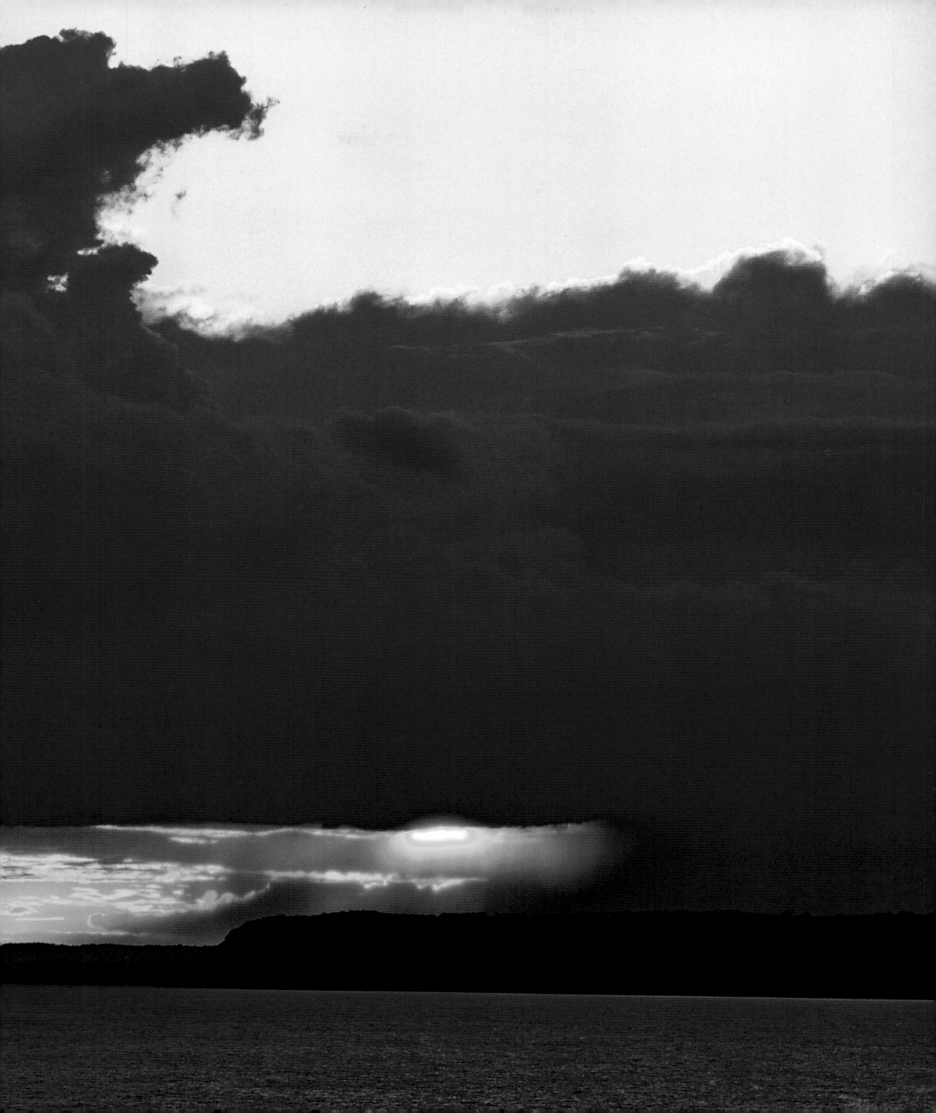

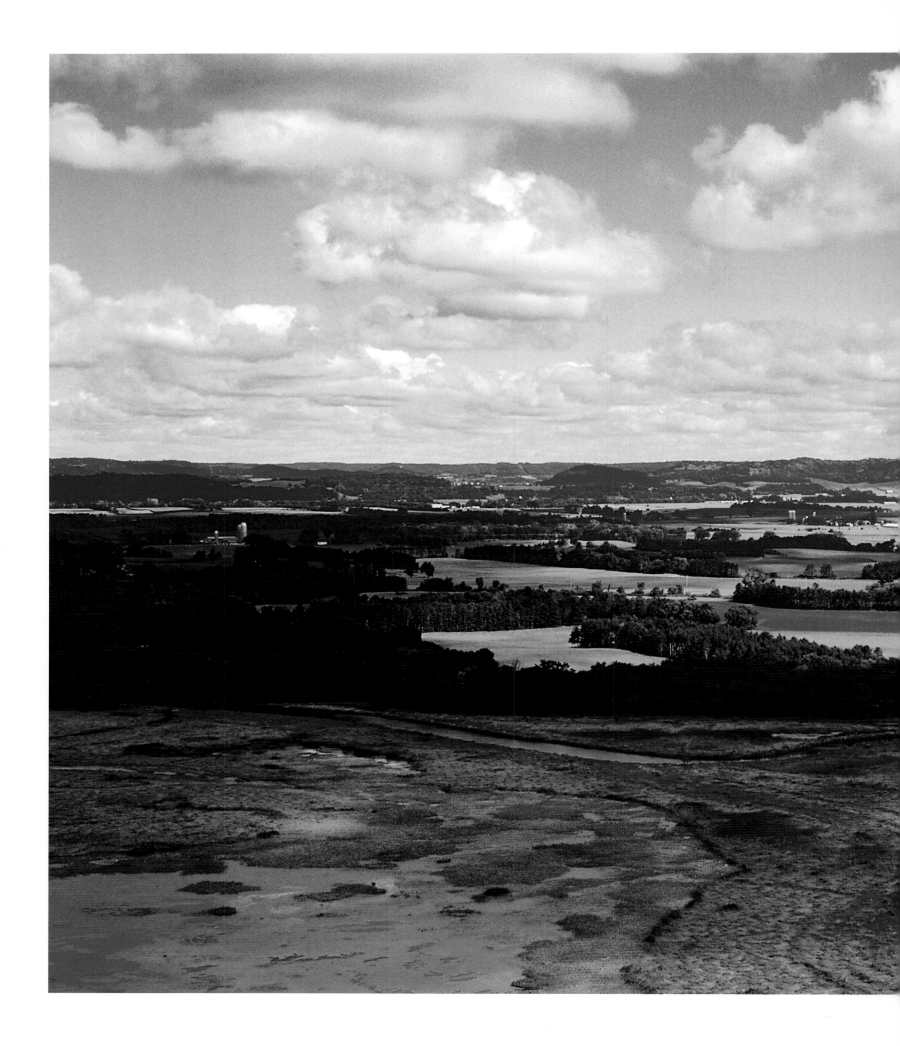

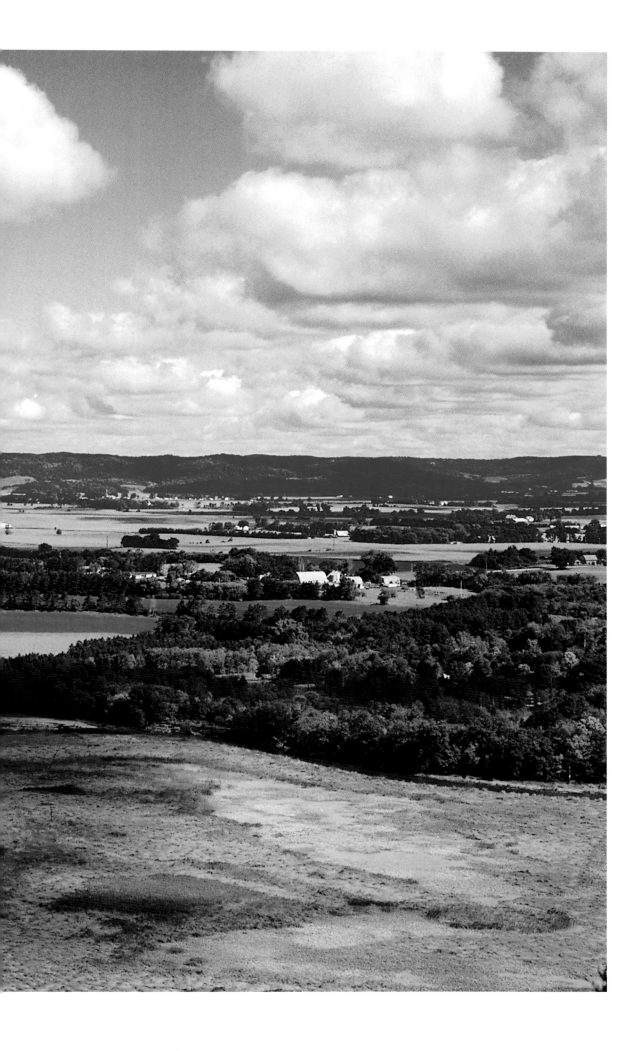

From the top of Trempealeau Mountain unfolds a panoramic view of lush Wisconsin dairy country.

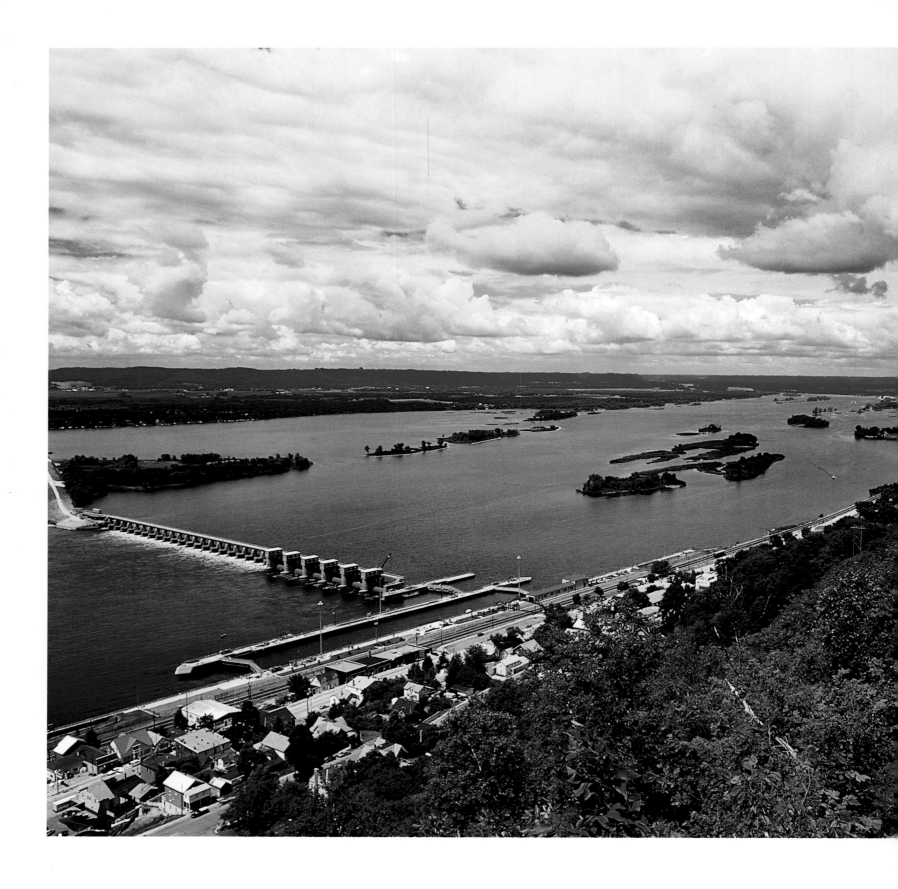

The limestone bluffs along the upper
Mississippi afford dramatic views like
those of Lock and Dam 4 *(left)* and this
railroad track slicing through the middle
of the river *(above)*.

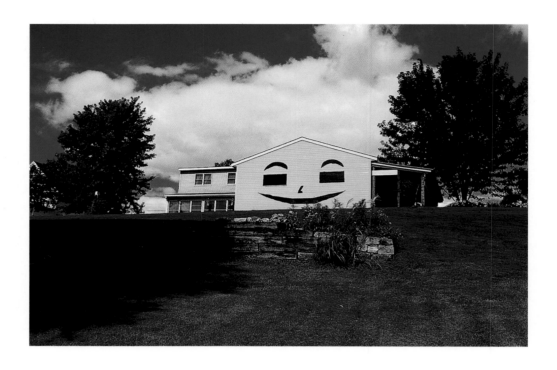

Passing houseboats, push boats, and other watercraft see this happy face in Trempealeau, Wisconsin, when they pass through Lock 6 *(above)*. Highway 35 in Wisconsin is one of many scenic segments of the Great River Road, which extends more than six thousand miles on both sides of the Mississippi.

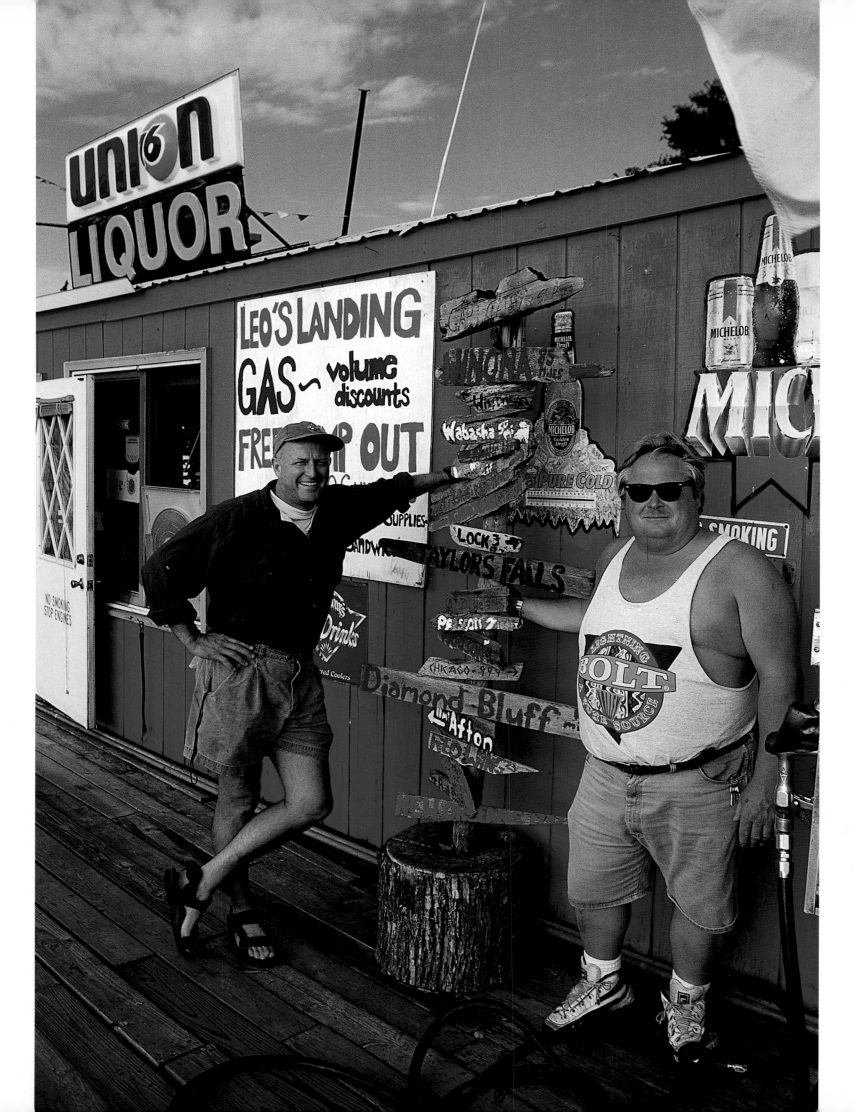

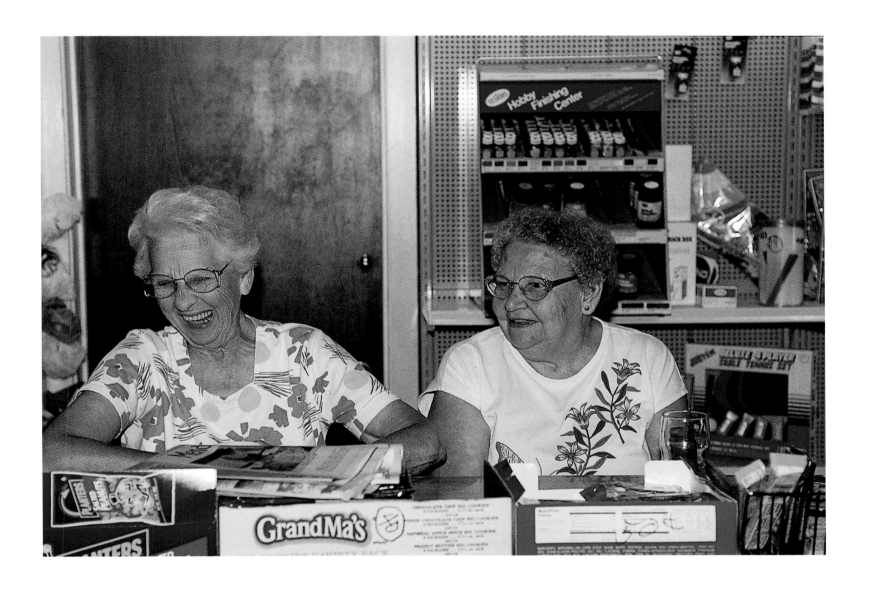

Mississippi travelers will encounter memorable people from all walks of life who make their unique imprints on their river communities. Jovial ladies enjoy a coffee break in Pelo's Drugstore *(above)*, and the caretaker of Leo's Landing poses next to his mileage marker at Prescott, Wisconsin *(left)*. Over four hundred passengers on the *American Queen (overleaf)* can return to the world Mark Twain vividly described in *Life on the Mississippi.*

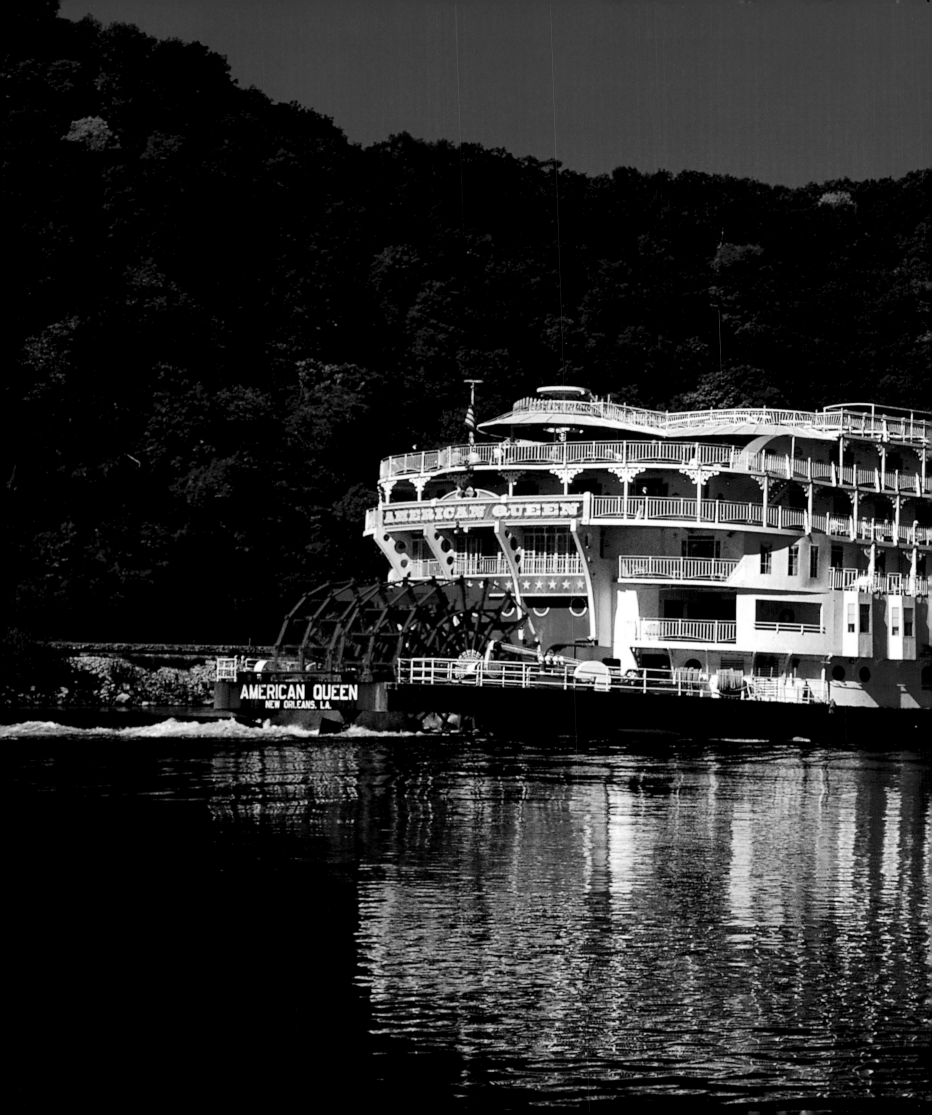

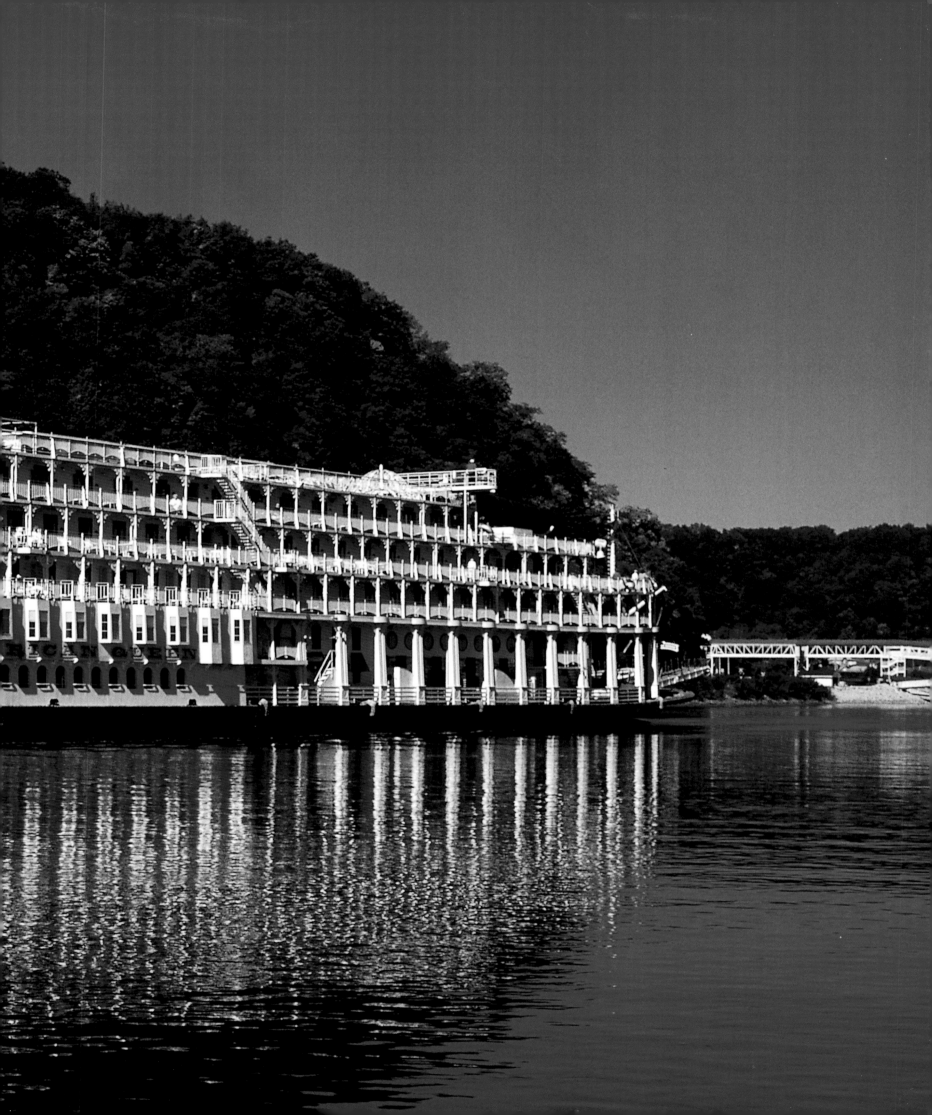

Celebrating Iowa's sesquicentennial in
1997, 110 canoes paddled the 313 Mississippi river miles that border eastern
Iowa *(above)*, passing numerous landmarks, such as the Church of the Immaculate Conception at Wexford, Iowa
(right).

Since 1519, when Spanish explorer Piñeda sailed by its mouth, the Mississippi has submitted to more and more development. Balancing industry, towns, recreation, flora, and fauna in and along the river is an immense challenge critical to both the river's future and the ecological health of our nation.

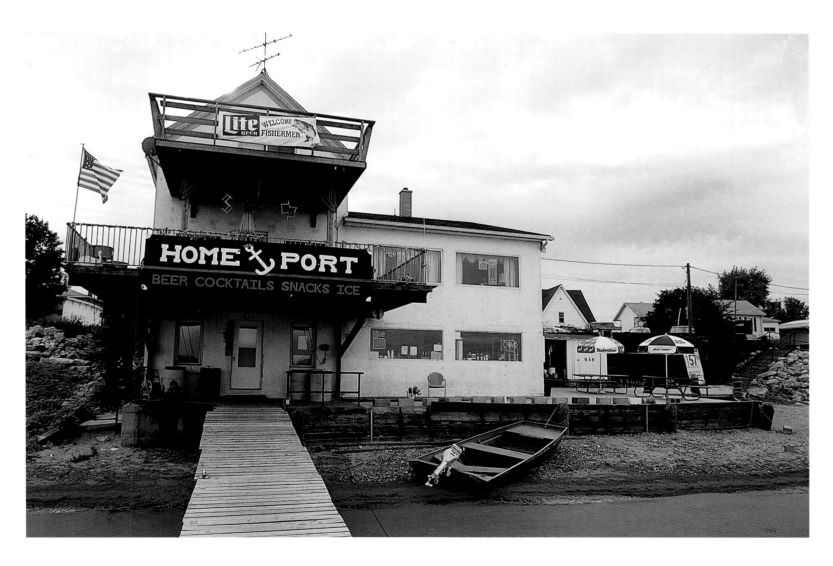

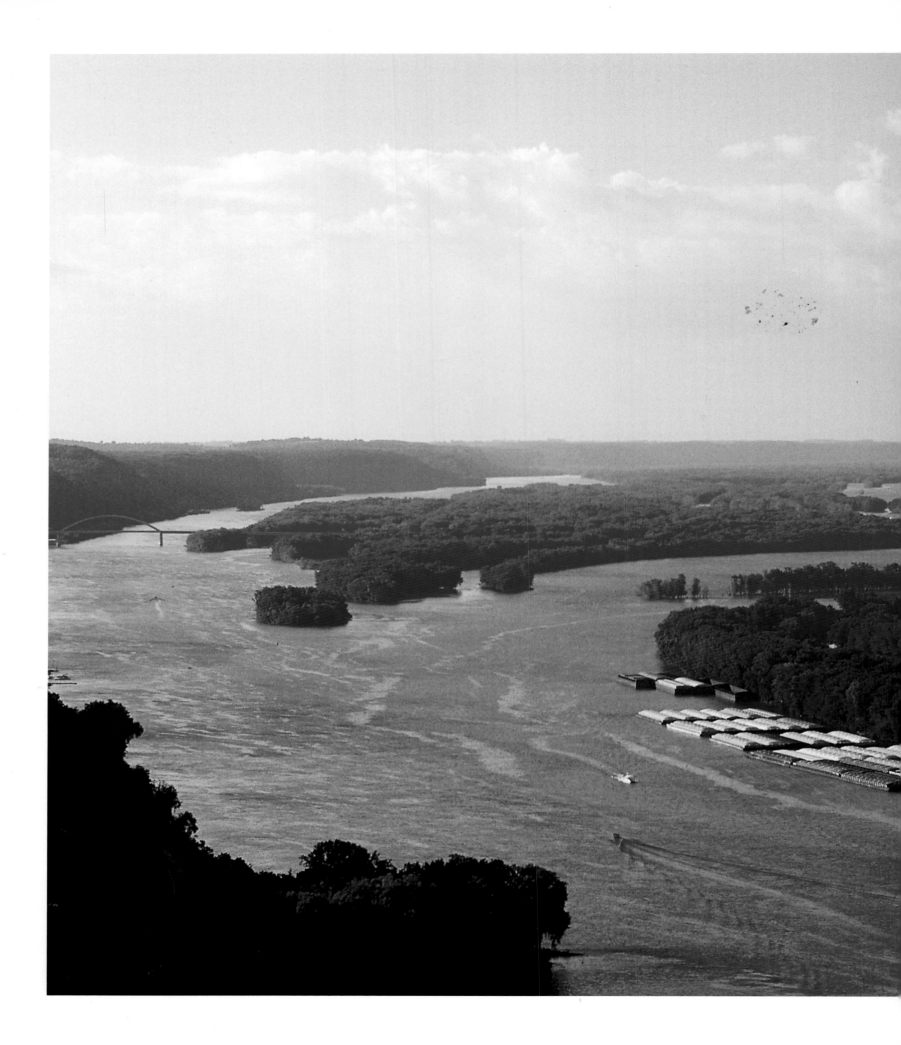

The view from Pike's Peak State Park in Iowa encompasses the multichanneled river and the town of Prairie du Chien, Wisconsin.

A pleasure boat *(above)* speeds through the early autumn light. Even poison ivy contributes to the midwestern fall palette *(right)*. This low-water season exposes the eroding roots of a pine tree *(far right)*.

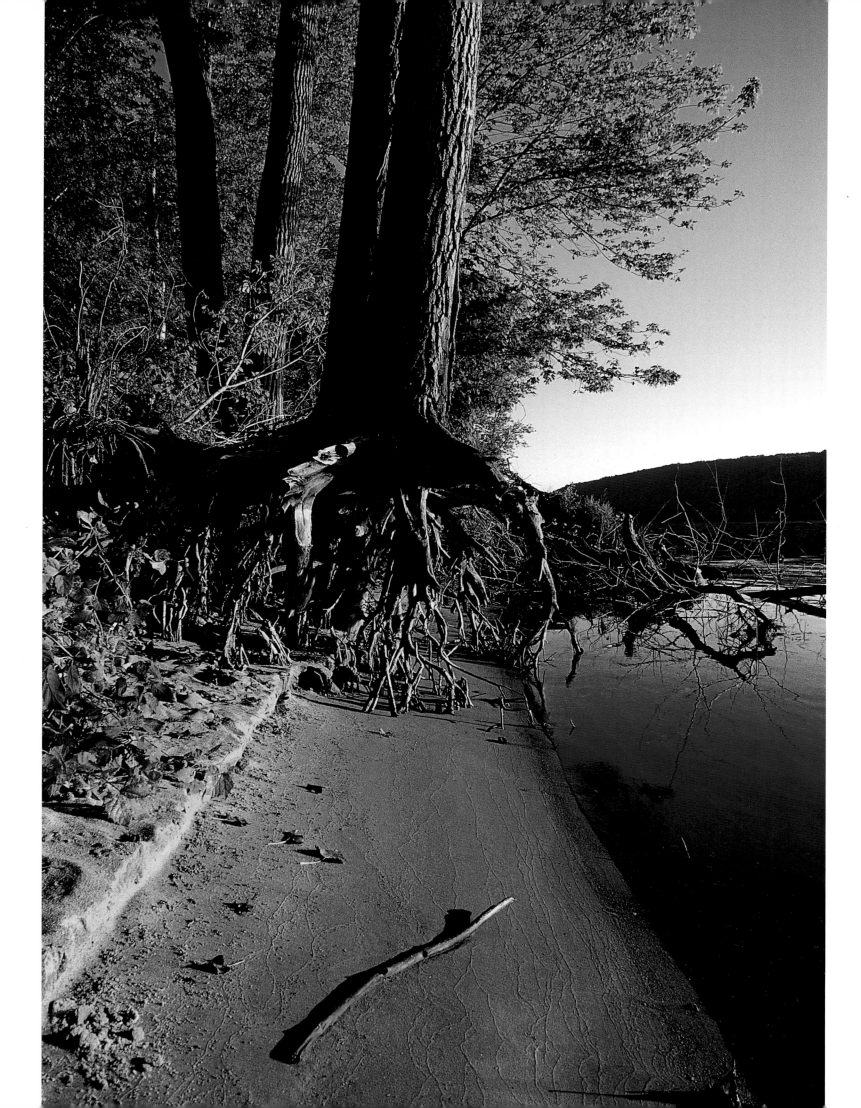

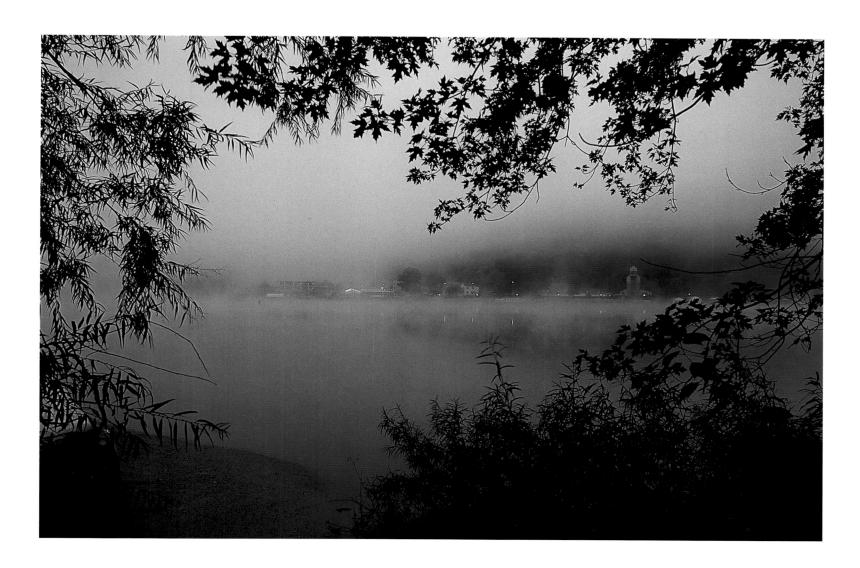

Fog on this autumn morning near Mc-Gregor, Iowa, lends an ethereal mood to sunrise *(previous double page)*. Lock 19 in Keokuk, Iowa *(far left)*, has a drop of thirty-eight feet, the basis for its ability to generate electricity. McGregor, Iowa, a quaint riverside town nestled in the bluffs, appears in the fog *(above)*. Modern-day petroglyphs enliven a stone garden at East Moline, Illinois *(left)*.

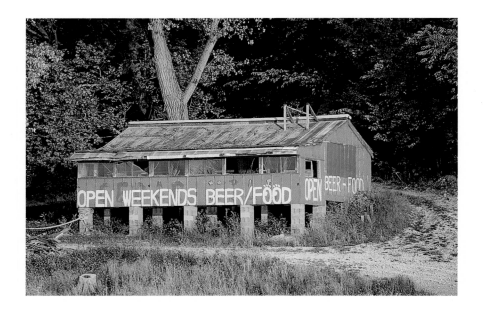

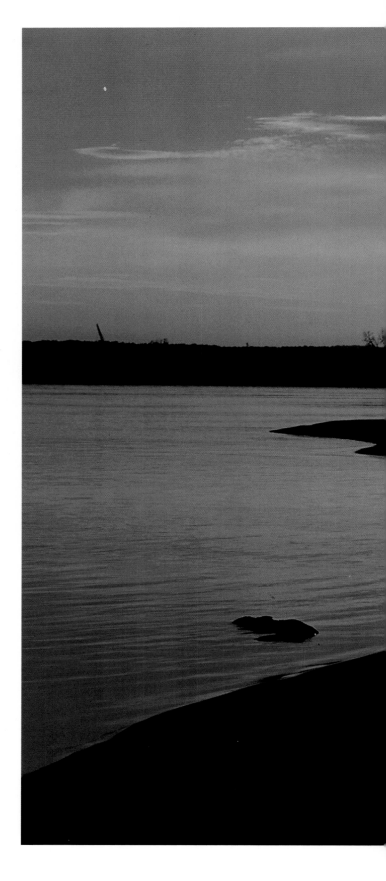

The Flood of 1993 damaged this riverside
restaurant *(above)*. A beautiful sunset over
Moro Island, Illinois, gave the author and
his wife no warning that push boat wakes
would pour over the side of their raft late
that evening *(right)*.

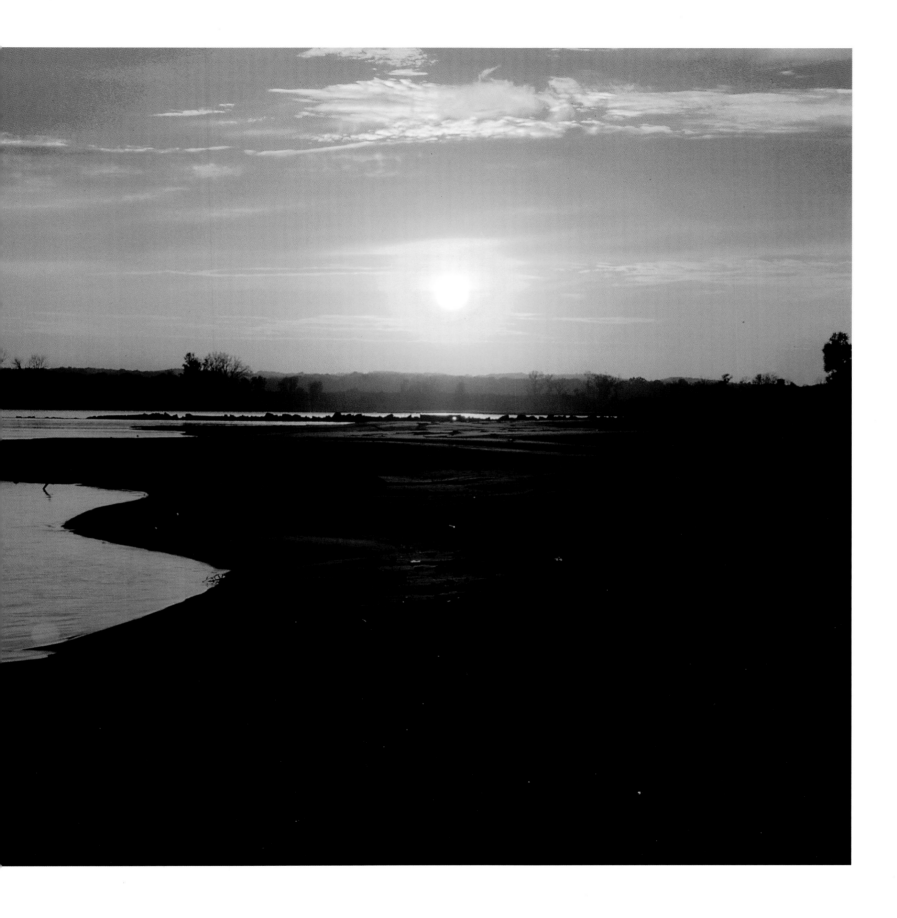

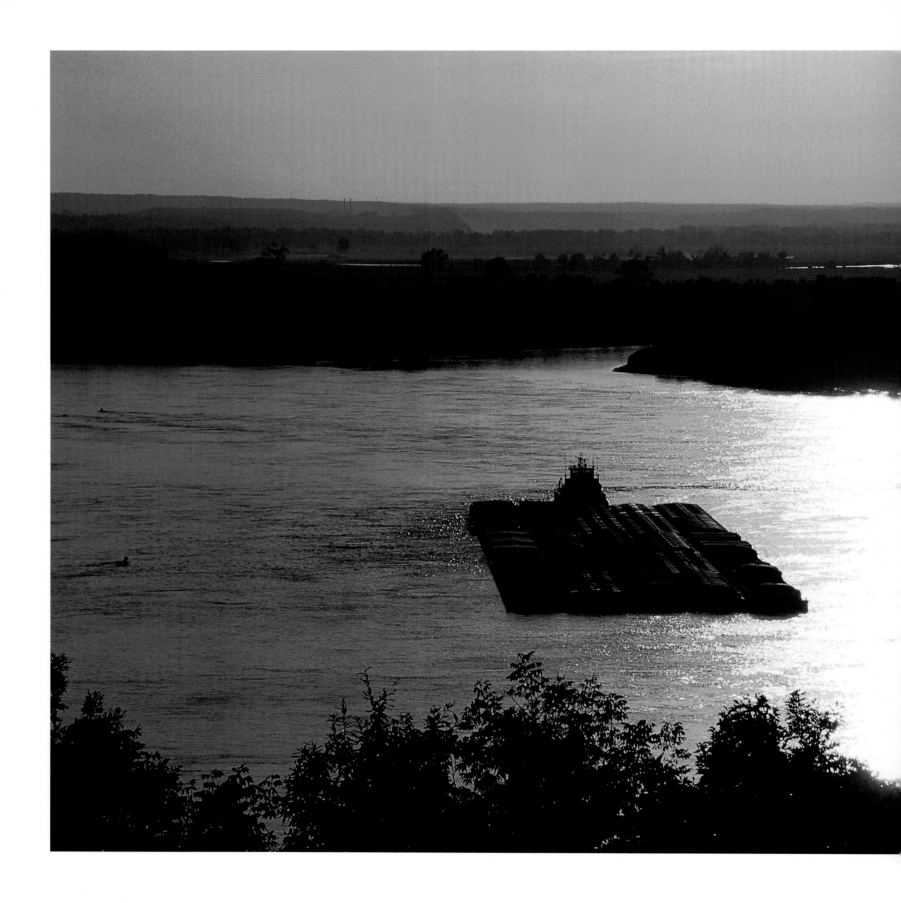

Push boats with up to 10,500 horsepower move massive quantities of products on the river *(left)*. A crescent-shaped sandbar is temporarily inundated by a push boat's wake.

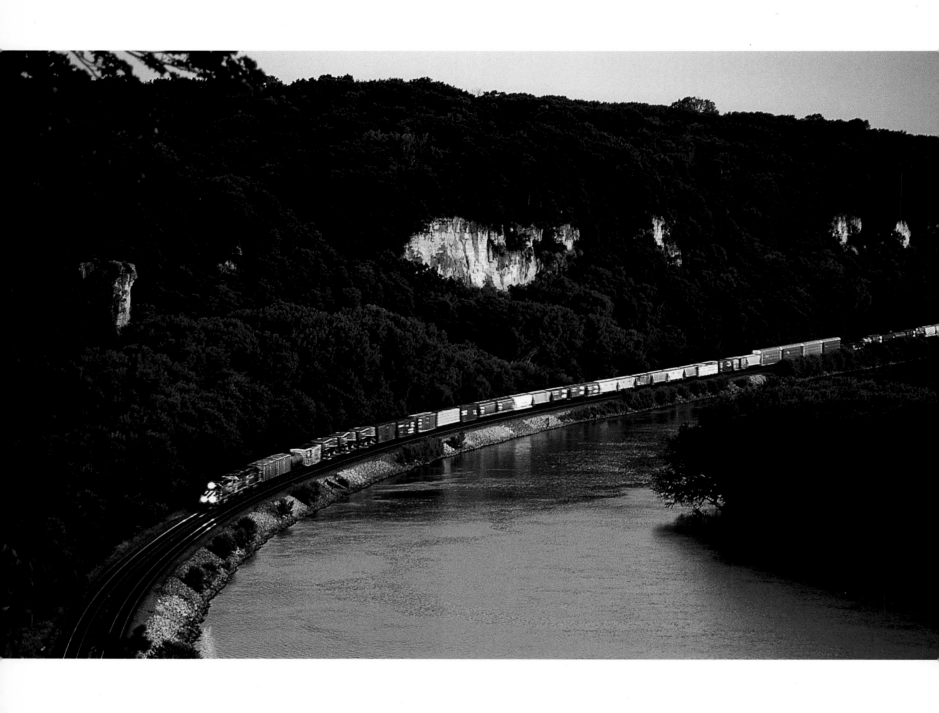

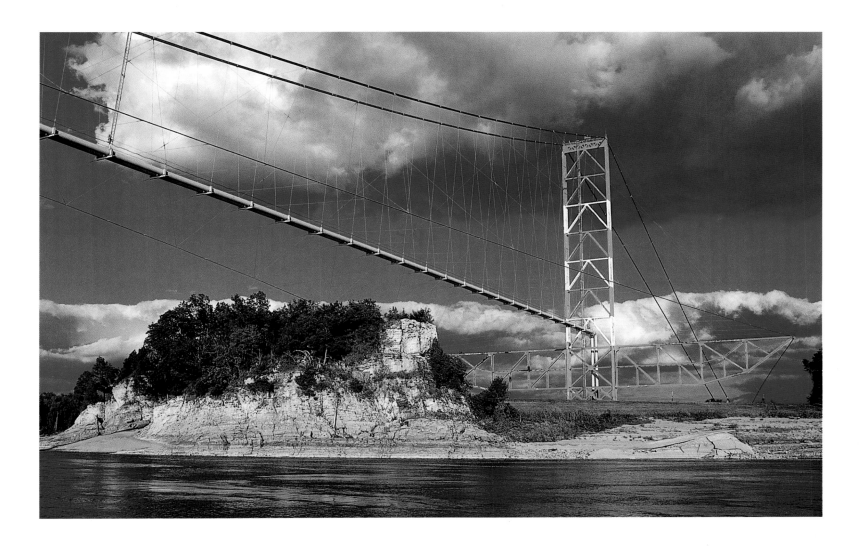

Some Mississippi River commerce is conducted along aerial petroleum pipelines *(above)* and on trains flanking both sides of the river in some places *(far left)*. Fall colors decorate a bluff in Clarksville, Missouri *(left)*.

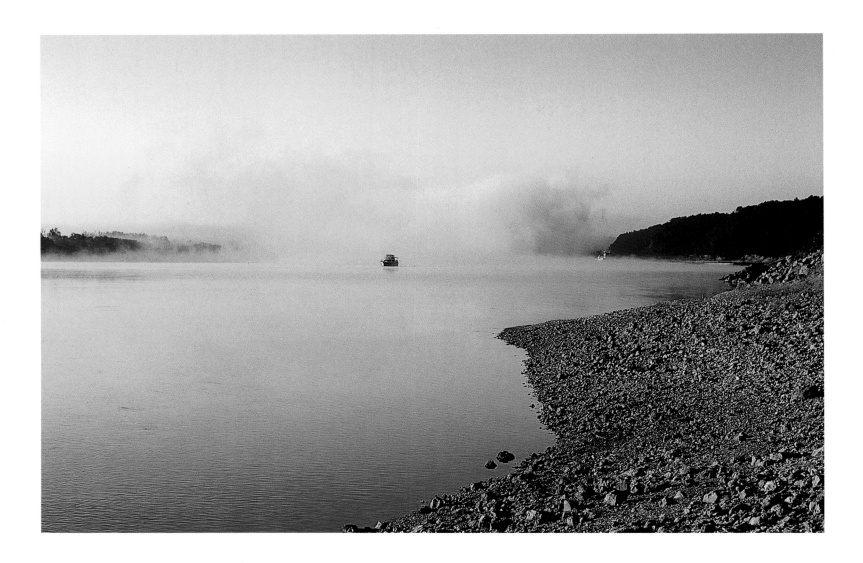

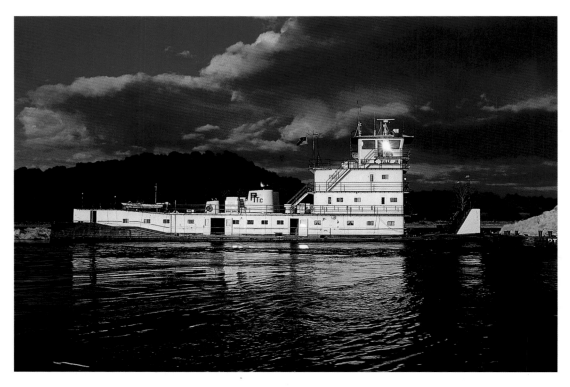

Two of the myriad vessels plying the waters of the Mississippi: a cabin cruiser in Missouri *(above)* and a push boat in Louisiana *(right)*. Sunrise *(far right)* is often a favorite time of day for river travelers addicted to beauty.

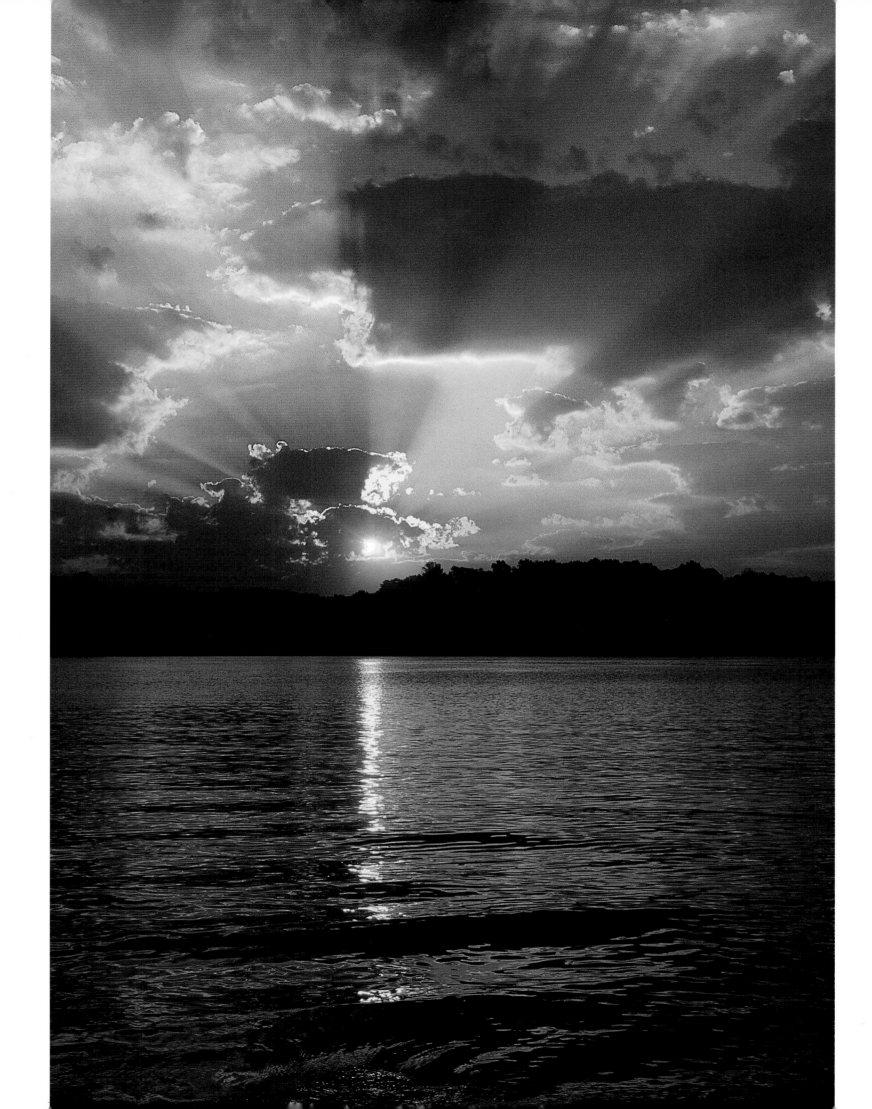

Trail of Tears State Park, Missouri, offers
visitors hiking and camping opportuni-
ties as well as outstanding views of the
Illinois floodplain.

On the Fourth of July in St. Louis, children are in position to greet a parade *(left, far left)* before an air show fills the skies over the Gateway Arch and Mississippi River. Sunday morning in Cape Girardeau, Missouri, finds the streets quiet in the downtown historic district *(above).*

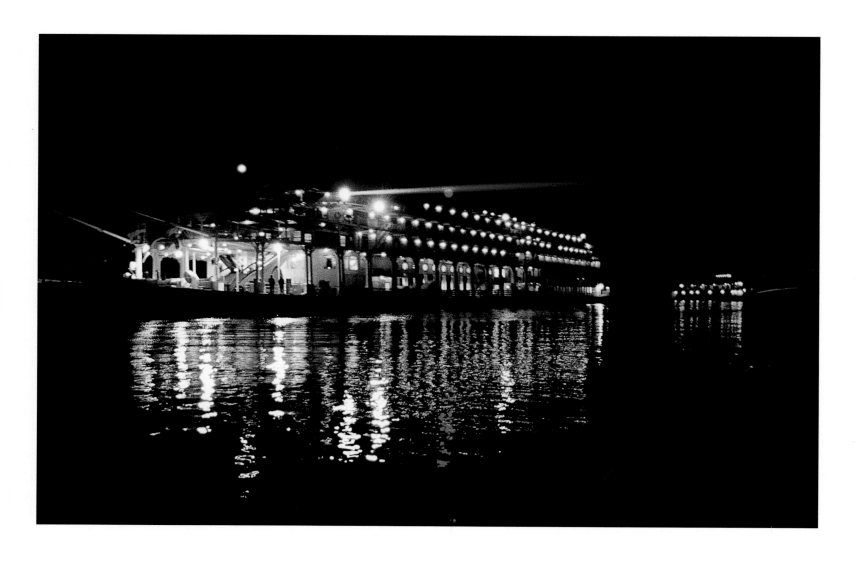

At Hannibal, Missouri, a modern bridge crosses the river, and diesel-powered push boats *(far right)* take the place of the steamboats common a century ago. Mark Twain would probably be astonished by the changes in his hometown as well as by the level of luxury aboard the *American Queen,* pulling into Hannibal at night *(above)*. An enactment of Twain's life is performed aboard this steamboat *(right)*. The author most associated with the Mississippi, Twain succeeded in memorizing the names of all the river's bends and the ways to navigate them in a steamboat. The sun sets over Choctaw Bend *(overleaf)*.

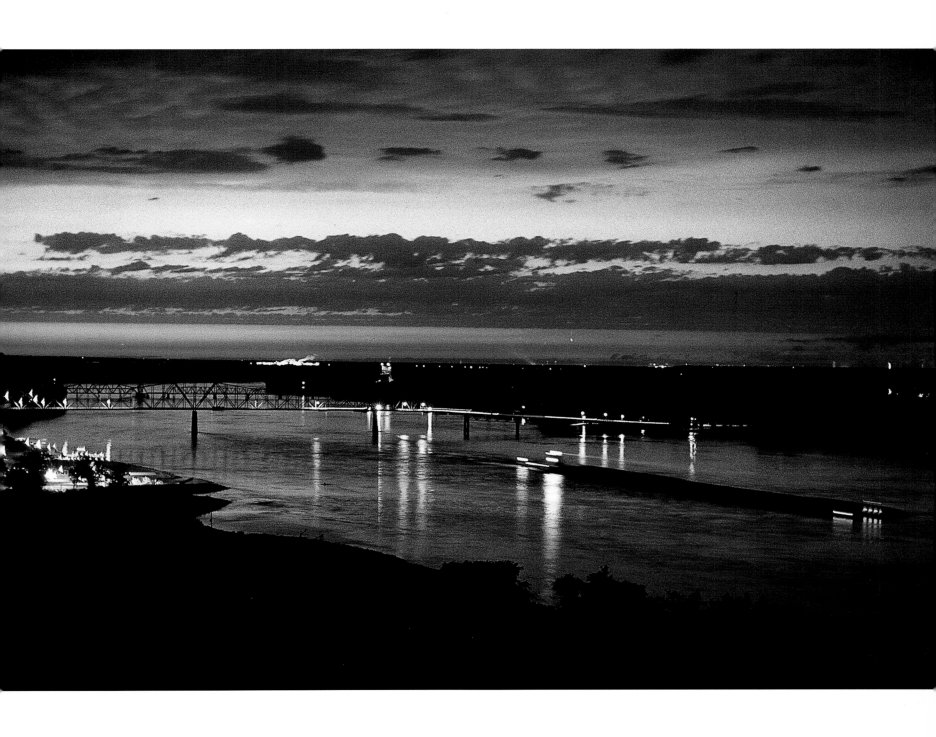

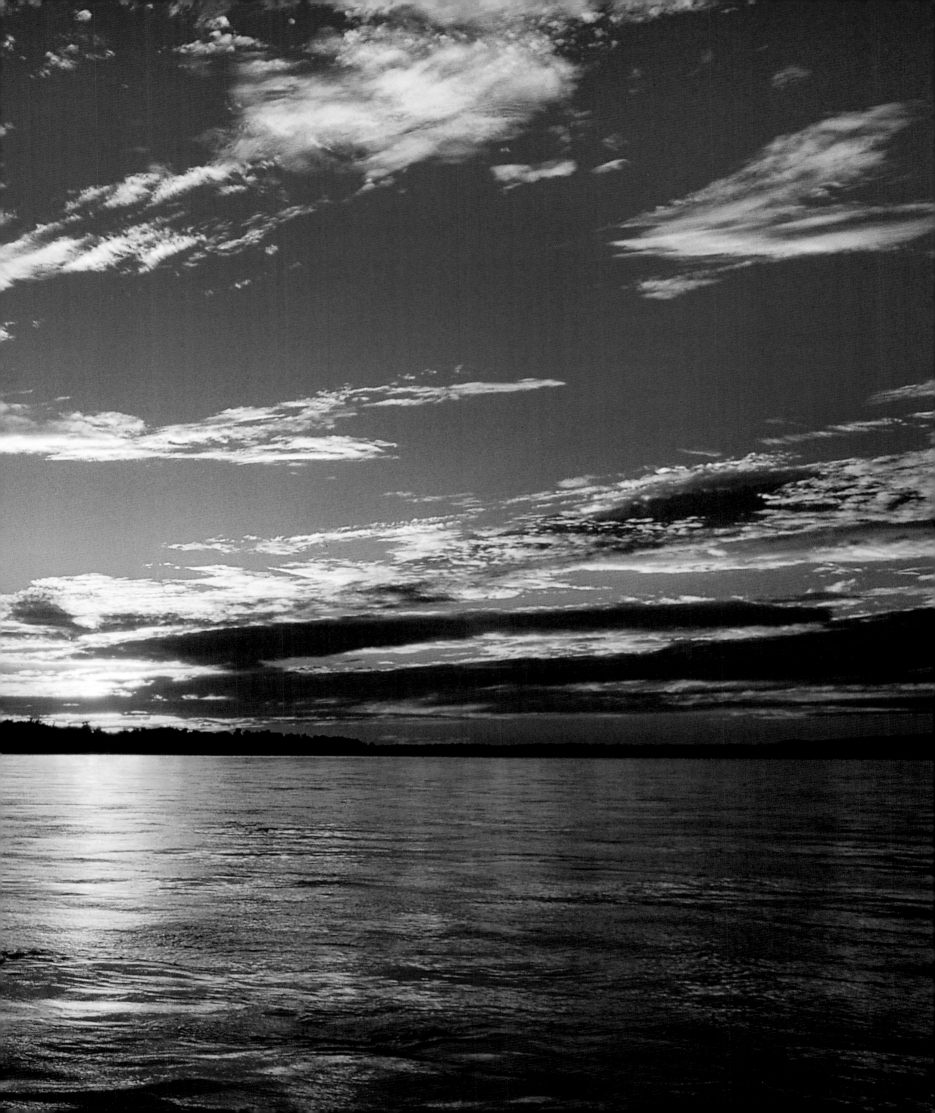

History blends with beauty at many of the state parks adorning the shores of the Mississippi. Hikers at Trail of Tears State Park, Missouri *(left)*, feel themselves steeped in a sense of the land's Native American past. At Columbus–Belmont Battlefield State Park, Kentucky *(above)*, visitors can touch the chain the Union Army used to blockade the river.

The upper Mississippi's limestone bluffs give way to clay bluffs *(above)* in Kentucky, Tennessee, and Mississippi. Fall colors light up an island near Red Wing, Minnesota *(right)*.

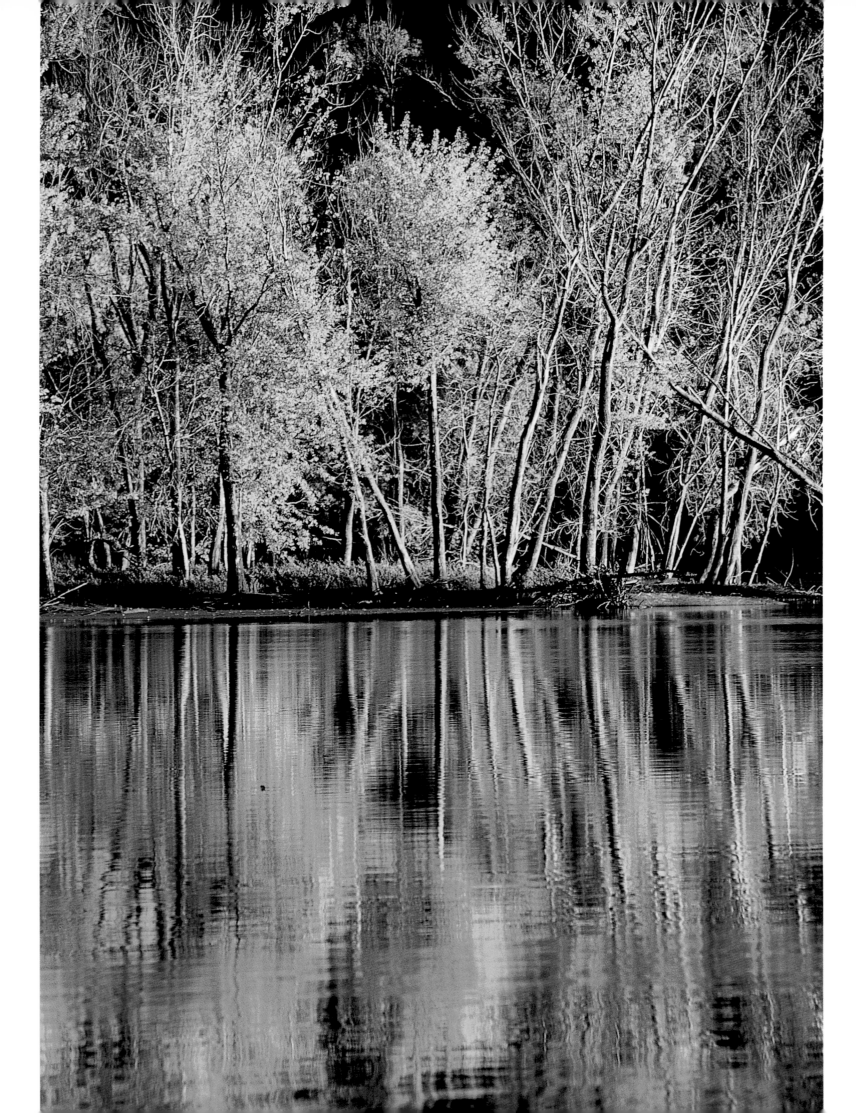

Memphis, Tennessee, lures visitors with its Beale Street blues quarter *(left)* and its Mud Island Museum, where a scale model of the Mississippi River is the main attraction *(far left)*.

The American lotus offers both a beautiful bloom *(far left)* and a meal for a grasshopper *(below)* along the river in Arkansas. A strange orange fungus coats a grapevine on Montgomery Island, Arkansas *(bottom left)*. Soft-shell turtles are common all along the 2,320 miles of the river *(left)*.

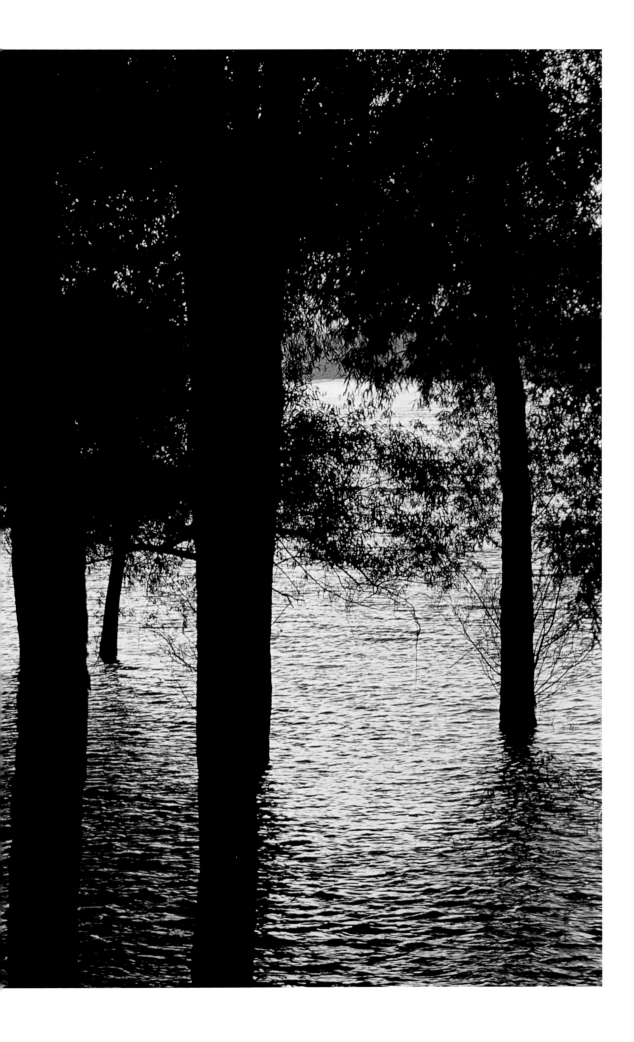

A spring flood submerges a riverside park in Helena, Arkansas.

Levees don't totally encase the Mississippi, but they extend along much of the River Road. Cows graze a levee *(above)* and cotton grows behind another *(right)*, indications that the levee system serves agriculture as much as flood control. A fallen soldier's grave lies covered by the fleshy yellow leaves of a ginkgo tree at Vicksburg's Battlefield Park *(far right)*.

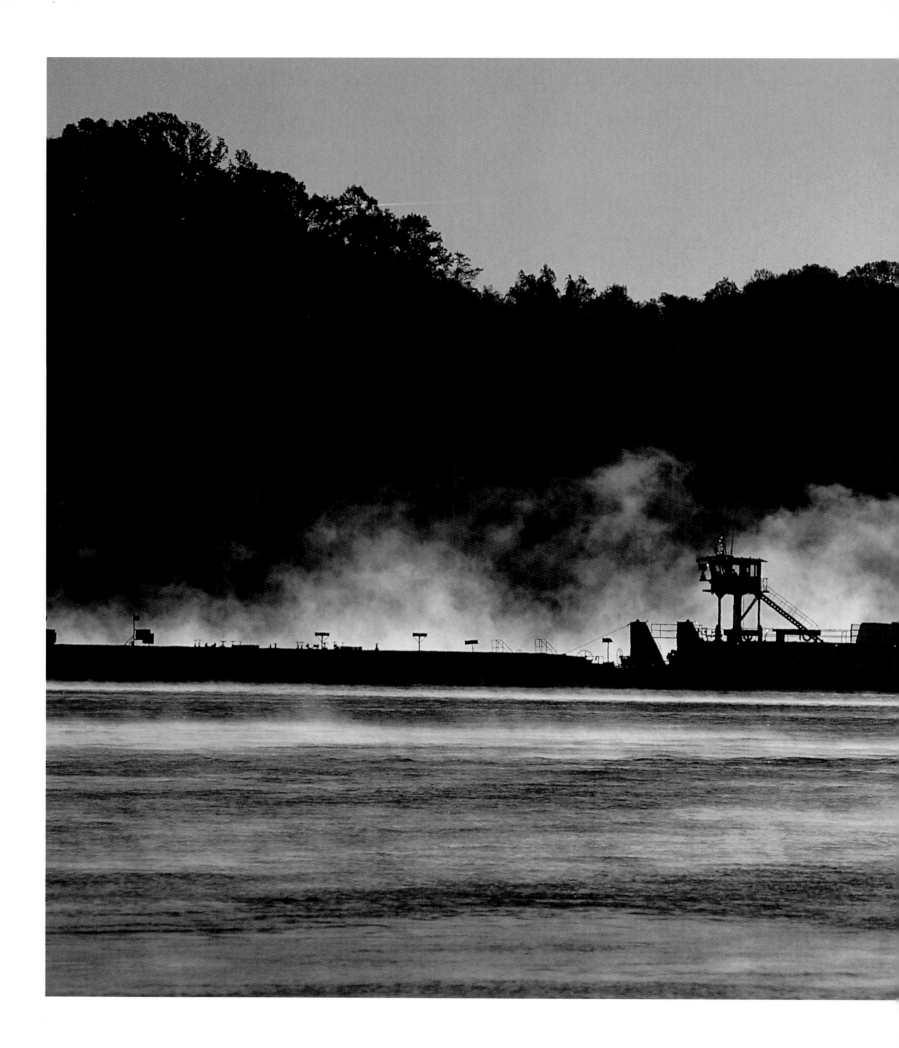

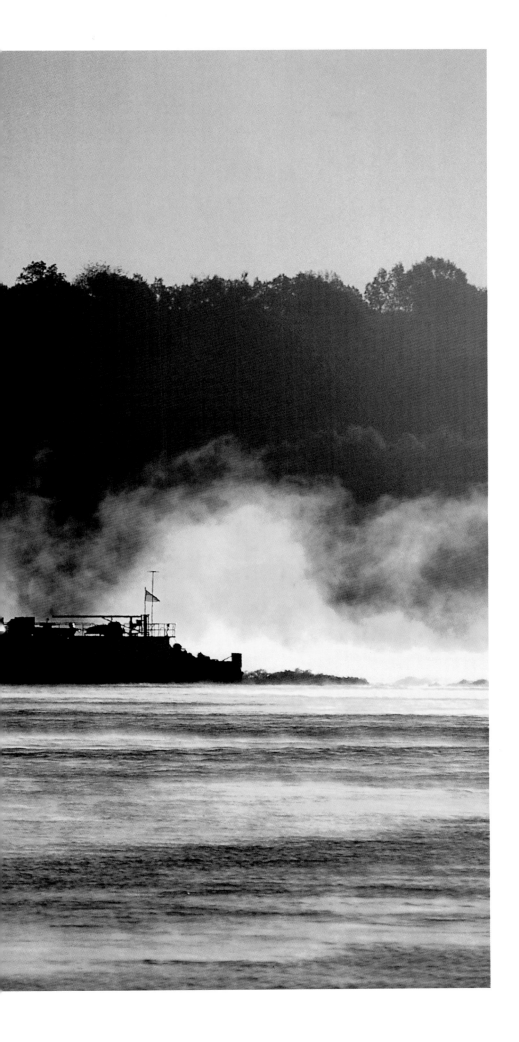

Through the fog over Fort Adams, Mississippi, slides an Illinois River boat *(left)*, so named because its retractable wheelhouse lets it pass beneath low bridges on the Illinois River. Dan and Bobbie Allen *(above)* can observe such interesting craft at a short distance from their camp near Fort Adams.

Fog develops on the lower Mississippi when warm air flows over the cold river and condenses *(above)*. Gambling joints like the Las Vegas Casino in Greenville, Mississippi *(right)*, must float in order to operate legally. (Casinos run by Native Americans are exempted from this rule.) An all-night exposure shows the full moon rising over and reflecting on the river in Missouri *(far right)*.

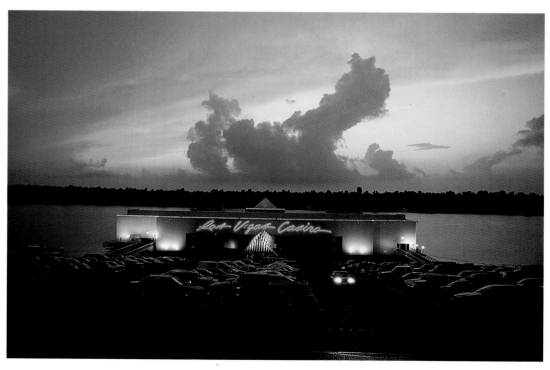

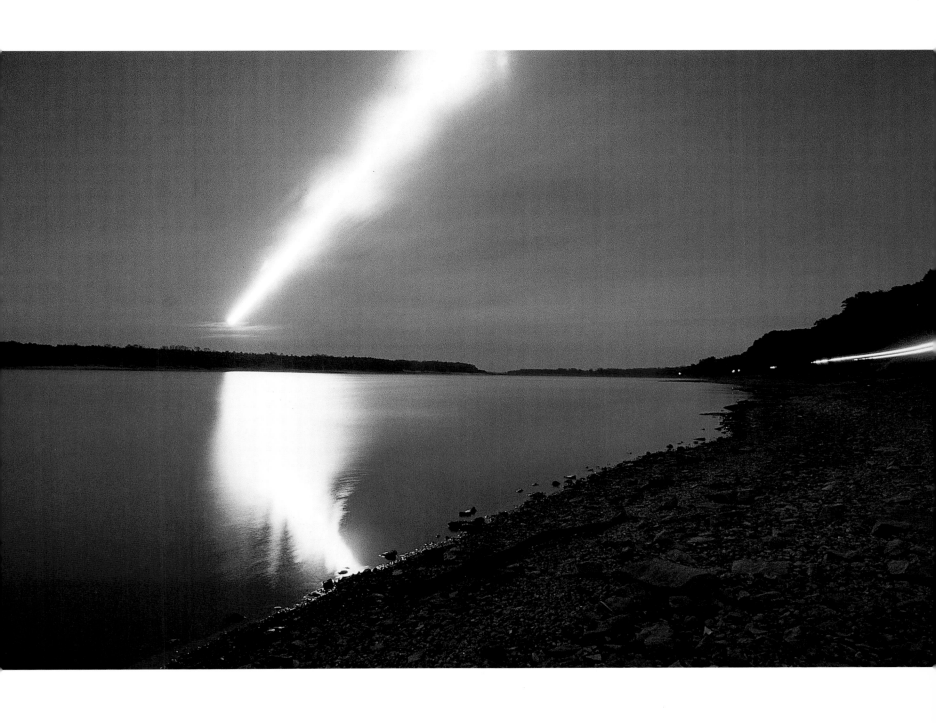

When the river is high, sometimes a seep will leak under the levee, a problem solved by sand-bagging at the flow's exit to raise the water pressure on the landward side *(above)*. The river turbulence associated with high water also creates a lot of work for deckhands *(right)*.

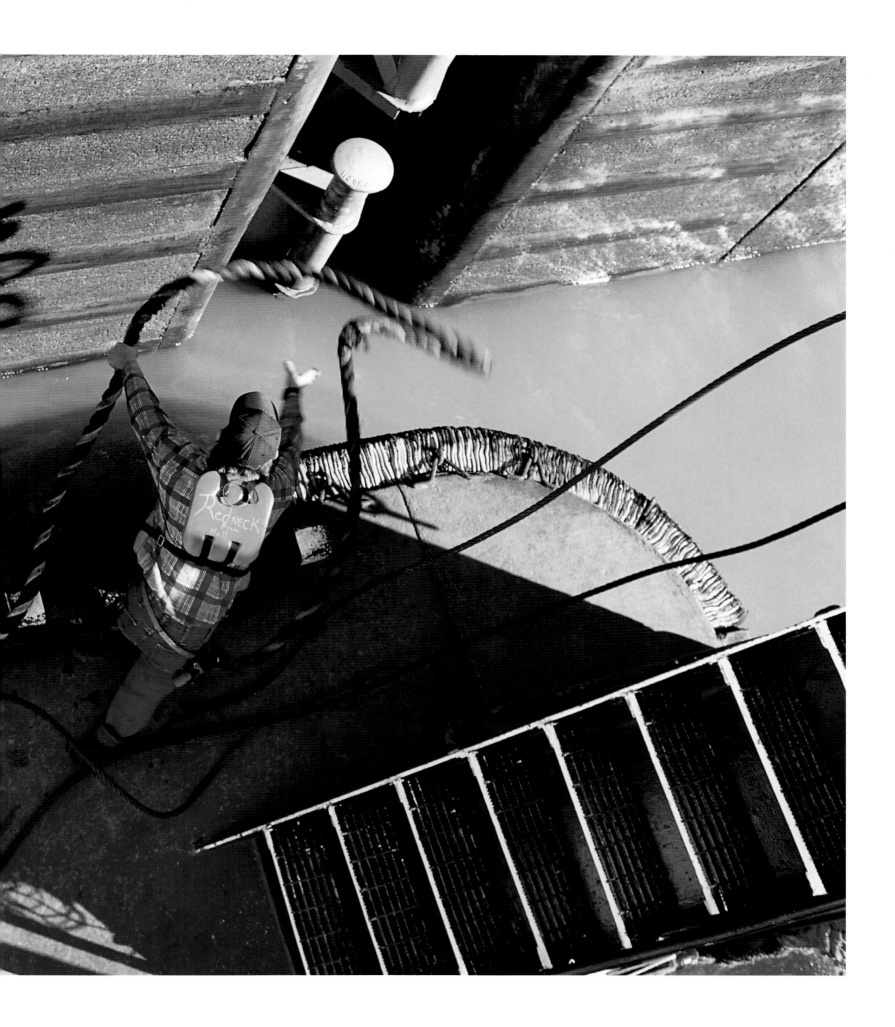

A Christmas full moon appears to magnify the Louisiana State Capitol *(far right)*, whose azalea-laden gardens bloom magnificently each spring *(above).* Huey Long started work on this monument but was assassinated before it was finished. White pelicans, whose numbers have increased due to easy fishing in commercial catfish ponds, gather at Louisiana State University lakes all winter *(right).*

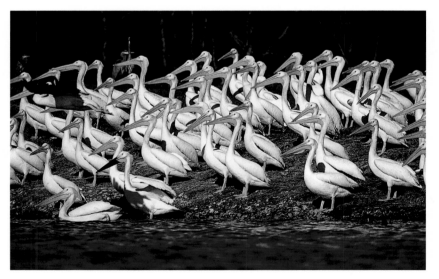

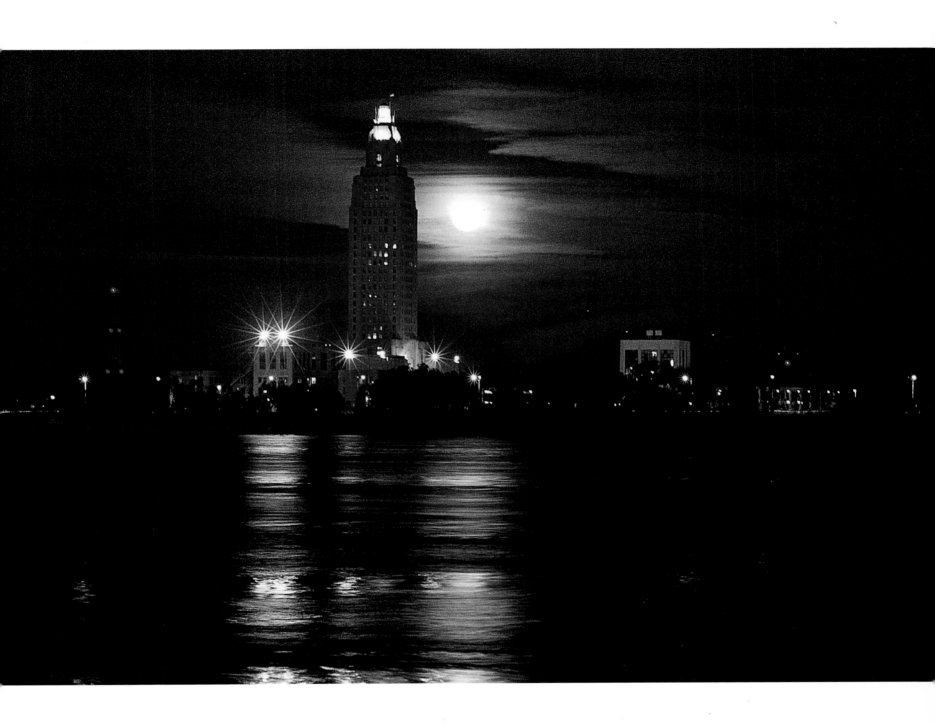

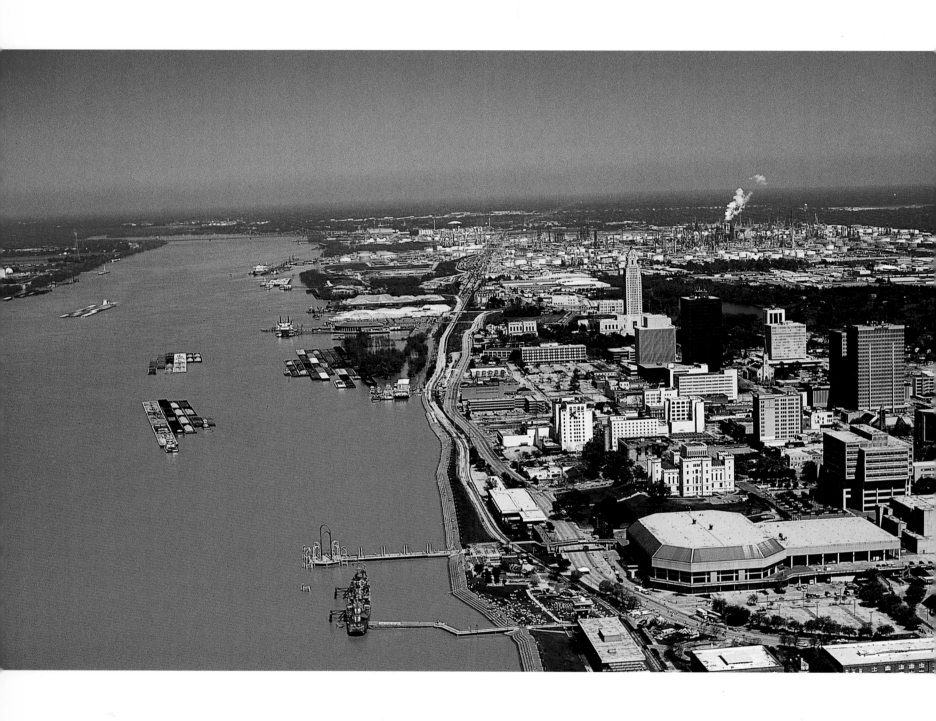

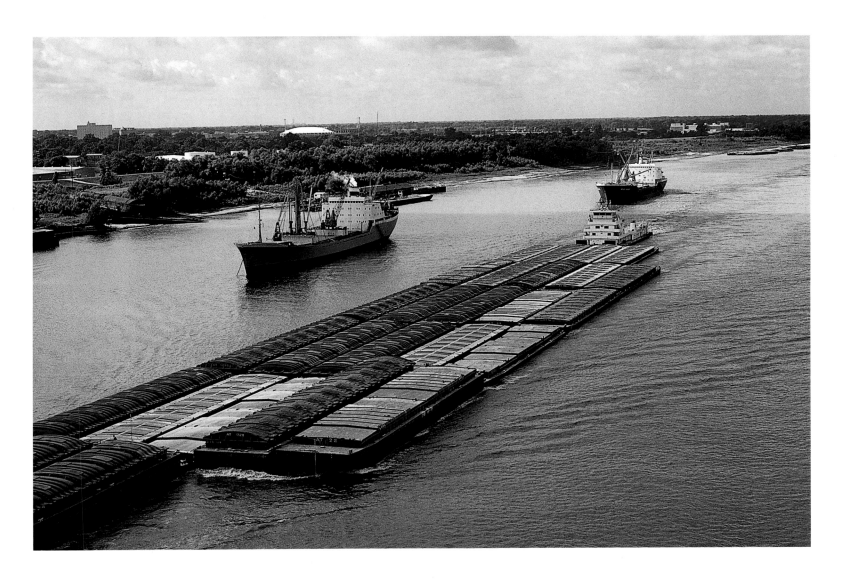

The remnants of the crowd assembled for the Great River Road Run linger on the levee by the USS *Kidd* in downtown Baton Rouge *(far left)*, whose port ranks fifth in tonnage among America's ports. Cargo ships and weighted barges pass with a view of Louisiana State University *(above)*, while empty barges wait for cargo to transport near the Sunshine Bridge *(left)*.

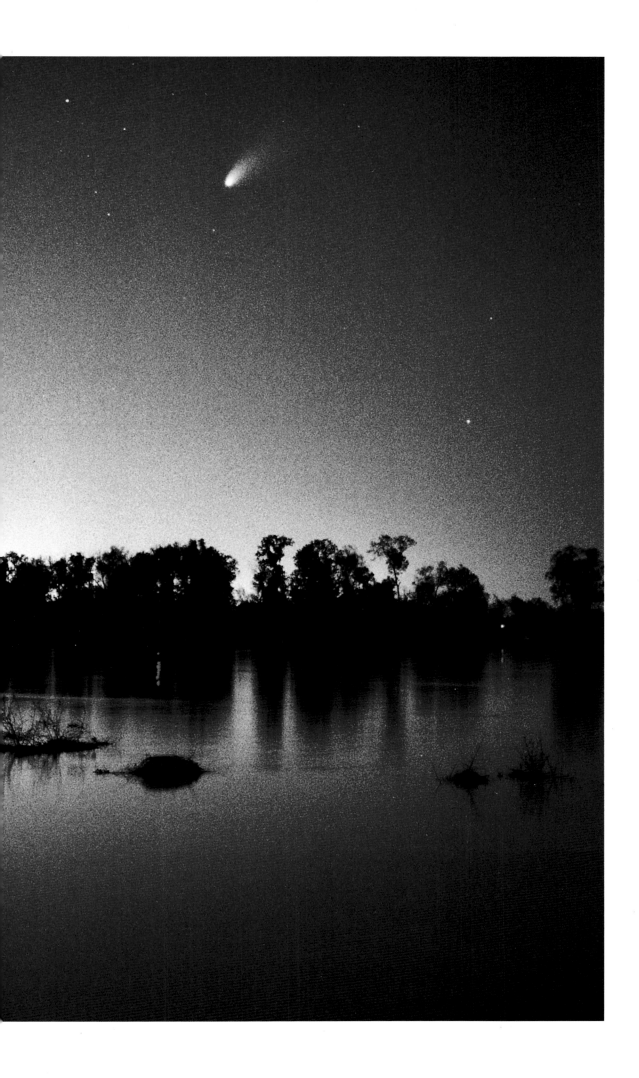

Comet Hale-Bopp glows in the evening sky over Plaquemine Point, just south of Baton Rouge.

The meandering path of the Mississippi creates a seemingly endless series of S-curves down the middle of America, easy to appreciate from the air.

The author saw a great blue heron *(far right)* every day in his journey from Lake Itasca to the Gulf of Mexico. This stately bird can be seen anywhere in the United States and all along the Mississippi River. The great egret is also in abundance along the Mississippi *(right)*. Live oaks frame the walk to the levee at Tezcuco Plantation, Burnside, Louisiana *(above)*.

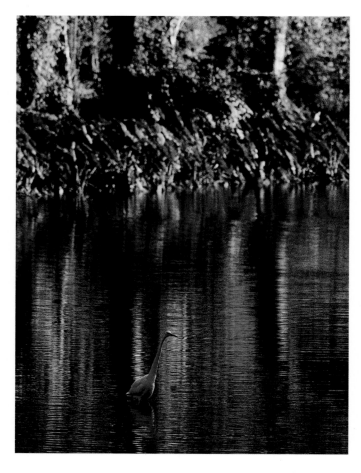

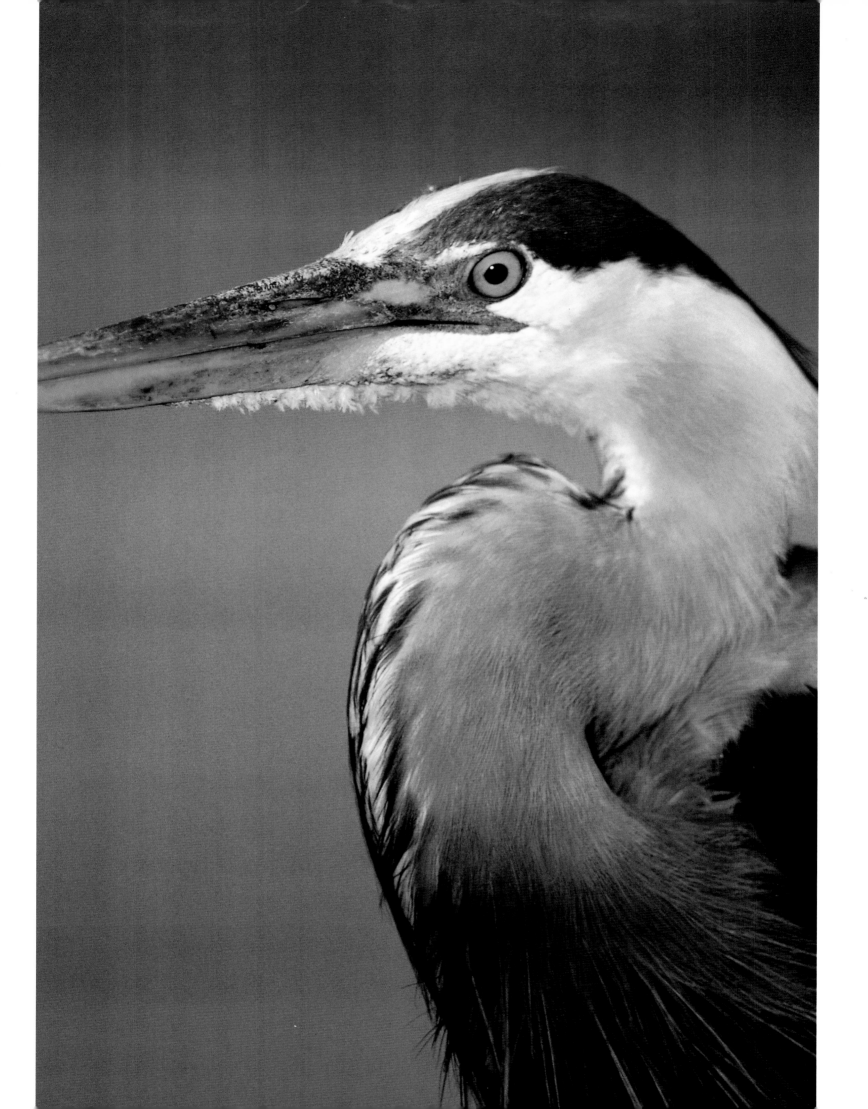

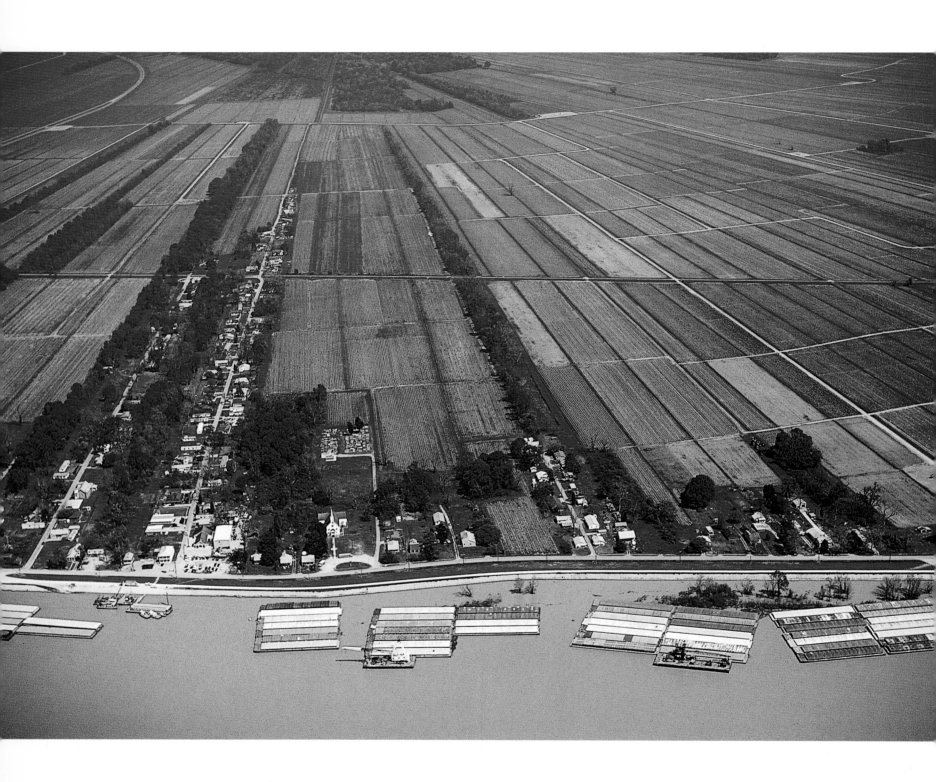

Formerly, the arpent system of land grants gave each landowner a small amount of river access with acreage measured lengthwise off the river *(far left)*. Now industry occupies much river frontage *(above)*. Annual passage of the Army Corps of Engineers' hopper dredge USS *Wheeler* keeps the main channel forty-five feet deep *(left)*.

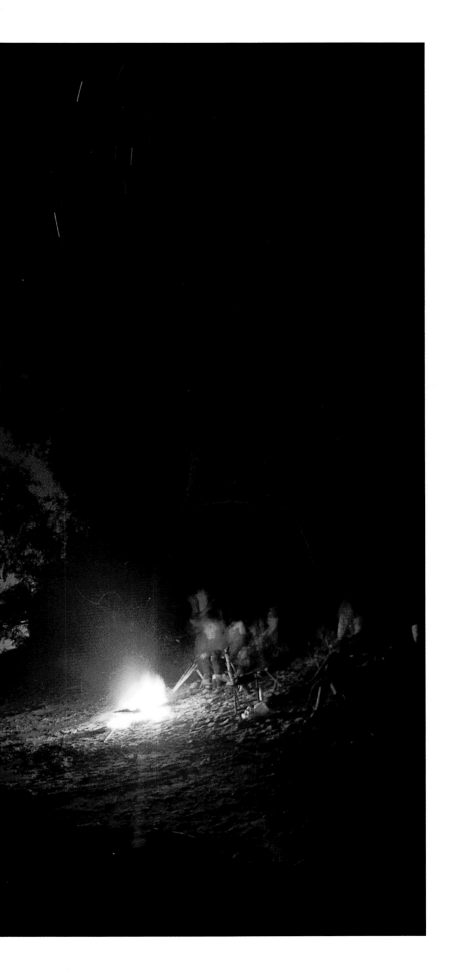

Campers enjoy both starlight and firelight on a sand-covered island near White Castle, Louisiana *(left)*. Multicolored barges moored to the bank await a call to pick up cargo near Donaldsonville, Louisiana *(above)*.

137

St. John the Baptist Church overlooks
the River Road at Edgard, Louisiana
(above). Shrimpboats rest in a bayou at
sunset in the Mississippi Delta commu-
nity of Hermitage *(right)*.

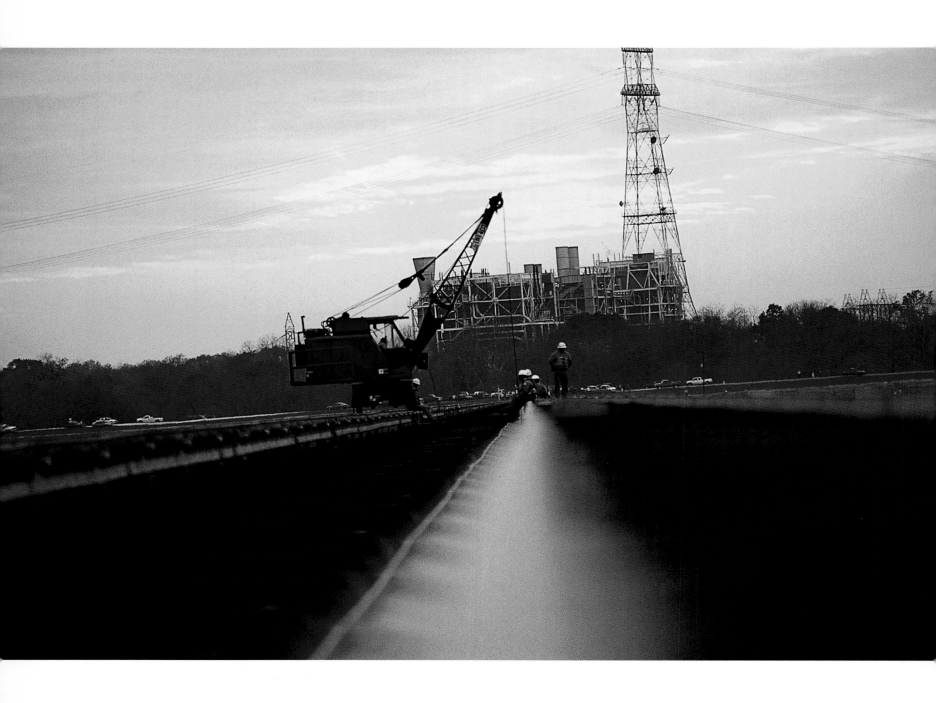

On March 17, 1997, cranes pulled the pins to open the floodgates of the Bonne Carre Spillway *(far left)* in order to protect farmlands *(left)* and industry *(above)*, as well as to prevent New Orleans from flooding. The Mississippi snakes her way through New Orleans *(overleaf)*.

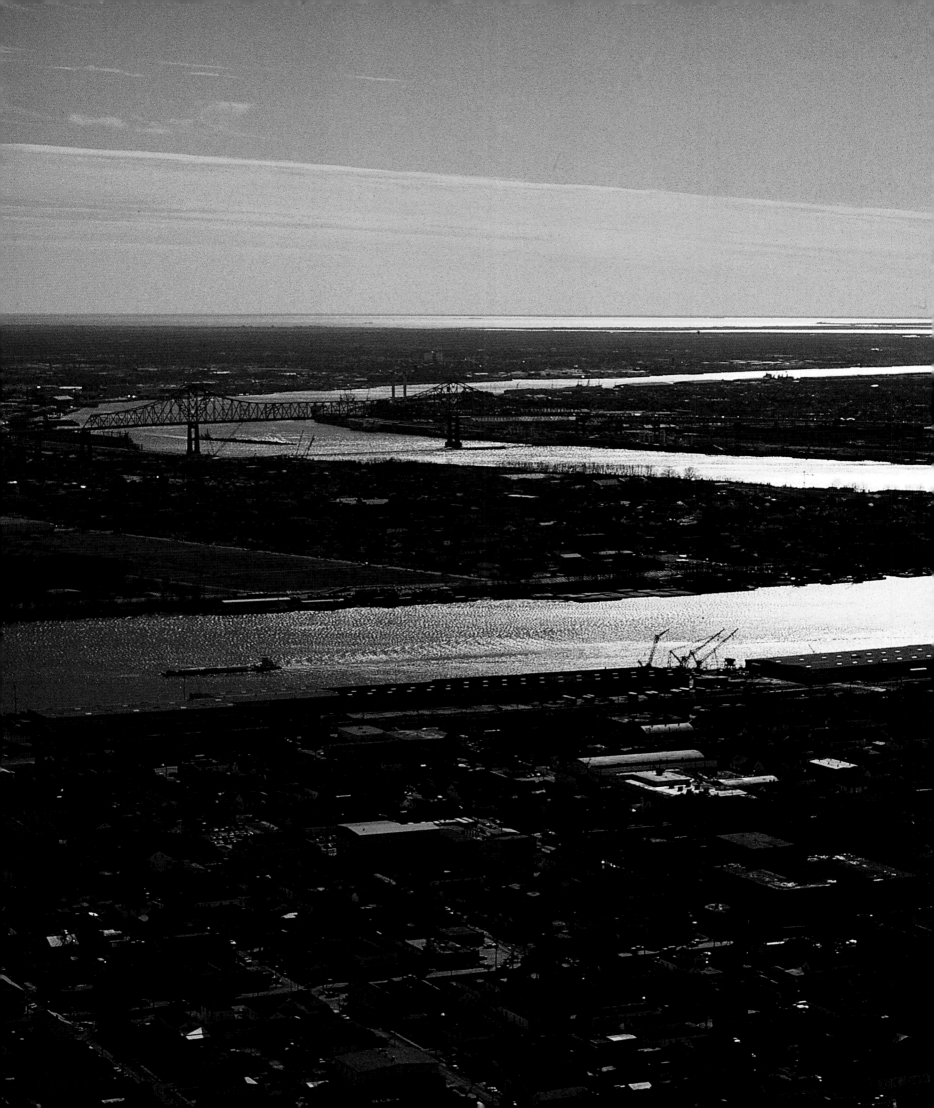

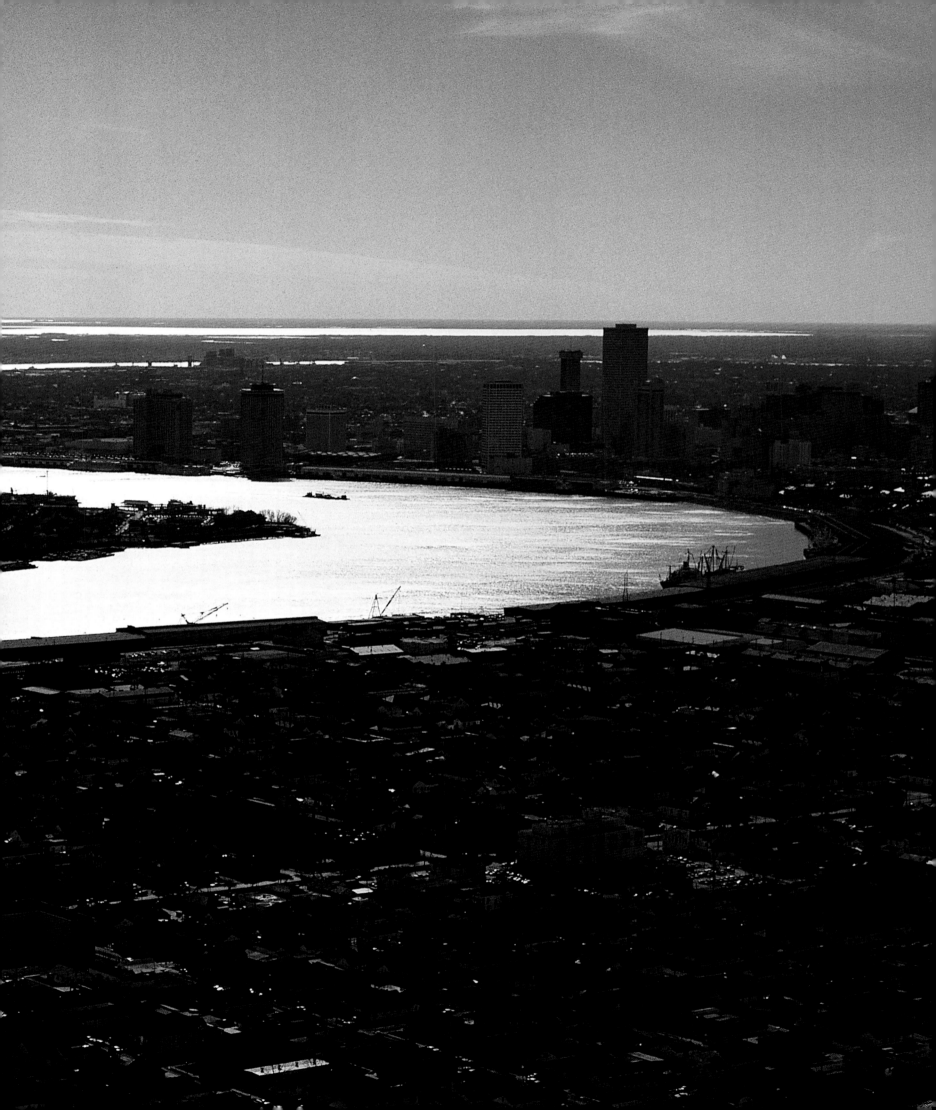

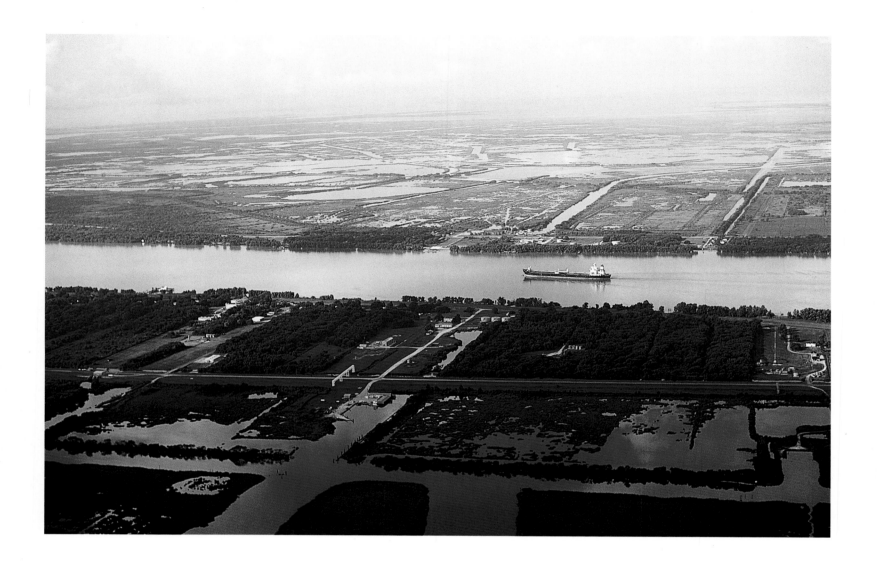

Natural sand contrasts with the rocks that the Army Corps of Engineers has introduced for bank stabilization *(right).* The Corps controls the river's course and depth as it makes its way to the Gulf past marshes and orange groves in Plaquemine Parish *(above and far right).*

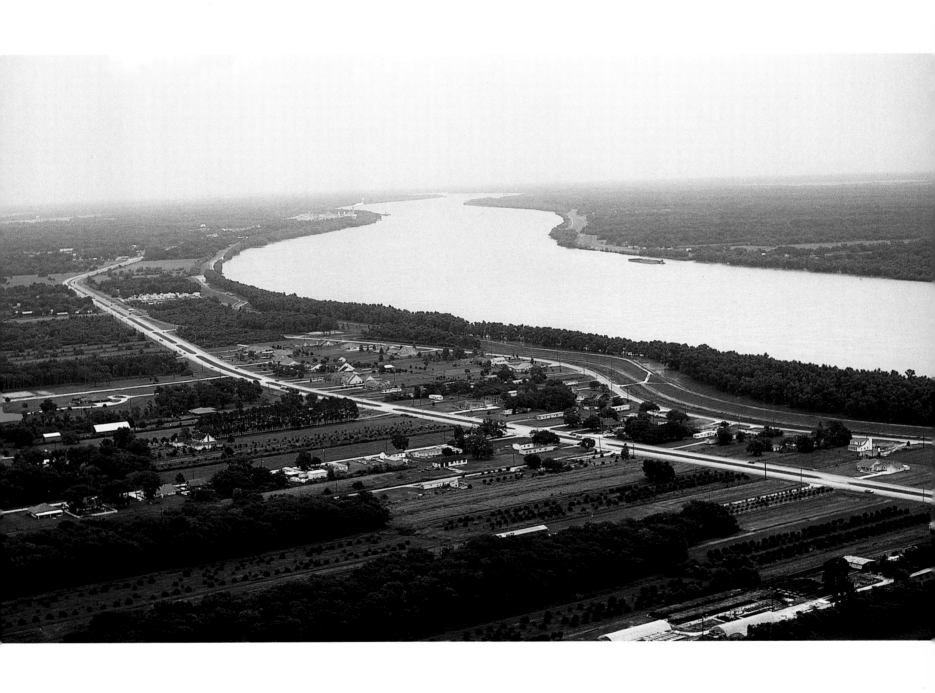

An aluminum plant is left in eerie abandonment near Chalmette, Louisiana *(far left)*. A fisherman dips for shad as a brown pelican helps himself to the catch at the Caernarvon freshwater diversion structure at Poydras, Louisiana *(left)*. Cargo ships passing also near Poydras appear perilously close to one another *(above)*.

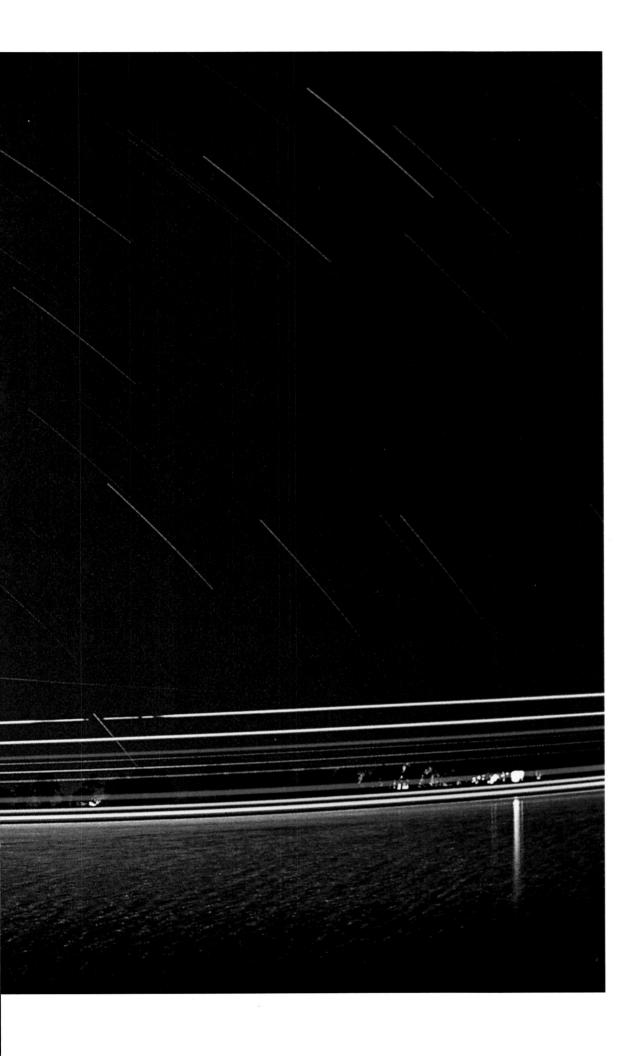

Planes, planets, stars, and navigation lights on towboats illuminate the Mississippi River at night . . . more than the average sleeping human would imagine.

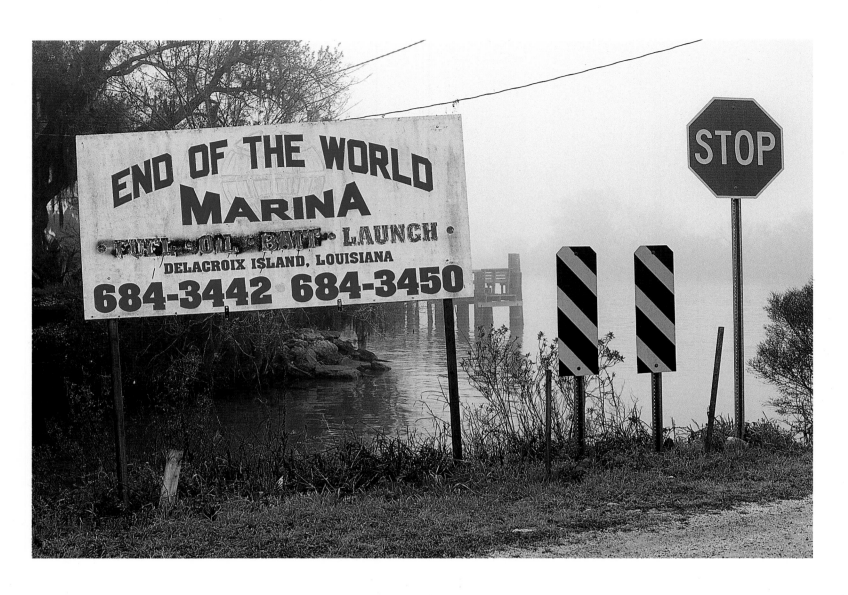

State highway 300 ends at Delacroix, Louisiana, a village surrounded by the swamps and marshes of the Mississippi Delta *(above)*. Christmas lichen grows on the north side of an oak tree in order to receive minimal light *(right)*.

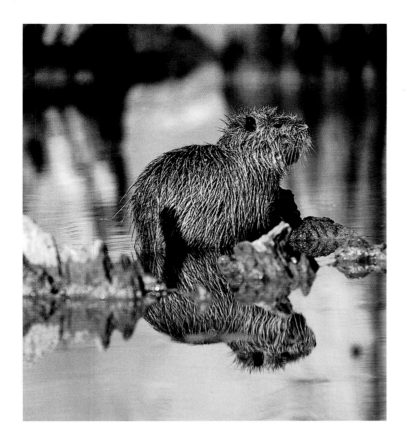

The prolific nutria, an exotic species from South America, aggravates marshland loss and compromises the levee system of south Louisiana *(left)*. The armadillo has likewise expanded its range and become quite numerous in Louisiana *(below)*.

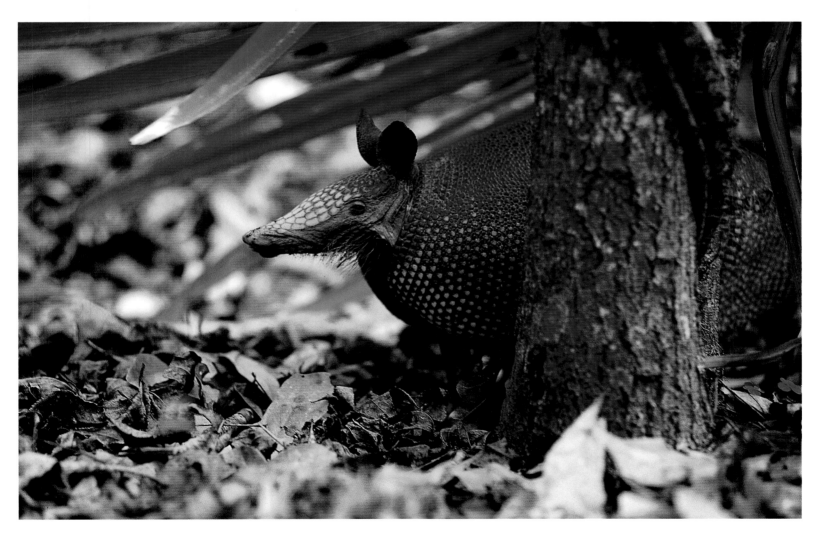

Southwest Pass lighthouse lies at the tip of the pass used for cargo shipping *(above)*. Dredge material from its channel is sometimes put in the surrounding bay *(right)* to help reduce the land loss due to subsidence and saltwater intrusion, which can kill baldcypress trees *(far right)*. A subsiding marsh shows a preponderance of open water *(above right)*.

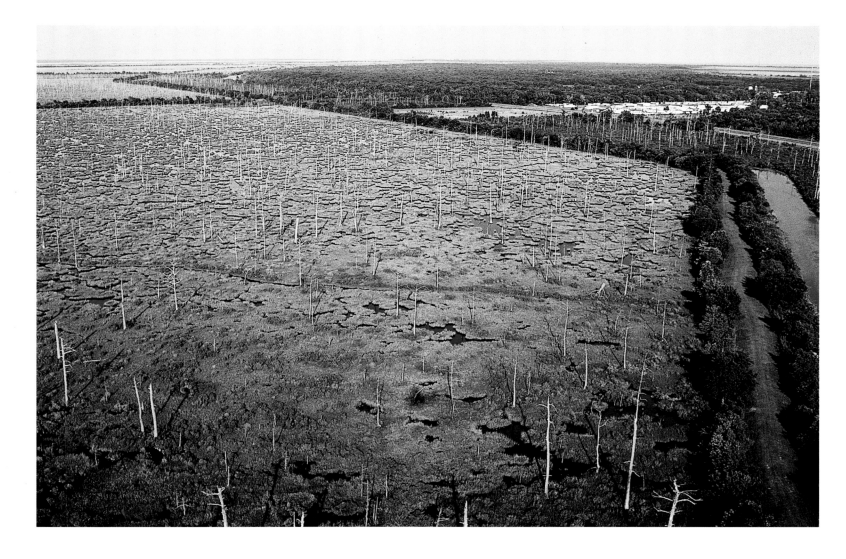

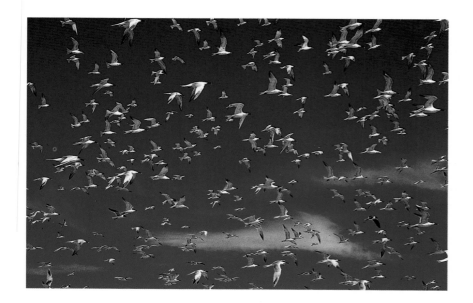

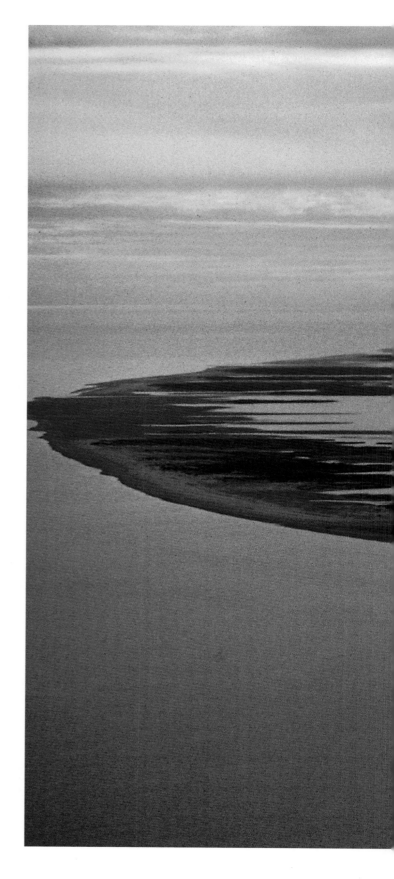

Sandwich terns circle over their rookery *(above)* on the Chandeleur Islands *(right)*, the extremities of one of the river's ancient deltas. The water to the right of the island is Chandeleur Sound, covering land that long ago subsided. The Mississippi is at a crossroads today, given the competing needs and desires of myriad people along its length haggling for their share of its resources *(overleaf)*. Can we take care of it?

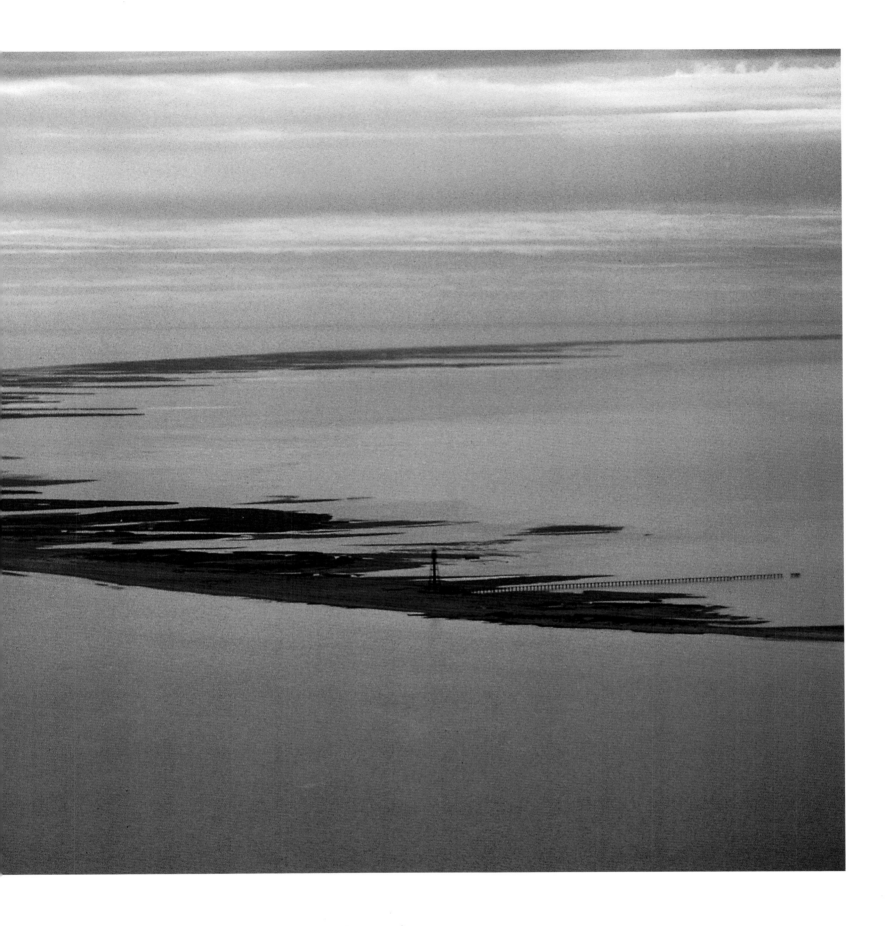

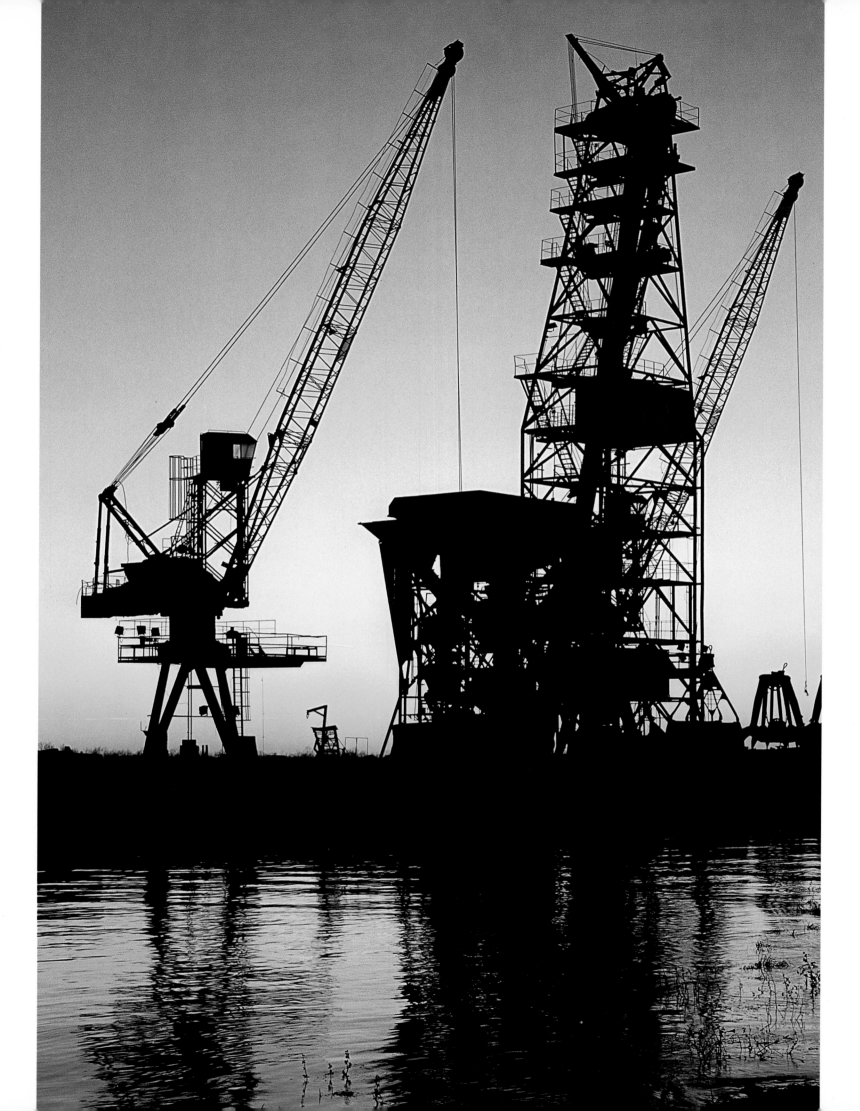

n o t e s o n p h o t o g r a p h s

Custom prints of all photographs used in this book are available. A limited quantity are printed in sizes 16 x 20 and 11 x 14. For information contact:

> The Lockwood Gallery
> 7656 Jefferson Highway
> Baton Rouge, Louisiana 70809
> (225) 925-0777

All photographs were taken with a Nikon F-4 or F-3 camera, using Fuji Velvia film. Most were taken from a tripod. The name of each photograph, along with lens and exposure, is listed below.

cover	Sunset from Mississippi Palisades. 80–200 f/2.8D Nikkor. f/5.6 @ 1/30.
page i	Peaceful Mississippi. 35–70mm f/2.8D Nikkor. f/8 @ 1/125.
page ii	Curvy Sunset. 24mm f/2.8D Nikkor. f/5.6 @ 1/4.
page vi	Raft at Rest. 20mm f/2.8 Micro-Nikkor. f/2.8 @ 90 seconds.
page viii	High Tech Huck. 24mm f/2.8D Nikkor. f/4 @ 1/60.
page 1	Source Snowstorm. 35–70mm f/2.8D Zoom Nikkor. f/5.6 @ 1/15.
page 2	Batture Sunset. 35–70mm f/2.8D Zoom Nikkor. f/8 @ 1/30.
page 4	GCE Raft at Sunset. 24mm f/2.8D Nikkor. f/8 @ 1/30.
page 6	Mini-Mississippi. 35–70mm f/2.8D Zoom Nikkor. f/11 @ 1/3.
page 8	Mississippi Rapids. 24mm f/2.8D Nikkor. f/8 @ 1/30.
page 9	Camo Frog. 55mm f/2.8 Micro-Nikkor. f/5.6 @ 1/8.
page 11	Mississippi River Swimmer. 24mm f/2.8D Nikkor. f/8 @ 1/60. Flash.
page 12	Willie P. 35–70mm f/2.8D Zoom Nikkor. f/8 @ 1/125.
page 15	St. Anthony Falls Lock. 35–70mm f/2.8D Zoom Nikkor. f/5.6 @ 1/30.
page 16	Rain Turns Green. 300mm f/2.8 IFED Nikkor. f/2.8 @ 2 minutes.
page 17	Night Boating. 35–70mm f/2.8D Zoom Nikkor. f/2.8 @ 1/8.
page 18	Coffee. 35–70mm f/2.8D Zoom Nikkor. f/5.6 @ 1/30. Flash.
page 19	Trempealeau Mountain. 35–70mm f/2.8D Zoom Nikkor. f/8 @ 1/125.
page 20	Lacy Fog. 80–200mm f/2.8D Zoom Nikkor. f/5.6 @ 1/15.
page 21	Wisconsin River. 300 mm f/2.8 IFED Nikkor. f/4 @ 1/8.
page 22	Lock Repairs. 28mm f/3.5 PC Nikkor. f/11 @ 1/30.
page 23	I-280 Bridge. 80–200 mm f/2.8D Zoom Nikkor. f/11 @ 1/125.
page 24	Reflections. 20mm f/2.8D Nikkor. f/11 @ 1/8.
page 25	Muddy Mussel. 55mm f/2.8 Micro-Nikkor. f/11 @ 1/30.